TALKING TO A PORTRAIT

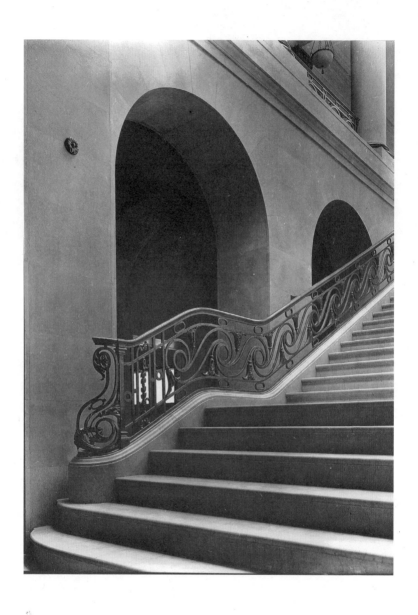

William Notman & Son, *Staircase, New Art Gallery*
(now the Montreal Museum of Fine Arts), 1913
McCord Museum, Montreal

Talking
to a
Portrait

*Tales of an
Art Curator*

ROSALIND M. PEPALL

Véhicule Press

Published with the generous assistance of the Canada Council for the Arts, the Canada Book Fund of the Department of Canadian Heritage, and the Société de développement des entreprises culturelles du Québec (SODEC).

Cover design: David Drummond
Typeset in Minion and Filosofia
Printed by Marquis Printing Inc.

LIBRARY AND ARCHIVES CANADA CATALOGUING IN PUBLICATION

Title: Talking to a portrait : tales of an art curator / Rosalind Pepall.
Names: Pepall, Rosalind M., author.
Identifiers: Canadiana (print) 20190230991 | Canadiana (ebook) 20190231017 | ISBN 9781550655414 (softcover) | ISBN 9781550655476 (HTML)
Subjects: LCSH: Art museum curators—Anecdotes. | LCSH: Art museums—Curatorship—Anecdotes.
Classification: LCC N406.A1 P47 2020 | DDC 708.0092/2—dc23

Published by Véhicule Press, Montréal, Québec, Canada

Distribution in Canada by LitDistCo
www.litdistco.ca

Distribution in the u.s. by Independent Publishers Group
ipgbook.com

Printed in Canada

For Armand, Philippe and Charles

CONTENTS

PREFACE

IN WRITING THESE STORIES, I often thought of fellow curators with whom I have worked both in Canada and abroad. Curators are at the heart of every art museum. Despite the current bandying about of the word *curator*, which may now refer to someone curating meals, curating wardrobes, curating podcasts or even curating dog shows, curators were traditionally associated with museums or libraries, watching over and building up collections. At the Victoria & Albert Museum in London, curators are still called "keepers" of a collection. Working behind the scenes, art curators select acquisitions, carry out research, install collections, court donors and interpret art, giving it meaning through exhibitions and publications. In this way a curator's tastes and passions contribute to the permanent fabric of the institution.

I fell into my profession by happenstance. I needed a job and a friend told me of an opening in the European Department at the Royal Ontario Museum in Toronto. It was a lowly position for a university graduate, but it set me on an unexpected course. I fell in love with the ROM's exhibition galleries, its wooden and glass cases, and its musty period rooms with their Georgian table settings, French salon chandeliers, heavily carved Elizabethan furniture and portraits of bewigged patricians. I was smitten by this "old world."

The former offices of the ROM had an allure of the past, too. Heri Hickl-Szabo, director of the European Department, sat at an antique desk in a dingy, gloomy room full of dark bookcases, dark paintings and cracks in the walls.

"Why don't you lighten up your office a bit, Mr. Hickl?" I asked him. "You know, paint the walls in cheerful tones?"

"Oh no, Rosalind, we must look poor and shabby, otherwise my visitors will think we don't need any funding," he replied with a grin, as Hickl-Szabo was an expert at raising cash from his devoted patrons.

Despite my enchantment with the ROM, I was only twenty-three and decided to pursue a further degree in Canadian art history, which eventually opened the door in Montreal (my hometown) to the Museum of Fine Arts in 1978. When I started there, the museum still functioned within its 1912 premises and a 1970s wing at the back. A white marble Beaux-Arts monument, the building was designed by Montreal architects Edward and W. S. Maxwell and stood regal and aloof on Sherbrooke Street. Sometimes, instead of taking the employees' back door, I would use the main entrance doors, passing through the four giant marble columns hewn from a Vermont quarry, each one cut from a single piece of marble. The lustre of white marble was carried over into the entrance hall, where I would continue up the stately staircase (its bronze railing copied from Paris's Petit Palais) and arrive at the exhibition galleries, laid out like a European palace in *enfilade*. One journalist called the rooms the finest in Canada. Over the next thirty years I served under the tenure of five directors, their moods and priorities shifting along the way, and the museum grew from a family-like concern to a vast operation. Now consisting of six pavilions united by underground tunnels and passages, the institution has become (in the words of present director Nathalie Bondil) a veritable village.

As Curator of Canadian Art, I would lose myself in the reserve of artworks waiting to be exhibited. It was a privilege that few art enthusiasts are given. There I could admire the luminosity of an Ozias Leduc painting, the rolling hills of an A. Y. Jackson Quebec landscape, or Jean-Paul Riopelle's *Vent Traversier*, in which a violent breeze seemed to have whirled the rich reds, greens and yellows into a glorious expansion of colour across the canvas. Later, I felt the same sense of pleasure as Senior Curator of Decorative Arts, wandering through the storage rooms to examine the simple beauty of Jean Puiforcat's silver soup tureen, the playfulness of Carlo Bugatti's

armchair, or the Surrealist motifs by Jean-Paul Mousseau painted on a skirt that once swirled with its wearer on a discothèque floor.

A curator's days are spent looking, observing what is distinctive about an art piece. Questions arise: Who created it? When was it made and where? Why this style? The answers tumble forth, and they have taken me on journeys of discovery to Saint Petersburg, New York, London, Paris, the Barren Lands of the Canadian North and the canals of Venice. Few people outside the art world know the emotions, surprising twists and obsessions in the work of a curator. When writing an academic essay, a curator doesn't describe what a lender looks like or include a conversation with a collector. You don't include your delight at standing before a painting that moves you. You don't describe the long hours of research that led to nowhere. You don't reveal the blunders in preparing an exhibition. In fact, you don't include what readers especially enjoy hearing about. I've had many unexpected encounters over the years—some delightful, some frustrating, some remarkable—so here it is: tales of an art curator.

Ludivine

"HAS A PAINTING EVER BROUGHT YOU TO TEARS?"

The question, posed by a fellow curator during a meeting, caught me off guard.

I pondered it briefly, feeling a little scornful of emotional outbursts. A work of art had often moved me deeply, but not to the point of weeping.

But later on, walking home from the museum, I remembered one moment in particular when a painting *had* brought tears to my eyes. It was a Tuesday afternoon in the spring of 2003, in a near-empty room in the National Gallery in Ottawa, where I had been staring at a painting, making notes on composition, colour and expression. It was a simple portrait of an ordinary girl. Entitled *Ludivine*, it was created by Montreal artist Edwin Holgate in 1930. Daughter of a poor fisherman in Natashquan, a remote town on the north shore of the Gulf of St. Lawrence, Ludivine had just lost her mother when Holgate painted her. At the age of fifteen she would now be in charge of raising her seven brothers and sisters. Sensing her plight, Holgate captured Ludivine numbed by grief and the weight of her new family responsibilities. The painting resounds with restrained emotion. Wariness, weariness, sadness and innocence can all be found in the face of this young girl with haunting jet-black eyes.

That year, I was preparing an exhibition on Holgate for the Montreal Museum of Fine Arts, examining many works for possible

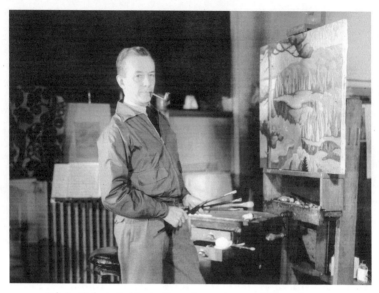

Edwin Holgate in his studio on Lorne Avenue, Montreal, c. 1939
Archives nationales du Québec, Centre de Montréal,
Conrad Poirier fonds

inclusion in the show. Holgate died in 1977 at the age of eighty-five,
but kept a low profile in the last decades of his career, residing in the
Quebec Laurentian town of Morin-Heights. I knew his work well
but had never met him. Now I wondered, who was this man who
had created such a striking portrait—and just as important, who
was Ludivine?

Edwin Headley Holgate is not known in the way that Emily
Carr or Lawren Harris are, but he was central to the development
of modern Canadian painting in the 1920s and 1930s. He is often
linked with the Group of Seven artists, as they invited him to join
their group as an eighth member in 1929, because the Toronto-
based group wanted to expand their representation of artists from
other parts of Canada. Holgate shared the Group of Seven's love
of the Canadian wilderness and in turn they admired his paintings
of the human figure. Apart from the short monograph on Holgate
written by Dennis Reid for the National Gallery of Canada in 1975,

we knew relatively little about Holgate except through newspaper articles, interviews, a few letters to friends and entries in general exhibition catalogues.[1]

After World War I, Montreal had a plethora of talented male and female artists. They painted landscapes, the human figure, portraits and scenes of the city—a new subject in Canadian art. They congregated in loosely connected groups of friends who came together periodically to exhibit their work. Many of them are now grouped together under the banner of the Beaver Hall Group.[2] Holgate was active in the early formation of the group, as many members had been his fellow students at the art school of the Art Association of Montreal. Holgate helped them find a studio in Montreal (on Beaver Hall Hill) where many of these artists would gather and hold exhibitions of their work.

Holgate was a well-liked member of the city's community of artists, but he was reserved—a quiet presence behind his outgoing friends and fellow painters A. Y. Jackson and André Biéler. Had he been as dynamic and outspoken as Jackson, Holgate might have emerged as the leader of the Beaver Hall painters. But Holgate was loath to get involved in the struggle between the conservative Royal Canadian Academy—deemed "old fossils"—and the young artists who took a more modern approach to art.[3]

Holgate may have been low-key and reserved, but he was also worldly. He had served in the First World War, was fluent in French and trained in Paris for two years with Russian émigré artist Adolf Milman. Holgate never ceased to speak of his debt to Milman, an ardent follower of Cézanne, who taught him how to build up structure and volume in his painting. Unlike most anglophones, Holgate moved easily between the English and French cultures of Montreal. In *Ateliers: Études sur vingt-deux peintres et sculpteurs canadiens* (1928), his close friend and journalist Jean Chauvin wrote a chapter on Holgate and described his studio, then at 364 Dorchester Street West, as "two large rooms, one devoted to printmaking, the other to painting." Chauvin mentioned the many Japanese prints on the walls—no doubt collected during Holgate's days in Paris and inspired

by his interest in printmaking—along with drawings, pastels, small paintings and a hand-woven Quebec *ceinture fléchée*, "for local colour."[4]

A great lover of the outdoors, Holgate took refuge from the noise and distractions of the city in a log cabin he built on Lac Tremblant, north of Montreal. There he set up his easel before the Laurentian hills, fir trees and granite outcrops, and painted some of his best landscapes. He also integrated the female nude figure into the Laurentian setting, which drew praise as well as outrage. Large, monumental forms, the fleshy nude figures lie sensuously in the foreground and almost burst from the frame, their limbs corresponding with the curvature of the boulders, hills and forest in the background. When Holgate joined the Group of Seven, his paintings *Nude in the Open* and *Nude in a Landscape* were exhibited in its 1930 show. Despite "some irate letters from very right-minded Methodist fathers in Toronto,"[5] these paintings were immediately snapped up by the Art Gallery of Toronto and the National Gallery of Canada for their collections.

Despite the sensuality of Holgate's nudes, there is something staged about his female figure posing in the landscape. His compositions are so carefully constructed at times that they leave little room for mood. The harsh light falls on the human body laid out on a boldly rendered white drapery like fruit on a tablecloth in a still-life painting. In an interview with one of Holgate's models for these paintings, Madeleine Rocheleau Boyer, she told me that Holgate would paint his landscape backdrop before inserting her, the studio model, into the composition. No wonder his backgrounds sometimes appear like stage sets.

In 1933 the art critic of the Canadian magazine *Saturday Night* especially praised Holgate's portraits, declaring that the artist should paint more of them.[6] But Holgate wasn't interested in receiving commissions to portray Montreal's social elite; he preferred to depict the faces of friends, family and those he was comfortable with, often of humble origin, who had no pretensions as to how they should be painted. He referred to his portraits as "studies" and often did not even name the sitter, preferring titles such as *Fire Ranger*,

The Lumberjack, Professor of Mathematics, or *The Skier.* The faces, serious, often introspective, were portrayed with a straightforward approach.[7]

The more I studied Holgate's portraits, in particular the painting of Ludivine, created when he was at the peak of his success, the more I realized how deeply he delved into the character of his sitters. His best portraits are charged with an intensity of feeling for their subjects—belying Holgate's cool, retiring nature and his belief in "a quiet statement."[8]

In the summer of 1930 Holgate and his wife, Frances travelled to the small fishing village of Natashquan, far up the St. Lawrence River. Holgate had been introduced to this area by his father, Henry Holgate, who had led a distinguished career as a civil engineer developing hydroelectric projects in Quebec.[9] Henry Holgate had travelled to the North Shore a number of times to explore for minerals on behalf of mining interests, and he made friends with a local bilingual guide, Alphonse Landry.[10] Through this connection, Holgate rented the house of Alphonse's father, Élie Landry, a fisherman in Natashquan. The extended Landry family lived close by, so Holgate and Frances, who had no children of their own, probably got to know the Landry children at family events.

While Holgate was visiting the fishing village, Élie Landry's daughter-in-law Imelda died during childbirth, leaving her eldest child Ludivine in charge of the household of seven children. At the time, Ludivine's father, Henri, was away buying fish at the First Nations community of Betsiamites (now Pessamit), about 650 kilometres southwest of Natashquan. As she recalled, "Travel wasn't easy back then; he returned about eight days later. My mother was already in the ground."[11]

Holgate was struck by the tragedy and drama of the moment and asked Henri Landry if he could paint his daughter's portrait. Holgate's request was not unusual, as he had made a charcoal drawing of Ludivine's uncle Paul the year before, turning it into a masterful portrait (now part of the collection of the Musée national des beaux-

arts du Québec). The artist felt great sympathy for Ludivine and was no doubt impressed by her natural self-assurance and her jet-black eyes. Henri Landry agreed, and Ludivine sat for Holgate while she still wore her black mourning dress. Her mother had died in May; Ludivine turned fifteen in June, and her portrait was painted in July.[12]

Years later Ludivine recalled that she posed for Holgate, two hours a day without moving, for seven days and that she was paid 50 cents an hour, which came to $7.00.[13] Also, she remembered that Holgate painted directly on the canvas, without making any preliminary drawings, and completed the portrait before leaving Natashquan.[14]

In the portrait, Holgate places Ludivine in a rigid, frontal position, hands tightly clenched in her lap, the muscles of her neck taut. She leans to one side, as if shying away from the bright source of light on her left. Even the collar of her dress has shifted off-centre. All attention is directed to her facial expression and her striking eyes, which stare out directly at the viewer. Her gaze holds our gaze. Her hair, like her dress, is black, a long strand curling into her cheek. The warm hue of her skin softens the darkness and glows through the muslin of her sleeves, as if to say, "I am very much alive." The aquamarine background and vivid green of the sofa with its sharp-edged lines increase the emotional tension of the painting.

Holgate claimed not to be a colourist, but he knew how to use colour to give expression to the forms. He painted with cool precision, constructing his portrait of Ludivine, stroke by stroke. His technique was a reflection of his personality, but at the same time the artist's outward reserve was overcome by his compassion for the young girl. The artist felt Ludivine's grief deeply and knew how to arrange the composition, the tones and the crisp silhouette to suit the mood and create one of his most accomplished portraits. As he later recalled, "In *Ludivine*, my great preoccupation was really I suppose a psychological one. I put the little girl off balance..." as she had been put off balance by the death of her mother. "I was preoccupied with character rather than just good painting."[15] Seven years after painting it, he knew it was a special accomplishment. The work "is one of the things I have done of which I am really fond."[16]

Ludivine was first exhibited at the Royal Canadian Academy exhibition in Toronto in November 1930, and offered for sale at $350. The portrait caught the eye of Group of Seven artist A. Y. Jackson, who was a friend of Canadian diplomat Vincent Massey and his wife, Alice. They were art collectors and often sought advice from Jackson for their purchases. When Jackson saw Ludivine's portrait, he quickly wrote to Mrs. Massey: "Lawren, Lismer [his Group of Seven colleagues] and myself are all agreed that the little Holgate I told you about is the best canvas in the exhibition. It's a study of a dark eyed little French Canadian girl very searchingly painted."[17] Two days later, on November 18, 1930, Jackson urged Mrs. Massey again to act quickly:

> So if you wish to be certain of getting it, you had better send a cable on receipt of this… I would buy it myself but it is almost Christmas time and it would tie me up. I have never known all the boys [the Group of Seven artists] to be more unanimous regarding a canvas.[18]

Mrs. Massey must have moved swiftly, as by the time the painting was shown in the National Gallery of Canada's annual exhibition in 1931, it was already on loan from the collection of the Honorable Vincent Massey. Alice Massey gave the painting as a birthday gift to her husband. Shortly after acquiring it, she wrote to Holgate: "I can't tell you how grateful we are to you for having painted such a *lovely* thing… It will have a place of honour in our gallery-to-be someday, and we love to think of the pleasure that for all time it will give."[19] The Masseys subsequently lent the painting to exhibitions in London, New York, Washington, D.C., and major cities across Canada before it was eventually donated to the National Gallery of Canada through the Vincent Massey bequest in 1968.

On loan in London for the 1938 exhibition *A Century of Canadian Art* at the Tate Gallery, *Ludivine* was reproduced on a poster to advertise the show. "I was getting out of an underground train the other day when I saw a poster that attracted me so much I

crossed to the other platform to look at it," wrote Margaret Eleanor Orr, an English friend of Holgate, writing from Buckinghamshire. "What was my joy to see 'E. Holgate' as the signature to the delicious portrait... I hied me down to the Tate Gallery and found all your pictures—a joy to look at."[20]

Today, the portrait is a fixture on the walls of Canada's august National Gallery. A recent label declares it to be one of Canada's most important modern paintings.

When Holgate painted Ludivine in 1930, he pulled this young girl out of the obscurity of a fishing village and placed her likeness before the world. In her life on canvas, Ludivine Landry has travelled the world. But who was she, and what did she do in her actual life? Curious for answers, I journeyed to Natashquan in the summer of 2017 to experience her surroundings and find people who had known her.

Natashquan is one thousand kilometres northeast of Quebec City along the north shore, beyond Sept-Îles. Historically, the village served as a summer camp for the Innu people, who fished for salmon at the mouth of the Grande Rivière Natashquan and traded furs with the French and then the Hudson's Bay Company (the name Natashquan means "the place where one hunts bears").[21] The Innu (Montagnais) reservation of Nutashkuan sits at the mouth of the river. In Holgate's day there was no road linking the larger community of Sept-Îles to the small fishing villages beyond, so Holgate would have taken a freighter, which is still the main link for the settlements beyond Natashquan, places such as Harrington Harbour, Tête-à-la-Baleine and Blanc-Sablon.

Following in Holgate's footsteps, I boarded the *Bella Desgagnés*, the Relais Nordik line's weekly ferry from Rimouski to Blanc-Sablon. Harbour porpoises and seagulls accompanied us as we left the south shore and moved into the middle of the majestic St. Lawrence, where the shoreline became a distant, dark-green ribbon, and scattered houses small white dots. Deck hands worked around the clock as the boat loaded and unloaded cargo, passengers and cars, sometimes in

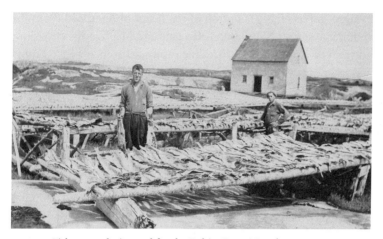

Fishermen drying cod for the Robin Co. at Natashquan, 1934
Collection Bernard Landry, gift of Peter C. Camiot

the middle of the night, at Sept-Îles, Anticosti Island, Havre-Saint-Pierre—and two days later, Natashquan.

The wooden houses of this small community (about 300 permanent residents) are spread out along the rocky coast, their backs to the tundra interior of stubby trees and lichen-covered rocks. Highway 138 now travels east from the harbour and crosses the Petite Rivière Natashquan to reach the church, the school, and the grocery store in the centre of town. The main landmark of Natashquan, apart from the church steeple, is a cluster of white cabins with red doors perched on a rocky point called Les Galets, after the word for stones polished smooth by the constant thrashing of the waves. A long, sandy beach stretches five kilometres from the village cove. In the nineteenth and early twentieth centuries, Natashquan families lived off seal hunting in the spring and, in the summer, the sale of dried, salted cod to large fishing companies which exported the fish to the Caribbean.

Holgate stayed in a house not far from the wooden cabins at Les Galets, where the families would store their equipment and would gather to clean and salt the daily catch before laying it out to dry on wooden racks along the beach. Mothers would put their babies

23

to sleep in their baskets on top of the heaps of dried cod.[22] On his summer visits to Natashquan, Holgate would place his easel in a position to paint these picturesque cabins, with their peaked roofs and red doors, but even he realized that the dried-cod market was already starting to collapse. Only twelve of the *magasins,* as they are called, remain standing on Les Galets out of the original two dozen or more, and the site was classified as an historic monument by the Quebec government in 2006. After many years of neglect, the *magasins* are now being restored with funds raised by the community and a promotional boost from legendary Quebec singer and poet Gilles Vigneault. A native son of the village, Vigneault has penned many an ode to Natashquan and the Côte-Nord, and he returns to his birthplace every summer. Descendants of Nova Scotia Acadians, the Vigneaults and the Landrys have played leading roles in the village since the mid-1800s as administrators, shopkeepers, fishermen, trappers, lighthouse keepers and musicians.

One destination on my visit was the house that Holgate rented from Ludivine's grandfather, Élie Landry. Through word of mouth I learned that the house now belonged to none other than Gilles Vigneault. When I spoke to him, Vigneault remembered Ludivine, although he was just a young boy. Vigneault also recalled Holgate, whom he had visited in Morin-Heights in 1975.[23]

Situated on the main road, Élie Landry's house is one of the oldest in the village. Apart from painting Ludivine in this house, Holgate also made two oil paintings of the kitchen's interior space.[24] Typical of rural Quebec kitchens are the gaily coloured walls, the braided carpets scattered about the floor, a two-tiered buffet in the corner and a pump leading from the water cistern. I was told that while Holgate was painting Ludivine, he taped spots on the floor to make sure that the chair was in the same place each day for the sitting. In the final painting, however, she sits on a living-room settee, more befitting of her formal mourning attire. Holgate even used the kitchen as a backdrop to another well-known painting, now in the Art Gallery of Ontario, which shows his wife, Frances, in the nude, tending to her hair in a mirror. The

kitchen seems to have been more a studio than a place to cook, as Edwin and Frances apparently ate their meals at the home of Alphonse Landry, Ludivine's uncle.[25]

My second destination was the Église de Notre-Dame-de-l'Immaculée-Conception, overlooking the Petite Rivière Natashquan. Inside the church there was an exhibition on the history of some of the buildings in the community, including a photograph of the different curés who had served in the village. I scanned the photograph, looking for one in particular. The Montreal Museum of Fine Arts had recently been offered a portrait by Holgate, entitled *Curé of Natashquan*, painted in 1931. In typical fashion, Holgate had not identified the sitter. It was a small oil on panel, a head-and-shoulders composition of a middle-aged priest looking reflective. The left side of his face was highlighted, revealing a long nose, generous jowl, a high forehead and a full head of wavy hair. A letter that was included with the portrait came from Father Gilles Bernier, the local curé in 1983, who, with the help of Mme. Willie Vigneault (Gilles' mother), identified the sitter as Jean-Marie Hulaud, a Eudist father who had come from France on a mission to Quebec's Côte-Nord. But when I compared the church's photograph of Hulaud to the museum's portrait, I was surprised to see a partly bald man with a round face, glasses, and no double chin. He was decidedly not our man. I glanced along the row of photos and stopped at Hulaud's predecessor, a fellow French Eudist, Joseph Gallix (1877–1942). Yes—here was a match for our portrait. A prominent figure in Natashquan where he served for twenty-four years from 1907 to 1931, Father Gallix would have presided at the funeral of Ludivine's mother. It is not surprising that Holgate knew him and chose to paint his portrait.[26]

From the church I walked out to the cemetery just behind it. Ludivine was buried there but no one could remember the exact year of her death, so I had to find her plot. It was a blustery, rainy day and, starting at the back, I walked through row upon row of headstones, squinting to read names as frigid blasts of wind blew in my eyes. I passed memorials to Vigneaults and Landrys, and other

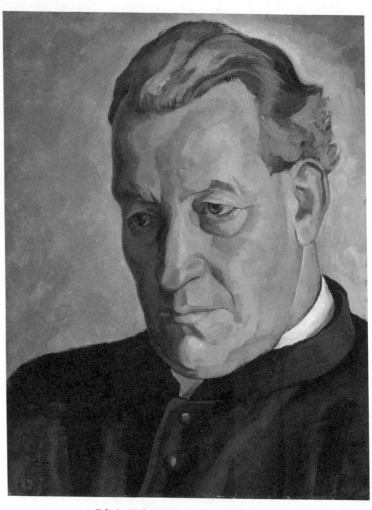

Edwin Holgate, *Curé of Natashquan*, 1931
The Montreal Museum of Fine Arts
Anonymous gift in memory of the Terroux family

historic families of the village like the Hounsells, descendants of an early Hudson's Bay Company trader. I came across quaint first names like Hormidas and Télésphore, Chrysologue and Radegone. As I approached the last few rows by the road, I found Ludivine's parents Henri Landry (1882-1966) and Imelda Chevarie—born 1895, died 1930, the year Holgate painted her daughter's portrait. But where was Ludivine? She had married into another Acadian pioneer family, the Cormiers. So finally, in the adjoining row, I came upon a single headstone to both her and her husband:

CORMIER
Paul Ernest 1909–1992
husband of
Ludivine Landry 1914–2000

Having brought up her brothers and sisters, and mothered six children of her own, Ludivine lived to the ripe age of eighty-six.[27] She was also like a mother to her niece Marie-Claude Vigneault, whom I met during my visit. Marie-Claude showed me where Ludivine lived as a young girl on Chemin d'en Haut, and it was clear how much she admired and loved Ludivine. "She was an optimistic, well-organized woman," she told me. "Always well dressed, with nicely done hair, painted nails and rings on her fingers. I'd call her chic, even stylish."

Ludivine became an expert seamstress, knitter and embroiderer. Just as Quebec weavers traditionally transformed worn-out rags into colourful *catalogne* carpets, Ludivine recycled the clothes of her siblings and her own children into dresses and shirts for the younger ones. As her daughter Rolande wrote in a 2012 poem dedicated to her mother:

A excellent cook
We were proud of your wedding cakes,
Your crochet work was as beautiful

27

as your knitted mittens, socks and sweaters.
Last to bed
First to rise
You never uttered the word *tired.*[28]

Ludivine saw her portrait for a second time, hanging in the National Gallery of Canada when she visited Ottawa in 1986. She was surprised to see her face on postcards, posters and the cover of an art book in the gallery bookstore. "I'd never have guessed this painting would be so celebrated," she exclaimed.[29] According to Rolande, Ludivine would have loved to visit Paris and see other parts of the world. Instead, her likeness did the travelling.

Three days after arriving in Natashquan, I took the *Bella Desgagnés* back to Rimouski. As the ferry pulled away from the harbour, leaving behind the sand dunes, juicy blueberries and brilliant red crowberries that hug the ground in late August, I thought of Gilles Vigneault's words from *Au coeur de la Côte-Nord*: "One doesn't so much arrive at Natashquan as return there to find one's self as if from some past life... The houses and the people, the fir trees, the fishing boats, even the sandy walkways seem to recognize you. And welcome you."[30]

Some day, I'd like to return to Natashquan.

Holgate was drawn back there more than once, and he kept in touch with the Landrys. On November 10, 1946, Holgate wrote to Anicet Landry, Ludivine's first cousin, telling him how he and Frances often thought of their happy days in Natashquan and remembered Anicet's father Alphonse, his brother Dérillas and his uncle Paul. Holgate then mentioned that *Paul, Trapper* was now hanging in the provincial museum in Quebec City.[31]

In 2005, shortly after the opening of the Edwin Holgate exhibition in Montreal, I gave a talk in the museum's auditorium. A man came up afterward and introduced himself to me as Gabriel Landry. He said that he had grown up in Natashquan, the youngest child of fifteen in the family of Emilien Landry, who owned the general

store. Gabriel had come to the museum to see the show, in particular the portrait of Ludivine. He wanted to tell me that he had known Ludivine, although he was only distantly related. She had died recently, he said, and he was especially keen to share a photograph of her. He pulled it out of his pocket and showed it to me.

There she was, Ludivine, whose youthful face Holgate had made eternal. She had grown old, a little plump, her short greyish hair held in a tight permanent. But there, unchanged, were those astonishing jet-black eyes, which set the photo ablaze.

Young Love in the Charlevoix

I'm drawing again. What joy. Felt pen and freely. No cheating allowed. You stretch your arm out and pray to land safely.[1]
 –Jori Smith, 1974

SHE WAS A FEISTY, LOVEABLE, CANTANKEROUS BUNDLE OF ENERGY. I first met the painter Jori Smith when she was in her eighties, after a retrospective of her work mounted by the Dominion Gallery in Montreal. The show's title, *Rediscovering Jori Smith: Selected Works, 1932-1993*, was apt. Smith's work may be known among collectors of Canadian art but her name is not familiar to the general public.

One of Smith's early works in the exhibition had attracted my attention: *Portrait of Jean Palardy*. A year later, as Curator of Canadian Art at the Montreal Museum of Fine Arts, I was on the lookout for new acquisitions, and I thought of this painting. Created in 1938, the portrait had all the characteristics of Jori's best work: spontaneous brushwork, vibrant colours and the feeling of a warm, personal connection with the sitter. It was still for sale, but alas, the asking price was too steep for my budget—and much higher than most of her other paintings still available for purchase. It was almost as if the portrait were intentionally priced *not* to sell.

Perhaps there was a reason for this: Palardy had been an art student like Smith in the 1920s, and the two had a passionate love

affair before getting married in 1930. I had met Jean Palardy back in 1976, when I was an art history student and he a distinguished consultant for the restoration of Montreal's historic Château Ramezay museum. Seeing his portrait reminded me of his lively personality and gifts as a raconteur. It was easy to understand why Jori had fallen in love with him.

I decided to seek out Jori at her studio-apartment to learn more about her work, and we began a friendship. Short and slight in build, Jori's bony arms would flutter while we talked, and her hands flew around like scrawny little birds. On cool days, she often wore a small beret perched on white hair rolled up in a chignon. The beret made her look much younger, hinting at the pretty, perky art student she had once been.

Jori began her training in September 1922 at the Art Association of Montreal's school of fine arts. When it closed temporarily the following year, she enrolled at the newly opened École des beaux-arts de Montréal. Jori grew up in the anglophone enclave of Westmount so her French was poor, but she made up for it with enthusiasm and humour. Still at the "Beaux-Arts" in 1928, she was not getting along with her parents and she seemed a little depressed, as she noted in her diary on January 1 (her birthday): "Am 21 today—not married and no outlook. Family must feel bitterly about it. New Y. E. party at John Meaghers [sic]. It was a flop."[2] Her outlook would soon change.

Through her good friends and fellow art students Jean-Paul Lemieux and Madeleine Des Rosiers (later his wife), Jori met Jean Palardy, two years her senior, who had also studied at the École and shared her eagerness to become a painter. In a June 1928 letter to his mother from Percé where he was painting, Jean Palardy asks her to call the École in Montreal to get Jori's address.[3] The two young painters exchanged letters, Palardy encouraging the less confident Marjorie (she soon dropped the formal version of her first name) to follow her ambition. In one letter Jean wrote from Chicoutimi in April 1929, where he was working, he encourages her in his imperfect English to join him:

Of course, nothing forces you to stay if you don't like it. Nevertheless I am sure you will be in better atmosphere to paint than in Montreal. Don't discourage yourself. You must expect many handicaps in the career you have chosen but nothing should impedit [sic] you from accomplishing what you have decided to do. You must not loose [sic] your aim in sight but throw away every obstacle, let it be moral or material, that is in your way... Au revoir, my dear Marjorie, may you persist in your dreams and stick to it. Art is a great risk that is worth attempting. Yours in art, Jean Palardy.[4]

By July, Jori had a studio in Chicoutimi and was sketching portraits of local children.[5] Ironically, however, Palardy was back in Montreal—and urging her to return to the city. Jori did go back to Montreal in the autumn, where she joined Palardy and Jean-Paul Lemieux in a short-lived commercial graphic design venture.

In the spring of 1930, Jori and Jean decided to run off without benefit of clergy to rural Charlevoix, on the north shore of the St. Lawrence River beyond Quebec City. Both families were aghast. Jean's father, Hector, was a prominent Outremont doctor, and Jori's father was an executive with Lewis Bros. hardware. Jori's father had encouraged and supported his daughter's art-school training, but her mother had been more dubious of its value, perhaps fearing Jori would be lured into a bohemian lifestyle. Mother turned out to be right.

The Charlevoix is an unfamiliar region of Quebec to many English Canadians. Yet for over a century, its rolling hills, picturesque fishing villages and stunning views from high cliffs overlooking the St. Lawrence have attracted American and Canadian summer visitors to towns like La Malbaie (Murray Bay), Pointe-au-Pic and Saint-Irenée. But Jean and Jori weren't interested in moving in these circles: they settled in the backcountry of small villages and farm fields, tilled by French settlers since the seventeenth century. Jori was an alien in the francophone, ardently Roman Catholic society of

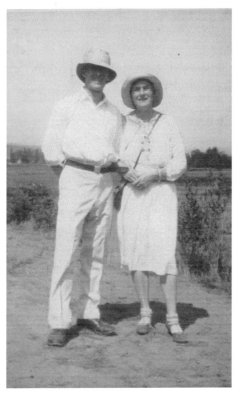

Jean Palardy and Jori Smith on their honeymoon, Baie St. Paul, 1930
Library and Archives Canada

farmers and tradespeople. "Une Anglaise, une Protestante, perforce damned to Hell," as she recalled. But she was full of enthusiasm for the landscape and grew to admire the sincerity of the people, who lived in their isolated communities without telephone, radio or cars.

The couple first settled in Baie-Saint-Paul. Despite being shunned by the village curé, Jori won people over with her charm, generous spirit and affectionate nature. "Only once, and then only after a long acquaintance did one of our friends ask me, looking at me so sweetly, 'How can a woman like you, so good and kind be a Protestant?'" [6]

After intense pressure from their parents, Jean and Jori were hastily married at La Malbaie in the summer of 1930 and for

the next seven years, with a European travel break in 1934–1935, the couple spent every summer and often the winters in the Charlevoix, lodging with different families along the concession roads near the town of Saint-Urbain. You can imagine the fun they had in Jori's description of their rented "summer kitchen" at a distance from the main farmhouse:

> It was one very large, low-ceilinged room, with at least six windows and an attic upstairs... filled with old harnesses and discarded machinery... The room was simply beautiful for the proportions were exactly right. The final storybook touch... was a narrow brook running alongside the little house, which had trout in it. We whitewashed the place inside and out, painting the ceiling a shade of dusty rose (making the paint ourselves from a mixture of linseed oil and red earth) and the floor a pale grey... The outhouse was a one-holer, a most private and peaceful repair offering visitors a truly spectacular view of the mountains.[7]

The two young artists spent the days in front of their easels or drawing in sketchbooks. Jean focused on landscapes, barns and grain fields dotted with harvesters against mountain backdrops. Jori preferred portraits of mothers and children and village scenes, especially the weekly *veillées* (evening parties) which enlivened the farmers' day-to-day existence:

> We danced with them, supped with them, sang with them, shared so many simple and innocent pleasures... All the spontaneity and extroversion which seemed to come so naturally to the people of the region suited me perfectly, so that I fitted in as though born there and was exceedingly happy.[8]

Jori captured the shyness, gaiety and patience of these rural people in some of her best paintings. *Rose Lavoie*, painted around

34

Saint-Urbain in 1936, is now in the Musée national des beaux-arts du Québec. With her apron still on, Rose rests her swarthy arms in her lap and sits calmly in a frontal pose. The colour tones are as calm as the sitter, but the brush strokes are rapidly executed in a confident building up of volume. Bold, dark outlines accentuate the blackness of her hair and eyes. Although the painting is modern in its focus on form, flat composition and lack of sentiment, Jori's sensitivity to the sitter still comes through.

Farmers' wives like Rose were usually too busy to pose for portraits, so Jori often painted children. Despite having none herself, she connected well with children, and the intimate nature of her portraits found an eager audience among buyers. *Rose Fortin* (1935) shows a solemn and frail child, from a very poor family of fifteen, gazing out at the viewer with dark, doleful eyes. Jori was greatly moved by the poverty and illness she saw in the Charlevoix, which is reflected in her sombre paintings of melancholy children, for example: *Young Girl* (1940) and *The Communicant* (1944) (both in the collection of the National Gallery of Canada). In contrast with her subjects, Smith's brush is spontaneous and assertive, the strokes showing an urgency of expression that matched her temperament. It is as though she had to catch her young sitters quickly before they jumped up and out of their chairs.

The economic hardship of the 1930s seems a ready explanation for these cheerless portraits. But as art historian Édith-Anne Pageot points out, Jori was still painting passive, unhappy-looking children decades later back in Montreal.[9] Jori, unsurprisingly, had her own opinion. Citing Jung's belief of inherited psyche, she claimed her portraits expressed "the accumulated sadness of the human race":

Millions of years of terrible struggles must have left an imprint or why should children have such desperately pathetic expressions when in repose? I have never yet, in all my experience of painting children found a truly happy child... so this is what I paint. What I see.[10]

The children in her portraits were not simply subjects she observed. She lived among them, loved them, knew their parents and their family problems. She watched them growing up and experienced great joy in painting them.

Sixty years later, these early portraits lingered in Jori's mind when she penned her memoir *Charlevoix County, 1930*. Jori wrote about the poverty of the farming families eking out a living from their "uncharitable soil," but she recognized they were far from poor in spirit. She admired their houses, describing the large sunlit kitchens, dotted muslin curtains and vivid orange floors "decoratively crossed by several wide runners of gaily-striped *catalogne* [fabric strips]." Jori had a gift for writing with a keen sense of observation. *Charlevoix County, 1930* reveals original turns of phrase and pithy humour with a sprinkling of local dialect, and the people of the Charlevoix come to life in its pages as they did in her paintings.

During the 1930s, encouraged by ethnologist and friend Marius Barbeau, Jean and Jori began collecting the simple pine furniture they found in Charlevoix interiors, long before these pieces became fashionable. Palardy would knock on doors as he travelled the roads, hoping to find some unique hand-carved cupboard, sculpture or early silver piece to sell to antique collectors or museums. One of my favourite photographs of Jori shows her in a hand-painted rocking chair (Jori loved to decorate old furniture) in their summer accommodation in Saint-Urbain. Taken by Montreal artist Stanley Cosgrove around 1936, Jori at twenty-eight years old looks plump and healthy in summer sandals and a sleeveless cotton-print dress. Central to the room is a black cast-iron stove. With no electricity, the kerosene lamp on the shelf would have been their only source of light in the evening. On the right, a two-tiered pine cupboard with chamfered panelled doors fits tightly under the beams of the low ceiling, with just enough room to display three antique Portneuf bowls on top.

Jean and Jori spent at least four winters in the Charlevoix during the early 1930s, but lack of money and the frigid cold sometimes sent them back to Montreal during the winter months.

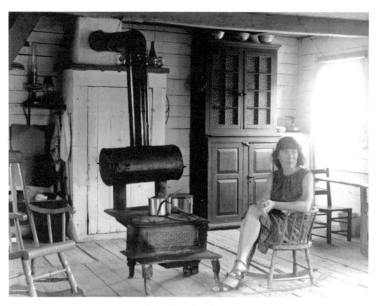

Jori Smith in the Charlevoix, c. 1936
Courtesy of the artist's estate

They rented a miserable unheated flat near Atwater Street, their meals consisting of nothing more than perhaps a shared orange and a quarter-pound of ground beef. At one point in 1933, with artist Jack Humphrey, they were painting matchboxes to sell on the street for 20 cents each.[11] "Oh, we were very poor," Jori recalled in a 1974 interview. "But we had such fun there, you can't imagine, you can't imagine. The parties. Nothing to drink, nobody had any money, you know. Just tea, tea or coffee, and often they would bring that."[12]

But things were changing. In the 1930s, Jori and Jean often exhibited in the same art shows. Newspaper critics initially described Jean's paintings at length, with "Marjorie Smith" or "Madame Palardy" mentioned merely in passing. But over the decade, references to Jori's portraits of children and the people of Charlevoix became longer, while Palardy's Quebec landscapes received less praise. By 1937 the balance of critical opinion had turned: "One might say that Jean Palardy is more interested in shrewd documentary reportage," wrote

art critic G. Campbell McInnes in the *Canadian Forum*, "and Jori Smith more concerned with the formal and spiritual significance of what she observes."[13] Collectors followed suit and Jori began to sell paintings directly from her studio. "They were selling like hotcakes," she boasted years later. The couple's financial fortunes improved enough to purchase a small summerhouse in 1940 in the Charlevoix village of Petite-Rivière-Saint-François. Probably sensitive to the reversal of roles in the couple's status as artists, Jean devoted less and less time to painting. By 1941, he had given up the idea of making a living as a painter.

A 1948 magazine photograph of Jori in her Montreal studio on Sainte-Famille Street contrasts sharply with the earlier image of her in the Charlevoix. She stands before her easel, slim, sophisticated

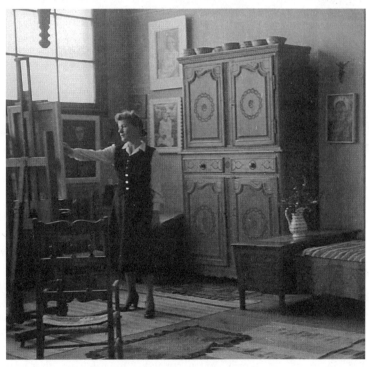

Jori Smith in her Montreal studio on Sainte-Famille Street, 1948
Courtesy of the artist's estate

and confident, working on a canvas. For this public-relations shot she looks elegant in high heels, a smart vest and skirt, her hair drawn neatly into a knot at her neck, curly bangs above her brow. No more dreamy young woman in a backcountry kitchen: this is Jori Smith, the confirmed artist. Yet links to her Charlevoix life are everywhere: the portraits of young children on the walls, a Quebec pine armoire with sculpted panels, those same Portneuf bowls, an early Quebec blanket chest, rustic chairs, catalogne carpets, a catalogne coverlet on the bed. The artist has transformed herself, yet her early days in the Charlevoix remain part of her personal interior.

The Charlevoix transformed Jean Palardy's career, too—in ways he could not have anticipated. This region of Quebec represented for him "a real laboratory of social culture."[14] In 1941, no longer an active painter, he joined the nascent National Film Commission of Canada.[15] Drawing on his knowledge of rural Quebec, Palardy served as a cameraman and producer of such films as *Ti-Jean Goes Lumbering*, *Bush Doctor* and *Primitive Painters of Charlevoix*, popular documents of Quebec's traditional rural identity. Palardy's interest in collecting and selling antiques from the Charlevoix region also turned him into an expert on the furniture of early Quebec.

During Jori and Jean's heady days in Montreal, their circle included francophones and anglophones with a common devotion to art and literature: art critics Henri Girard and Robert Ayre, writers Jean Chauvin, Gabrielle Roy, Mavis Gallant and poet P. K. Page; artists Stanley Cosgrove, André Biéler, Alfred Pellan, Fritz Brandtner, John Lyman, Goodridge Roberts, Philip Surrey, Marian Scott and Louise Gadbois. Jean-Paul Lemieux and his wife, Madeleine, would visit from Quebec City. As founding members of the Contemporary Art Society in 1939, along with John Lyman, Paul-Émile Borduas and Fritz Brandtner, Jean and Jori exhibited with this group of French- and English-speaking Quebec artists who rejected academic traditions and looked to European modern art for inspiration. There were also collectors who became friends: Dr. Paul Dumas, Dr. Albert Jutras, diplomat John P. Humphrey (who penned the Universal Declaration of Human Rights), lawyer Joseph Barcelo, and law professor and poet Frank Scott.

Jori observed her friends intently and could be both witty and harshly critical in her letters. Writing to Jean in 1944 she was particularly censorious of Mme. Suzor-Côté (wife of the famous painter) with "her hair died [sic] as black as night and make-up so vulgar it more than emphasized her whorish looks. ."[16]

She also had harsh words for writer Gabrielle Roy, who purchased a summer house in 1957 just up the road from theirs at Petite-Rivière-Saint-François: "I always feel that she has endlessly rehearsed all her stories beforehand and... she never listens to ours, except impatiently, so that she can begin another right away... I feel that she is always acting a part and never truly herself before us."[17]

When painter Alfred Pellan and his girlfriend stayed with Jori for six weeks in the summer of 1941, while Jean was away filming, Jori felt he was an ungrateful guest and that he copied her specialty—painting the young children of Charlevoix. She also accused Pellan of borrowing shamelessly from other artists. "Do you know that while he painted, he would place on his easel, at his elbow, postcards of paintings by Van Gogh, De Chirico or Fernand Léger, or whoever interested him?" she scoffed to me during one interview.[18]

P. K. Page recalled parties in the Palardys' studio on Sainte-Famille street. "One night she asked all the women to close their eyes and draw a man, frontal, naked, and all the men to close their eyes and draw a woman, frontal, naked. The results induced great screams of laughter at their creations."[19]

But there were fissures beneath the couple's bright facade. They loved entertaining but their raucous parties might end with Jori heaving crockery at Jean. Immersed in his success with the National Film Commission, Jean was fully enjoying the female attention he received there and elsewhere. Jori and her close friend Marian Dale Scott, married to Frank Scott, would bemoan their husbands' philandering. "At least your husband has good taste," Jori told Marian, whose Frank was having an affair with poet P. K. Page.[20]

Jori's burgeoning career and critical success, along with Jean's womanizing, continued to strain the marriage. After a 1945

exhibition of the Contemporary Art Society painters in Toronto, art critic Paul Duval in *Saturday Night* declared Jori "one of the most instinctive painters we possess, with a natural sense of colour and a lyrically fluent technique," and went on to claim that Jori's portrait of the young *Communicant* (1944) was one of the best canvases the artist had done.[21]

With their respective careers taking different turns, the couple parted ways in 1957, and eventually divorced when Jean married Margaretha Hengstler in 1977. Jori always felt that Jean had envied her success as an artist: "He comforts himself by saying, 'If I had wanted to, if I had not had to abandon painting and make a living, I would have certainly been a lot better than all of them.' This is his Achilles heel—all painters make him uneasy and unhappy."[22]

Today, Palardy is probably best known for his book on Quebec heritage furniture, *The Early Furniture of French Canada* (Toronto: Macmillan of Canada, 1963). His early appreciation and collecting of antiques in the Charlevoix had turned him, over the decades, into a leading authority on the restoration of historic interiors.

When I met Jori Smith in 1993, she felt like an old friend from the start. Impulsive, outspoken and still painting every day, she had an infectious sense of humour. Then eighty-seven years old and living with her cat in a seniors' residence near Westmount Park, she was in what she referred to as her "Blurry Period." Floor to ceiling, the walls of her apartment were hung with her works: watercolours, oils and drawings, spanning the length of her career. And there, just as in the photos, were her fine Quebec cupboards, her Portneuf bowls and a few pine chairs from the Charlevoix days.

I quickly learned that Jori had many friends, of all ages, whom she would invite for afternoon tea or evening cocktails. She was a dramatic storyteller, and with humour or pathos, she milked the details of the lives and loves of the characters who had shared her life. She was among the last of a generation of Montreal artists who grew up in the 1920s and 1930s, and she had clear memories of that period. Despite the respect of her fellow artists, as well as critics,

she never had great confidence in her work. Jean's lack of support for her work during their marriage only confirmed her feelings of inadequacy, even though she had sold hundreds of portraits, still-life paintings and watercolours from her many travels.

In 1975, her portrait of Rose Lavoie was included in the landmark exhibition *Canadian Painting in the Thirties*, organized by curator Charles C. Hill at the National Gallery of Canada. The show included many Montreal artists of Jori's generation whose work had not been highlighted nationally: Louis Muhlstock, Philip Surrey, Fritz Brandtner, John Lyman and Marian Scott were hung alongside the more celebrated Emily Carr, Lawren Harris, A.Y. Jackson and David Milne.

Jori was shy about accepting her invitation to the show's opening. However, spurred on by a friend, she travelled to Ottawa to attend the important *vernissage* and was overjoyed by the warm welcome she received from old friends. She wrote about it in a letter to P. K. Page, telling how as she walked in, Jori received a "big kiss" from Prime Minister Pierre Trudeau, whom she had known in Montreal. "Strange ghost-like figures were swarming behind me waiting to claim me. To my astonishment. I had really believed I was dead and buried. But there they were, extraordinary metamorphosed creatures of the thirties with arms to pluck me, devour me, people I never thought had given one whit about my existence."[23] Poet Frank Scott interrupted his conversation with an earnest economist to extoll the benefits of his new pacemaker: "It's wonderful Jori, you can even make love better with it." In her judgemental way, Jori was critical of the show and of her own painting, but the event buoyed her up and spurred her on. A few days later, back in Montreal, she dashed out to buy more painting materials and got to work on "something fresh."

Not long after I met Jori, she invited me to accompany her and close friends Joe Stratford, Philip Stratford and his wife, Jacqueline, on a journey to the Charlevoix to revisit old haunts. Beginning in Baie-

Saint-Paul, the first place Jean had taken Jori on their flight from Montreal in 1930, Jori led us along the roller-coaster concession roads nearby, past the barns and hills featured in many of Jean's landscapes. At one point we passed an old stone gristmill which Jori knew as the home of the Bouchards, a family with fifteen children who gained renown in the community as folk artists, sculptors and artisans, especially the eldest child, Simone Mary.

On the outskirts of Saint-Urbain, Jori pointed to the small house they had once rented from the Tremblay family. As we approached, she shouted, "Stop the car!" and to our surprise, leaped out and knocked on the cottage door. The young woman who opened it knew immediately who Jori was. Sixty years on, the house and land still belonged to the Tremblays, who had owned it for generations. The young woman proposed we drive to the farmhouse down the road and visit her mother and father.

An excited Jori led us on for about half a mile to a typical Quebec white clapboard farmhouse. She could hardly wait to get out of the car. The door to the house swung open and an elderly couple emerged with joy on their faces.

"Madame Palardy, Madame Palardy!" they exclaimed loudly.

After hugs and kisses, Jori introduced us to Monsieur and Madame. Their weathered features had such character, I mused that they would be worthy models for a portrait. And indeed, Jori told me that Madame had featured in her portraits of Charlevoix children. Madame's young face has endured, a valued work of art now probably hanging in a private collection or on the walls of an art gallery.

After this warm encounter, we continued along a few miles to the "summer kitchen" with the old black stove, where Jori and Jean had spent so many blissful summer months in the 1930s. She pointed to where she had kept an "immaculate" vegetable garden, and we walked along beside the stream which had served for their drinking water, trout fishing, washing dishes and bathing nude, hidden by overhanging bushes. Far from being melancholy, Jori delighted in telling us about her youthful days with Jean. I could

imagine her painting his portrait in the summer kitchen, sunlight pouring through the window, a bowl of newly plucked flowers from the garden arranged on the table.

We continued our pilgrimage to the property Jori and Jean had bought in 1940 at Petite-Rivière-Saint-François, overlooking the mighty St. Lawrence. The house and their land had been expropriated in 1976 to make way for the ski development, Le Massif, but Jori was so fond of the old farmhouse that she'd had it relocated onto a friend's property nearby. There we found it, in a forlorn state, plunked down in the middle of a farmer's field. The interior doors and some of the old furniture were still there, decorated in Jori's hand with large fat leaves and flowers, reflecting the colours and exuberance of her easel paintings. The cottage may still be there today.

In my conversations with Jori, she often mentioned her close friendship with Jean-Paul Lemieux, her former art-school classmate and one of Quebec's most celebrated painters, and his wife, Madeleine. Lemieux had introduced Jori to Jean, beginning the romance that had so shaped her life, and she had kept up a regular correspondence with Jean-Paul and Madeleine. In her letters, Jori had confided to Madeleine her joys, sorrows and general thoughts on life, and she recommended that I read them. These letters were in the possession of the couple's daughter, Anne-Sophie Lemieux, in Quebec City, who agreed to lend them to me. When I met with her, she handed me the box of letters. The entire correspondence was numbered and packaged by date in well-organized bundles. Included with them was a legal document stating that if any were lost, I would have to forfeit $1,000 per letter. This was a shock. Jori Smith was not a Hemingway—she wasn't even a Stephen Leacock. I pondered for a moment: the box contained almost a hundred letters. But I was unwilling to let either Jori or my own curiosity down. Against my better judgement, I signed the document.

As soon as I arrived home, I called Jori to announce the good news. She was thrilled.

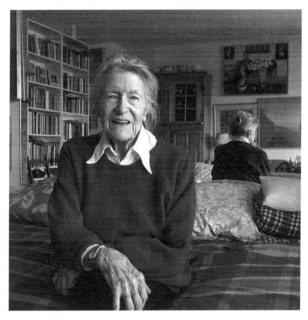

Jori Smith in her studio apartment, Westmount, c. 1997
The Montreal Museum of Fine Arts

"Oh, I want to see them. Give me the letters right away!" she said over the phone.

I tried to put the brakes on, explaining my uncomfortable legal responsibility for the valuable documents.

"But they're *my* letters," she wailed. "I wrote them! I want to see them all right now."

Feeling fatigued after my bus journey from Quebec City, but sympathetic to her pleas, I drove to her residence with a small packet of letters, hoping this would calm her down. I explained I would give them to her one bound and numbered package at a time. She balked at this, but accepted. And so, every other day I arrived at her apartment to deliver a batch of letters, making sure to retrieve the previous bundle.

One afternoon, I phoned Jori from the office to check on her progress.

"These letters make me so depressed and sad," she said in a quiet voice. She had been poring over an upsetting letter, dated from the time of her final split with Jean.

"I'm going to destroy them," she said in a firm tone. "I don't want anyone to read them."

"No, no, Jori, you can't do that," I replied. "I'm coming to get · them right away." I threw myself into a cab and raced to her residence.

When I arrived, Jori had regained her composure. I think she had purposely sounded the alarm to get my attention. On a near-by table, the letters lay unharmed. I made some tea in her tiny kitchenette and we sat down to talk. I proposed photocopying some happier letters for her and whisked the offending ones away. She had found it traumatic to relive the unravelling of her passionate marriage to Jean. The correspondence, which she had not seen in more than forty years, had reignited her bitterness over the loss of her great love.

With the epistolary drama behind us (and the letters safely re-turned to Quebec City), Jori and I set about preparing a show to celebrate her ninetieth birthday and to bring new attention to her place in the development of Canadian art.[24] The exhibition, *Jori Smith: A Celebration*, opened January 22, 1997, at Concordia University's Leonard and Bina Ellen Art Gallery. It was a great success and a joy for the artist. Old acquaintances surfaced, and new admirers sought her out. Hung prominently was her 1938 portrait of Jean from the Charlevoix that had served as the introduction to our friendship three years earlier. Jean has the air of a young painter in a collarless shirt and beret covering wavy, light-brown hair. Jori builds up the form of his face and shirt with purposeful, spontaneous broad brush strokes. Dark lines set off the ear and eyes as he looks intensely to-wards the light. The stiffness of his pose and background geometry are countered by the floral burst of vibrant colour in the foreground.

In the end, Jori agreed to sell her portrait of Jean to the Montreal Museum of Fine Arts for a reasonable sum. She had kept it stashed away for years, and my hunch is that her original price had been so high because she was loath to part with it. The love

of her life had led her into the adventure of her life: the discovery of the Charlevoix, its people, language and traditions. The simple country folk had inspired her formative years, and the portraits she painted there propelled her forward to future success as an artist. But the time had come to pass the painting on, to a museum, to keep this creative period of her career alive for all to see.

Jori died in 2005 at age ninety-eight. Her star has faded, but her paintings can be found in every major collection of Canadian art. I miss her rapid-fire conversation, her passion for life and the effervescent personality that spilled into her canvases. Yes, she was feisty and had a quick temper, but she was also generous and caring. An indomitable spirit, her determination and love of painting held true throughout her life, as evidenced in a letter she wrote in her late seventies to P. K. Page:

> Yes I'm still joyfully painting each afternoon. Quite wild bold things, lots of bright spots hitting you in the eyes and I can hardly wait to finish one before I'm leaping into another one. And up on the wall they go... I'd like to do a new one every day... joyful expressions not to be taken as anything but a strangled shout from this old woman who has to prove she is still alive and loving it.[25]

Discovery, Disappointment, Delight:
The Big Show

MORE THAN TWENTY-FIVE YEARS AFTER *THE 1920S: AGE OF THE METROPOLIS*, Montrealers still recall this 1991 exhibition as one of the best shows ever presented at the Museum of Fine Arts. With good reason: It was one of the largest exhibitions the museum had ever mounted, intended to coincide with the opening of the new Jean-Noël Desmarais pavilion, designed by architect Moishe Safdie. While the new "wing" of the museum, stretching an entire city block, was under construction on Sherbrooke Street, director Pierre Théberge planned an ambitious blockbuster of a show which would shake up the museum as much as the chaos of construction below and above ground. The exhibition would catch the mood of the great metropolises of the 1920s—Berlin, Paris and New York—as it swung from revolution to reverie and finally despair when the decade ended with a financial crash.

Looking back today, the preparations for this extravaganza epitomize the disappointments, discoveries and delights of being a curator. When I got the call from Pierre Théberge, asking me to join the curatorial planning committee as exhibition coordinator and curator in charge of decorative arts, I had just returned from a year's sabbatical with my husband and two children in France. The job seemed daunting. I would be working with French art

historian and author Jean Clair (now a member of the French Academy's *immortels*), whom Théberge had hired as *commissaire général* of the show. Clair's concept for the exhibition included paintings, drawings, sculpture, photography, films, decorative arts, architectural models, installations, posters and even music. I had worked with the museum on contract for a number of years in the area of Canadian art and design, but Théberge wanted someone devoted solely to this one show, who could work with French, British, American and German lenders behind the scenes. Excited by Clair's vision and the director's trust, I leapt at the challenge.

Alongside the Montreal staff was local expert Professor Constance Naubert-Riser of the Université de Montréal, and a team of guest curators all living abroad: Helen Adkins in Berlin, architectural historian Jean-Louis Cohen in Paris, and in New York, art historian Romy Golan and photography specialist Christopher Phillips.

Being a curator is like being a treasure hunter. You draw up a list of works that are crucial for the show, and then hope to find

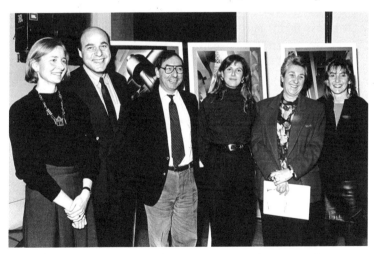

Curatorial committee for exhibition, *The 1920s: Age of the Metropolis,* at press conference, November 26, 1990. *Left to right*: Rosalind Pepall, Jean-Louis Cohen, Jean Clair, Romy Golan, Constance Naubert-Riser, Helen Adkins (*missing*: Pierre Théberge, Christopher Phillips)
The Montreal Museum of Fine Arts

even greater exhibits while on the hunt. We fanned out across North America and Europe, connecting with museums, art dealers and private collectors by letter, by telephone and in person. Themes changed and ideas evolved. Favours were called in, especially for key pieces intended as pivotal frameworks for exhibits by lesser-known artists. The preliminary list of works, indicating first choice, second choice or deletions, was revised again and again and again.

For the next two years, we requested over a thousand artworks in every medium, and I prepared hundreds of letters for the director to sign. After an introductory paragraph describing the project, I would add a few judicious sentences proposed by a member of the curatorial committee to justify why we needed that particular piece:

> Your Wenzel Hablik painting, *Utopian Architecture Cycle. Aircraft Towers, Silos and Artists' Dwellings*, 1921, would be indispensable for our show, as it reflects the Utopian vision of artists who offered radical ideas for the post-war renewal of urban society. The Hablik would be a key work for this theme and share the gallery with such images as the pyramidal glass structures of Hans Scharoun, Bruno Taut's crystalline cathedrals in glass, and Malevich's *Planits*, his floating cities in space … We would be most grateful if you would agree to lend your painting and give our North American visitors a rare chance to see the work of this progressive German artist.

Explaining why one needs to borrow a specific work is at the heart of the job. The curator makes the first step in persuading a museum or private collector to lend, but in some cases, the final decision of the lender is based simply on the persuasiveness of a couple of sentences in a letter from the director or *commissaire général*. It becomes a game. Some you win, others you lose.

Curators get used to disappointment. After drawing up a list of essential pieces, it's not unusual to find a third of them are unavailable

for loan. A work might be too fragile. Or it has been promised to another show. Or private lenders, for reasons of security, might be too nervous to let it out of their sight.

My own first efforts to secure important exhibits for the show came up short. Jean Clair wanted to begin with something that showed the devastation of World War I, from which Europe had barely emerged in 1920. Eager to prove myself, and with my background in Canadian art, I proposed we go after the impressive mural-sized canvases that decorated the walls of the Senate Chamber in Canada's Houses of Parliament. Two of them by James Kerr-Lawson, a Canadian artist who settled in England before the war, seemed particularly appropriate. *The Cloth Hall, Ypres* and *Arras, the Dead City*, both dated 1919, depicted the war-torn ruins of these towns: roofless buildings open to the sky, hardly a human figure in sight, black smoke on the horizon. Bombed-out buildings were the perfect introduction to the theme of post-war urban and aesthetic regeneration. Jean Clair gave the nod.

Elated, I called the curator of the Houses of Parliament to make preliminary enquiries about borrowing the paintings.

"I'm sorry, Ms. Pepall, but the paintings cannot be removed from the Senate," she said.

"Surely we can come to some arrangement," I said. "It's a temporary exhibit, after all."

"No, I mean physically: they don't fit through the doors."

"Oh. But… then how did they get into the Senate in the first place?"

"I don't know. The paintings have never been removed."

"Well, there must be *some* way of getting them out," I said.

"No, I don't think there is," she said.

Director Théberge did not want to give up so easily, and he dispatched to Ottawa the museum's head of security, Monsieur Claude, to try to solve the dilemma. Claude took the measure of every opening into the chamber. No door, window or angle could accommodate removing Kerr-Lawson's four-by-five metre paintings. A little research suggested that when the Senate Chamber was rebuilt after a

devastating fire in 1916, the brand-new canvases were likely brought in through a large temporary opening during the reconstruction of the chamber, or they were rolled up and mounted within the wall panels on site. After seventy years, Kerr-Lawson's paintings would be far too brittle to roll up now without damaging the paint surface. They were permanently ensconced in the Senate—not to be budged.[1]

To counter my disappointment, I turned to finding decorative art objects for the show and made some real discoveries. I focused my efforts on a spectacular folding *paravent* by Paris's foremost designer in metal, Edgar Brandt. The five-panelled *Oasis* screen had been a highlight of Brandt's pavilion at the famous 1925 Paris Exhibition of international design. Created in brass and wrought iron polished to a silvery sheen, the central panel featured a fountain spouting high arcs of water, flanked by a mass of giant palm leaves in the adjoining panels. No one had laid eyes on the paravent since 1925, and only one picture of it existed, a black-and-white photograph in an old book. No one knew where the screen was.

However, when I showed the picture to Féix Marcilhac, a long-time Paris dealer in Art Deco objects, his eyes lit up. He simply said, "Check with Robert Zehil in California." Not long after, I telephoned Zehil, an art dealer in Los Angeles.

"Hello, Mr. Zehil, I'm trying to track down a paravent by Edgar Brandt. I'm wondering if you could help me," I said.

"A Brandt screen? Which one?"

"The *Oasis*, 1925, five panels. The one from the Paris Exhibition."

"Aha! Yes, I can help."

"Oh, wonderful!" I exclaimed. "Do you know who owns it?"

"Well, actually, I do."

"What?"

"Yes! It's in my warehouse."

"How did you get it?"

"I found it in South America a few years back. Someone stashed it away and forgot about it."

I told Théberge about my incredibly lucky find, and suggested we write a follow-up letter to request the loan. "Rosalind, don't be so lazy," he replied. "Get on a plane, pronto. We want that screen!" With the snow piling up outside my office window, I happily booked a late-winter flight to sunny California for the next day.

In Los Angeles, Zehil confirmed that he would lend the screen, which was looking tarnished and neglected, and he promised to have it cleaned. When it arrived in Montreal for its first public appearance since Paris 1925, it glittered as if it had come straight from Brandt's workshop.

My spirits lifted, I turned my sights on another trophy, a piece of furniture by Jacques-Émile Ruhlmann, the most influential French interior designer of the 1920s. His *chef-d'oeuvre* was a high side-board called the "Meuble Élysée," as it had long been part of the president of France's official residence, the Élysée Palace. Because it needed restoration, it had been deposited in the government's official storage, the Mobilier National. Every piece of furniture or other furnishing used in presidential palaces, state residences, offices and French embassies all over the world is stored and catalogued by the Mobilier National.

After getting Théberge's approval, I set up a spring trip to Paris to visit the Mobilier National at 1 rue Berbier-du-Mets. In the horse-shoe-shaped courtyard of this modernist four-storey building of reinforced concrete—designed by France's celebrated architect of the 1930s, Auguste Perret—I met the government curator assigned to my file. I felt privileged to enter this hall of French design history, hidden away in the 13th arrondissement. The Mobilier National turned out to be a museum in itself: row upon row of richly gilt chairs, silk-upholstered settees, tapestries, tall Sèvres porcelain vases, and whole rooms full of chandeliers, elaborate clocks and gilt metalwares spanning four hundred years of French craftsmanship.

I found Ruhlmann's celebrated Meuble Élysée languishing in a stairway landing. A massive piece of furniture, roughly two by two-and-a-half metres, its six tiny bronze-ball feet rested on a platform. Circular lines of ivory marquetry decorated the entire front and sides, and a silvered bronze relief by French sculptor Simon Foucault

adorned the central doors. But some of the ivory was missing or had been replaced by mismatched yellowed pieces, and the sun's hot rays had bleached the exotic bur amboina wood veneer. The curator indicated that the Mobilier National administration was not keen to pay for the restoration of the sideboard, nor to lend it to the Montreal museum in its present condition.

Disheartened, I turned to leave. But then the curator remembered something that she thought would interest me. Up a floor and down a long hall, she showed me a magnificent Beauvais tapestry screen from 1924–1926, woven with scenes of Paris after a design by artist Raoul Dufy. The Eiffel Tower stood prominently in the foreground and other architectural monuments dotted surrounding hills like a seventeenth-century map of the countryside. I added the screen to my list of objects to request for the show, and it was eventually confirmed. [2]

I was happy about this discovery, but I knew the show still needed a significant piece by Ruhlmann, whose influential buyers in the twenties included politicians, financiers, actors, couturiers and even the Indian Maharajah of Indore. I continued the hunt for a Ruhlmann closer to home, making arrangements to visit a private collector in New York with our guest curator, Romy Golan. Two weeks later, Romy and I found ourselves in a small, private elevator hidden behind the famous Rainbow Room cocktail lounge on the sixty-fifth floor of the Rockefeller Center. Two floors up, we reached the offices of Steven A. Greenberg. Dubbed by the press "the king of New York rooftop bars," this high-flying investment dealer was crazy about Art Deco design. The style's glamorous appeal suited Greenberg. Film stars Barbra Streisand and Jack Nicholson were also decorating their houses with the best of Art Deco furnishings. At the time we met Greenberg, he owned New York's *Fame* magazine, which featured big-name artists Warhol and Basquiat, along with Hollywood starlets.

In the hall outside the elevator, we passed paintings and water-colours by Jean Dupas, a French artist whose murals filled the interiors of the great ocean liners of the day, ships like the *Île de France* and the *Normandie*. I stopped mid-stride, transfixed, until finally Romy tugged my sleeve. We had come in search of Ruhlmann furniture.

As we walked into Greenberg's office, there in the centre of the room stood the dining-room suite from Ruhlmann's pavilion at the 1925 Paris Exhibition, the Hôtel du Collectionneur. Greenberg held meetings around the table (I shuddered at the sight of an agenda scotch-taped to the table's surface), and he owned several more outstanding Ruhlmann pieces, each one worthy of our exhibition. I noted a small stiletto-legged cabinet, a vanity table and a chest of drawers, all veneered in expensive woods with the characteristic ivory trimming that Ruhlmann favoured. In fact, there was ivory all over the designer's furniture: ivory handles, ivory knobs, ivory *sabots*, dentilled bands of ivory, ivory stringing in a criss-cross pattern, and even lines of tiny ivory dots, each one cut individually and set into the wood.

There in Greenberg's office, the Hudson River and the bustle of Manhattan far below, he talked with Romy and me about his Art Deco treasures. Alas, he wouldn't part with his Ruhlmann pieces. But we kept talking, first about the Jean Dupas paintings in the hall, then about the superb Jean Dunand lacquer and metal bowls that just happened to be sitting behind us on a shelf. I couldn't resist: How about a painting? How about the bowls?

Greenberg's answers were no and no. He did not want to disturb his office decor. But he could tell that we appreciated and shared his taste in design, and this became the basis for further conversation and trust in following years. A curator is a hunter, but the job is about more than obtaining loans: it requires establishing good human relationships. Steven Greenberg eventually lent the museum three exquisite pieces of Ruhlmann furniture and a Jean Dupas gouache for a 2004 show we organized devoted to Ruhlmann in collaboration with the Metropolitan Museum of Art.[3] When Mr. Greenberg passed away in 2012, I couldn't help but remember my first visit to his perch above the Rainbow Room.

Coming down from the heady heights of Rockefeller Center, I paid a visit to the Brooklyn Museum of Art. Success! The museum agreed to lend a fabulous 1923 Ruhlmann living-room ensemble of very high quality. The suite included one of the decorator's most

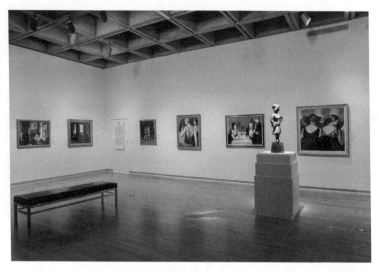

Installation view of exhibition *The 1920s: Age of the Metropolis*, 1991, showing
Prudence Heward's *At the Theatre*, 1928, on the wall at far right, alongside
Guy Pène du Bois paintings, and Chaim Gross sculpture
The Montreal Museum of Fine Arts

celebrated designs for a corner cabinet, the front panel featuring a
large floral medallion made up of hundreds of tiny pieces of ivory
marquetry.

Flying home from New York, I took stock. I hadn't got what
I came for, but I had found other pieces that were even more
impressive. There was still a lot of work ahead, and I was keen to get
back to my husband and children. What was going on in their lives?
Preparing for this exhibition was proving to be an all-consuming
task.

A year away from opening day, the curatorial committee gathered
for a regular meeting with Pierre Théberge and Jean Clair to examine
the most up-to-date list of exhibits and to see if all the essays for
the exhibition catalogue were complete. We had requested over one
thousand works, to arrive at close to seven hundred exhibits. Oskar
Schlemmer, Max Beckmann, Mies van der Rohe, Piet Mondrian,
Josef Albers, Vassily Kandinsky, Paul Klee, Eliel Saarinen, Max Ernst,
Robert Delaunay, Fernand Léger, El Lissitsky, George Grosz, Charles

Sheeler, Albert Renger-Patsch, August Sander... The list went on and on. We had the first models of radical tubular-steel furniture from the Bauhaus designers. We had American "skyscraper" chairs and jazzy glass bowls. We had Tamara de Lempicka's kitschy portraits of French aristocrats in satin evening wear, which provided a stark contrast to the angry faces of German factory workers and the lonely figures of Edward Hopper's urban interiors. We had architectural models for Ludwig Hilberseimer's proposed *High-Rise City* of sinister-looking Berlin apartments, and Le Corbusier's *Plan Voisin*, which called for the demolition of a large section of historic Paris.

Despite the relentless search for exhibits by the curators, a few important loans continued to elude us. Certain themes within the exhibition still had to be filled out, and the Paris section needed boosting. Théberge and Clair identified crucial pieces that needed extra attention (or an arm twisted) to persuade reluctant museum colleagues or private collectors to change their minds.

Five months before *The 1920s: Age of the Metropolis* was set to open, a major problem arose. The new Desmarais pavilion, still under construction, would not be ready by opening day. Pierre Théberge decided that the show would go on—but in the museum's original 1912 building and its adjoining 1970s wing. The museum's entire permanent collection would need to be taken down. And because the gallery space was more confined, the number of works exhibited would have to be reduced accordingly. Most of the British, Italian and Canadian artists would have to be dropped. The Russian artists, whose radical work was at the forefront of twentieth-century invention, would stay.

After this news, we went out for a meal and over wine managed to quell our disappointment at losing some hard-earned loans. The show had, after all, been created with Berlin, Paris and London in mind, but I was unhappy to let drop the small contingent of Canadian paintings I had proposed, especially one Canadian canvas, Prudence Heward's *At the Theatre*, 1928. It showed two women in Art Deco dress, viewed from behind as they sat in the theatre. It

was in our museum's collection, and I lobbied to keep it on the list and in the American section of the show alongside Guy Pène du Bois' paintings of New Yorkers dining out, which we had borrowed from the Whitney Museum of American Art and the Metropolitan Museum of Art.

"Do you think *At the Theatre* stands up beside the other works?" Jean Clair asked me.

He had a point. Heward's painting would be hanging in the same gallery as masterpieces by Edward Hopper, John Sloan, Stuart Davis and, not far away, Charles Sheeler and Charles Demuth.

"Maybe not," I said. "But we are in Montreal, and Heward was one of Canada's most progressive artists, and a Montrealer. Let's keep it."

Clair smiled, said nothing, and we moved on. I don't believe that he agreed with me, but, later on, I saw that Heward's painting was still on the list.

Three months before opening day, I got a call from the museum's transport manager, Simon Labrie, who was constantly on the phone with transport companies and hundreds of lenders in Europe and North America.

"Bonjour, Rosalind. You know, I'm getting questions from nervous registrars at the Met, the Virginia Museum and also Brooklyn, asking whether we have the appropriate documents."

"For what?" I asked.

"To take furniture containing ivory out of the USA. Well, more to the point, the right papers to get it back in."

I knew that the importation of ivory around the world was under scrutiny, but I was dumbfounded.

"We need more documents?" I asked.

"Yeah. Apparently, we need a CITES permit from the American Fish and Wildlife Service for each work that contains ivory."

"I've never heard of a CITES permit for museum objects. Really, for a few ivory knobs and ornaments? Simon, these works have been in bona fide museums for decades. The ivory is sixty or seventy years old!" I exclaimed.

"Old ivory, new ivory—they don't seem to care."

I got off the phone. Canada and the USA had both been signatories to the 1973 Convention on International Trade in Endangered Species (CITES), which forbade the exchange of ivory (among other materials) across borders. But I thought this was to stop the present-day trade in ivory. We had no such problems getting our ivory loans out of France. But without a permit, according to Simon, furniture and decorative objects from the USA risked being seized at the American border upon re-entry.

The situation was urgent. American lenders with Art Deco treasures containing ivory were not going to let their many-thousand-dollar sideboards and tables exit the country without a guarantee that they would be returning.

I telephoned the Metropolitan Museum of Art's registrar.

"Hi, Judy, I'm trying to find out more about this CITES permit."

"Hi, Rosalind. Yes, I know, it's a worry. The permits are required for anything under one hundred years old. But last year we lent an eighteenth-century ivory fan to a show in Japan, and it was a nightmare getting it back into the country," she explained. "We don't want to repeat that."

While I was making inquiries with the Met, Simon spoke with the American Fish and Wildlife Service. Obtaining a CITES certificate apparently depended on the approval of a single biologist in the department. Because of the high demand for these documents, and so few biologists on staff at the service, it would take six months to obtain the necessary certificates. The show started in two months.

I ran into director Théberge's office. He took the problem in hand at once and called the museum's legal team. For the better part of a week, there was no word. Then the lawyers got back to us with an ingenious proposal: the gallery in the museum displaying ivory would be declared American territory. If the items in question were kept in bond, they would be deemed never to have left America, and as such, anything containing ivory could be transported to Montreal and back again without having to pass through Canadian customs. Legally speaking, the furniture would never have left the USA.

Amazingly, there was precedent for this clever arrangement. When the Dutch royal family fled Nazi-occupied Holland for Canada during World War II, the Crown Princess Juliana gave birth to her third daughter, Margriet, in Ottawa in 1943. To avoid future problems of succession (the Dutch constitution requires its royals to be born in the Netherlands), the Canadian government had declared her hospital room Dutch territory.

To our great relief, the major museum lenders in the United States were placated by our plan, and we moved forward with transportation arrangements. When the crates arrived at the museum, they were brought straight up to their designated exhibition gallery, where an American customs official was waiting to examine the works and fill out the required paperwork. The gallery of Art Deco furniture and *objets d'art* was saved. Simon, who had lived through many anxious days of tracking each loan, took me aside and whispered a final word of advice: "Rosalind, for your next exhibition—please, no more ivory, stick to white plastic!"

As opening day drew closer, the installation of several hundred works of art began. In the case of paintings and simple sculptural works, setting them into place could be relatively simple. But in the case of larger, more complex pieces, mounting them in the galleries could be an adventure all its own. While the huge spiral frame of the Centre Pompidou's model of Vladimir Tatlin's tower, *Monument to the Third International*, 1919–1920, was rising up to five metres in height in the museum's largest exhibition gallery, a corner of the neighbouring gallery had been reserved for Kurt Schwitters' Dadaist masterwork *Merzbau* or the "Merz building."

Developed by the artist from 1923 to 1937 as an appendage to his studio in Hanover, Germany, the *Merzbau* consisted of an assemblage of architectural elements and objects which grew and expanded into a sculptural environment, gradually taking over the artist's home. *Merz* was Schwitters' made-up word to describe the personal effects and curious or mundane objects with which he created his collages, paintings and installations. Schwitters' original *Merzbau* was destroyed by wartime bombing in 1943, but in 1981 to 1983, stage

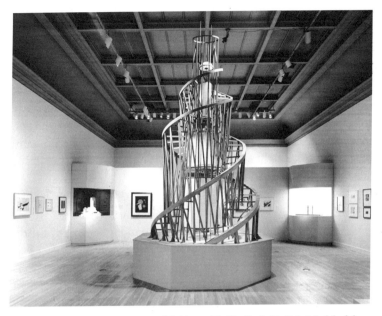

Installation view of the 1920s exhibition with Vladimir Tatlin's *Model of the Monument to the Third International*, 1919–1920 (reconstruction 1979) Musée national d'art moderne, Centre Georges Pompidou, Paris

designer Peter Bissegger reconstructed the main room for the Sprengel Museum in Hanover from only three known photographs—and a travelling copy of the *Merzbau* was also made in 1988 to 89 for loans to other museums. The travelling room measured 3.9 metres high by roughly 5.8 x 4.6 metres and came to Montreal from Hanover, then part of East Germany. It was a coup for our museum to be able to display Schwitters' pivotal work,[4] but the museum paid a hefty sum for its loan and at some cost to our staff's patience, when two technicians were sent from the Sprengel Museum to install the complicated structure on site.

It took ten days for the two men to assemble the *Merzbau* with its constructivist juxtaposition of empty shelves, compartments, angled wall surfaces and steps leading nowhere. Jagged wooden elements hung down threateningly from the ceiling or projected from the walls. The room was painted a blinding white in every

nook and cranny—and there were plenty of those—in which the two technicians, as rumour had it, took nips of schnapps behind the wooden stalactites. Day after day the two men padded around in felt slippers to preserve the whiteness of the floors as they hammered sculptural components into place. Day after day they would arrive at my door with new requests: light bulbs, a rope, an extra paintbrush, rolls of sandpaper. When the room was finally completed, the two fellows came to my office one last time to state that the museum needed to order eight custom-made pairs of large felt slippers.

"Why do we need slippers?" I asked.

"Schwitters wore slippers," they informed me.

"The show opens in one week, I don't think…"

"Schwitters himself wore slippers, so as not to mark up the white floor," they repeated.

"All right, I'll pass on your request to the commissaire."

"You must arrange the slippers in rows outside the *Merzbau*, and only permit visitors wearing them to enter the room."

"Thanks, but that means only eight people can enter at a time. I'll see what I can do!"

To my amusement and surprise, the museum complied with this request. Also following Schwitters example, a white guest book was placed on a white table within the white room, for visitors to note down their comments. Museumgoers loved it. They gaped at the strange interior of obliques and angles and pointed edges, intrigued, if not puzzled, by this defiant fantasy of one man's mind. After one person had clambered around the claustrophobic interior of the *Merzbau* in the obligatory felt overshoes, he scribbled in the visitor's book: "Beam me up, Scotty!"

No exhibit is free of last-minute changes—positive or problematic—as in the case where a courier arrived from Europe with the wrong painting. Everyone pulls together to adapt to the circumstances. In another case the painting did not live up to expectations: when Ernst Ludwig Kirchner's *Brandenburg Gate, 1929*, was removed from its crate, it was immediately clear that the dominant blue and

green tones in the painting would clash with other works in the exhibition. Despite the prominence of the artist, it did not stand up to Jean Clair's critical eye. "Where do we place it?" I asked Clair, quietly questioning the judgement of borrowing a work none of the curators had viewed recently. He shrugged. "It's our blind date!" he grinned, and relegated it to the music room, where it hung behind a player piano spewing out twenties tunes.

Days before the opening, the *pièce de résistance* of French design rolled up a ramp and into the museum on four wheels: a Bugatti Royale, Type 41, one of only six ever sold, which Pierre Théberge had discreetly secured for the exhibition at the last minute. Its sleek white body with polished chrome fixtures was slung low to the ground like a racing car. Placed in an open gallery between Van Dongen's sighing Parisian women in fur stoles and Paul Strand's photographs of steel pistons and wheels, the Bugatti Royale embodied the ultimate in Art Deco glamour and machine elegance. It stole the show.

At the end of its five-month run, *The 1920s: Age of the Metropolis* boasted record attendance at the museum. And to my own personal satisfaction, Prudence Heward's painting *At the Theatre* adorned the front page of the arts section in Montreal's newspaper *The Gazette*, alongside a glowing review of the show.

Now that the exhibition had come to an end, I quietly observed the activity in the galleries. It was like watching a film rolling backwards: the decor came down, the paintings were removed from the walls, the objects went back into their crates. And, of course, the schnapps-drinking workers from the Sprengel Museum returned to dismantle the *Merzbau* and pester us a little longer.

Walking through the scene, I felt sad remembering how everyone had pitched in to get this monumental show up and running. Like a play, an exhibition is a performance, of the moment, never to be revived. But certain scenes may be brought back to life in the memory of a curator.

[CHAPTER FOUR]

Talking to a Portrait

IN 1990, AS A YOUNG CURATOR, I WAS SET A DIFFICULT TASK: TO convince an elderly widow to lend my museum a portrait that had become her cherished daily companion.

The Montreal Museum of Fine Arts was putting together *The 1920s: Age of the Metropolis*, the largest international exhibition in its history, on the theme of the Roaring Twenties, a period of *Great Gatsby* extravagance, radical invention and utopian ideals in art, as well as soaring ambitions, symbolized by New York's skyscrapers. There was also a darker side to this decade in the disillusionment that followed the devastation of World War I and ended with the financial crash of 1929. The twenties shifted dramatically from "a red October to a black October" in the words of Jean Clair, *commissaire générale* of the exhibit.[1] Guest curator Helen Adkins, who lived in Berlin, had discovered a 1926 painting by German artist Christian Schad that she felt would be critical for the Montreal exhibition. Schad had died in 1982, but Helen had learned from his wife, Bettina, of a wonderful portrait in a private American collection. Perhaps its owner might be persuaded to lend it to the museum for the show? Helen phoned me from Berlin to suggest I go to New York to pursue the loan.

A week later, on a bright spring afternoon, I stood outside a nondescript 1960s high-rise on the Upper East Side of New York, the home of Ilse Goodman, the owner of the painting. I went up in the elevator and rang the bell of her apartment. A casually attired

lady in her early eighties opened the door and invited me in. As I moved from the vestibule into the living room, I looked up and was immediately drawn to the portrait of a woman on the wall: Baroness Vera Wassilko.

Dressed in an alluring Art Deco evening gown, she faced full front and stared at me with arresting brown eyes under sharply defined eyebrows. The jazzy geometric motifs and silvery tone of her dress, décolleté front swooping into a tight bunch of violets at her waist, was the ultimate Art Deco chic. Illuminated apartment blocks with rickety black chimney stacks created a theatrical late-night backdrop. The baroness was realistically depicted—not in the soft-focus, lovingly detailed realism of an Andrew Wyeth painting, but with a cold, harsh realism. Two men in tuxedos hovered at her side, their faces cropped out of the frame, drawing attention to the long fingers and manicured nails of the gentleman on the right. The diseased leaves of a spiky plant reared up by Wassilko's shoulder, hinting at a seamy decadence behind the elegant evening clothes.

Despite an indifferent expression, the woman's gaze held me in an unsettling way. She seemed to be alive. I couldn't take my eyes off her.

"It feels as though she's here, in the room with us," I said to Mrs. Goodman.

"Yes," replied Mrs. Goodman. "I often speak to her."

I paused, "Who is she?" I asked. "Is she a relation?"

"Oh no, not at all," laughed my hostess. "I did not know her. My husband and I saw the portrait in an art gallery in Germany, only a few months after it had been painted and not long after my first husband and I were married. I was so taken with the painting that I asked him to buy it for me and we brought it to Zurich where we lived. The painting came along with us when we moved to New York in 1939. It has been with me ever since."

Christian Schad, born in 1894 in the small Bavarian town of Miesbach, had grown up in Munich. He was from an affluent family: his father was a lawyer and his mother came from a family of industrialists and brewers. At nineteen Schad enrolled in the

Munich Art Academy, but at the outbreak of the First World War, to avoid military service, he spent six years living in Zurich and Geneva. There he mingled with Dada artists who challenged the dogmas of traditional art.[2] Schad pioneered innovative experiments in photography before returning to Munich in 1920, but a summer trip to Italy that year directed his art away from abstract Dadaist inventions towards figurative painting, especially portraits, inspired by the clarity and traditions of Italian Old Master paintings from the Renaissance. Schad was one of a number of German artists, including Otto Dix and George Grosz, who, in the aftermath of the Great War's devastation, rejected pre-war avant-garde developments in art and looked back to the realist traditions both in Italian and in fifteenth- and sixteenth-century German painting.

In this new movement, termed Neue Sachlichkeit (New Objectivity), Schad's unsentimental, dispassionate, yet realist portrayal of his sitters was modern in approach. Like other Neue Sachlichkeit artists, Schad was drawn to the cultural capitals of Europe, and in 1925 he moved to Vienna for three years, and afterwards Berlin. Because of his well-to-do family background, Schad gained entry to the upper social circles of these cities, which had become the refuge of displaced post-war nobility from Eastern Europe. These refugees, along with theatre people, writers, artists and the hangers-on of café society, became Schad's subjects. A keen observer, he portrayed them with disturbing realism: stiff coiffures, sharp silhouettes, erotic poses, misshapen bodies, the cold glare of flesh and the too-red blossom in a young beauty's corsage.

Baroness Vera Wassilko (1895–1984) took her place in Schad's gallery of aristocrats who had lost their land, their status and their wealth in the shuffle of boundaries after the war. She descended from the family of a knight and politician, Nicholas Wassilko, who hailed from the Bukovina region of the Austro-Hungarian empire (now part of Romania and Ukraine).[3] When Schad painted her in 1926, she was living in Vienna and had promoted herself to a baroness—for who could verify her rightful title in the strata of dispossessed nobility in that city?

The artist was drawn to Wassilko's elegance and vulnerability, and said that he had created the painting from memory, as he claimed to do with most of his portraits. Not as searing in his political and social commentary as Neue Sachlichkeit artists like Dix or Grosz, rather, his portraits have an enigmatic, uneasy quality in their coolness, sharp contours, lack of volume and passive expressions, suggesting the unreality of a stage setting. Schad painted the baroness during his sojourn in Vienna, but the artist included the illuminated letters ULIN to suggest a Parisian setting near the famous Moulin de la Galette nightclub in Montmartre. "I gave her a Parisian cityscape as background," wrote Schad, "and placed her between two movable urban sceneries: male fragments in evening dress. She belongs to them but remains a stranger."[4]

It's unclear whether Vera Wassilko ever saw the portrait. After her glamorous days in Vienna, she ended up leading a more mundane life, running a bed-and-breakfast in the seacoast town of Folkestone, England, where she died in 1984.[5]

Three years after painting the baroness, Schad's family lost its fortune in the economic crash of 1929, and the artist lost the financial support that he had always relied on. Destitute, he could barely sell any works. The public disliked his provocative portraits, and by 1933, with the rise of Hitler and the National Socialists to power, the Neue Sachlichkeit artists were considered to be "degenerate." Between 1928 and 1934, Schad sold a total of only four paintings privately. He finally turned his back on the art world and in 1935 became an agent for a Bavarian brewery business.[6] The story of Schad and the baroness speaks more to the underside of the decade than its soaring ambitions.

When I met with Ilse Goodman, a charming widow with Old World European flare, I felt ambivalent about wrenching this cherished canvas away from her. For over sixty years the portrait had been her daily companion—and a reminder of her young married life in Europe. How remarkable that she had had the perspicacity to

spot this portrait in the late 1920s, one of the very few paintings that Schad had been able to sell at the time. How could I urge her to give it up, even for a few months?

But I did not want to let down my museum colleagues either. The portrait was such a critical work for the exhibition. So, there I was in her living room, the required loan papers in my hand, the baroness's eyes upon me. A moral dilemma for any curator.

"We're planning an exceptionally ambitious show," I told Mrs. Goodman. "Over seven hundred artworks, from Paris, Berlin, Moscow, Munich, London, Rome and New York, to name a few cities we are borrowing from."

She nodded her head with interest when I gave the names of celebrated artists and architects who would be in the show: Robert Delaunay, El Lissitsky, Vassily Kandinsky, Paul Klee, Le Corbusier, Ludwig Mies van der Rohe, and Schad's German contemporaries: Otto Dix, George Grosz and Max Beckmann.

"Mrs. Goodman, your Schad painting would symbolize the allure, the daring, the decadence, and… and… the folly of the time," I said, smiling as I ran out of words in my effusive description of how important the painting was for the show.

Mrs. Goodman was listening intently. But then she wistfully looked over at Wassilko.

"If I lend her, when would you take her away?" she asked. "And how long would she be gone?"

I calculated quickly: two to three months for transport and installation, five months for the exhibition, and then another month for packing up and transport back to New York.

"Nine to ten months," I said.

"This is so long. I may be dead before I see her again!" she replied.

I assured her that the painting would travel in tight security with the New York shipment, along with works from the Metropolitan Museum and Museum of Modern Art, all under the eye of museum couriers.

"We would give your painting a full-page colour illustration in the exhibition catalogue," I continued.

Just then, the doorbell rang, and her son-in-law turned up. She invited him in for drinks, as it was now early evening.

"Walter," she said, "Rosalind is here from the Montreal Museum of Fine Arts. They are very keen to include my Schad painting in their exhibition."

We all sat down in the living room and Walter immediately asked, "Why is your museum so eager to borrow my mother-in-law's painting?"

I mentioned the large wing of the Montreal Museum that was under construction as we spoke, and I dropped again some names of celebrated artists who would be featured in the exhibition alongside Schad.

"It would be such an opportunity to introduce this German artist to our many North American visitors, who are unaware of his remarkable portraits," I continued.

Mrs. Goodman was clearly flattered that we wanted to include her painting in an important international show. She was losing a friend, so to speak, but by the end of my visit, she and her son-in-law seemed to have warmed up to the idea of lending the portrait to the exhibition. On my way out of the apartment, I left the loan form behind in the hope that she would sign it.

Although she was nervous about introducing Baroness Wassilko to the art world, Mrs. Goodman did finally agree to lend the painting to the show, and it was given a prominent place in the galleries. Schad was not a familiar name in North America in 1991, when the exhibition was presented. Lead curator Jean Clair had been instrumental in bringing this artist and other Neue Sachlichkeit painters from Eastern Europe back into the limelight,[7] and the Montreal museum was borrowing two other Schad portraits from private collections in Germany. I knew Schad's paintings were sought after, but I was surprised at the high insurance evaluations attached to them. Mrs. Goodman had had no idea of the value of her painting, but after my visit, and with a little research, her family became aware that she owned a real treasure.

The 1920s: Age of the Metropolis ran for five months in Montreal through the summer and autumn of 1991. Then the paintings were removed from the walls, packed up in crates and returned to their owners. I presumed that in no time the baroness would be safely reinstalled on Mrs. Goodman's living-room wall, and I moved on to the next project.

A few months after the end of the exhibition, Helen Adkins in Berlin sent me distressing news that Ilse Goodman no longer had her portrait. In waning health, she had moved from New York to California to be closer to her daughter there, but the portrait of the baroness had not followed. At the time I had surmised that once the family realized the painting's worth and the high cost of insuring it, they had probably sold it right after its Montreal exposure. I subsequently learned, however, that the portrait had been passed down to her granddaughter in New York.

In 2003, the Neue Galerie in New York mounted the first major American exhibition devoted to Christian Schad. I made a special point of seeing the show. I had no doubt the baroness would be part of it. Sure enough, there was that familiar gaze, and printed on the label below the canvas: "Christian Schad, *Baroness Vera Wassilko*, 1926, private collection." A few years later, in 2006, I saw the portrait again, in the exhibition *Glitter and Doom: German Portraits from the 1920s*, on loan to the venerable Metropolitan Museum of Art from Anatole and Nancy Gershman, Ilse's grand-daughter.[8]

Mrs. Goodman had lovingly held on to the portrait for sixty-five years, sheltered from public view. Then, in a generous gesture, she had let her prized companion go, not realizing that she would never see her again. Ilse died in 1995, only four years after our show. Perhaps such a compelling painting was destined to be shared with the world. Now, with the flick of a digital finger, the portrait of Baroness Vera Wassilko may be enjoyed by anyone.

The Tragic Tale of Paul Beau, Metalsmith

PAUL BEAU IS A NAME ALMOST ENTIRELY FORGOTTEN TODAY, BUT in the early twentieth century this uniquely talented artist was the most sought-after metalsmith in the country. If you visit the Houses of Parliament in Ottawa today, almost every piece of wrought iron you pass in its halls and offices is likely the work of Paul Beau and his craftsmen. If you are in Regina and happen to enter the office of the premier of Saskatchewan, Beau is represented there, too, in the polished brass implements beside the fireplace. And every visitor to the grand old Canadian Pacific hotels, from the Empress in Victoria to the Château Frontenac in Quebec City, has probably admired an antique chosen by Beau or sat beside a giant brass *jardinière* crafted by his hand.

My own interest in Beau started with a golden brass vase my husband owned—a gift from his mother, who had bought it at a church bazaar for $10 in the early 1970s. Expertly hammered with fluted sides, its handcrafted rim curved out to the thinnest of edges, the sign of a real artisan. Pressed into the metal of its base was the mark "Paul Beau & Co/Montreal" within a circle. I had never heard of Paul Beau, but since utilitarian brass objects usually bear no maker's mark, I concluded that Beau must have been an artist of some renown.

After I began working at the Montreal Museum of Fine Arts in 1978, I was wandering through the museum's decorative-arts storage one day when I spied a small, attractive brass jug with a copper handle, made in the style of the English Arts and Crafts movement. I picked it up and turned it over: there was the stamp of Beau & Co., and nearby, on another shelf, stood three more Beau pieces: an ornamental jardinière, an old-fashioned glove or letter box, and a small brass bowl with three lion-paw feet.

Museum files had little to say about this intriguing craftsman, so I resorted to what researchers did in pre-Internet days: I asked around. "My mother has a brass trivet with copper trim by Beau," said one Westmount dowager. "Instead of silver from Birks," said another, "I received a Beau vase and a jardinière as wedding gifts." Others recalled visiting his shop on Montreal's Mountain Street. Many prominent English-speaking Montreal families before the First World War seem to have owned one or two works by Beau. Over the decades, some of these pieces (like my vase) ended up in antique shops and at church fairs. Out-of-fashion objects like inkwells, blotter corners and glove boxes were probably gathering dust in attics, having lost their use (and perhaps a willing hand to polish them). Talking with dealers, collectors, architects and decorators, I slowly constructed a profile of this elusive metalsmith.

Paul Beau was born in Montreal on November 1, 1871, the son of French émigré Charles-Arsène Beau and Marguerite-Clementine Hippé, a native of Montreal. By the time of Paul's birth, the couple were in the restaurant business.[1] Paul's older brother Henri Beau (1863–1949) was a successful painter best known for his mural *The Arrival of Champlain at Quebec*, which hung in the Quebec Legislative Council Chamber from 1904 to 1931. Henri spent the interwar years in Paris, serving as the official artist for Canada's public archives, and Paul often visited his brother in France to tour the museums and antique stores.

Paul Beau was self-taught in his trade.[2] With the revival of crafts in the early twentieth century, many how-to books were

available for amateurs to learn the art of working with soft metals such as brass and copper. Beau had a good eye for design and learned his trade through careful observation of how objects were made. He summarized his early career in a letter to Canadian ethnologist Marius Barbeau:

> At the age of fourteen, my father made me take up watch-making as a profession. During this apprenticeship I learned how to work with metal and this helped me greatly afterwards. When the moment came to go out on my own, … I decided to go into antiques… As an antique dealer, I came across many beautiful metalwares which I always sold with great regret. Therefore, I decided to try my hand at metalsmithing on the advice of [architect] Mr. W.S. Maxwell, and I gradually was able to create some interesting pieces.[3]

The young metalsmith launched his career in hammered brass and copper at the Canadian Guild of Crafts in Montreal, where W.S. Maxwell sat on the Council. Inspired by the nineteenth-century English revival of Arts and Crafts under William Morris, the Guild was founded in 1906 to encourage and preserve the traditional crafts of Quebec, and held exhibitions of local weaving, hooked rugs, metalwork, and aboriginal bead and basket work.

The Guild's long-standing archivist Alice Lighthall, a sprightly eighty-eight year old from a distinguished Montreal family, certainly knew about Paul Beau. On my visit to the Guild's then Peel Street offices, she led me to some large filing-cabinet drawers where I found letters, newspaper clippings, announcements and invitations to exhibits stretching back a century. Thankfully, Miss Lighthall was at my side to make sense of the orderly disorder.

"Here, look at these," she said, pulling out some old black-and-white photographs. To my delight, the pictures showed images of a jardinière and the Montreal Museum's small brass jug made by Beau. The Guild had exhibited the works in 1907 and 1908, at the

beginning of Beau's career. He must have quickly risen in stature, as just three years later a pair of his brass bookends were among the gifts sent by the Canadian Handicrafts Guild to Queen Mary, wife of George V, at the time of his coronation in 1911. I also found some letterhead from 1916, which read:

PAUL BEAU & CO.
Artistic Metal Workers
Hand Work Only
Antique Art Goods, Old Clocks,
Ancient Arms, Brass and Copper Jardinières

By this time, Beau had set up shop in an elegant three-storey stone townhouse at 291 Mountain Street, just south of St. Catherine Street West. Beau lived upstairs along with his sister Yvonne, who ran the business during Paul's frequent trips abroad. He kept this storefront-workshop-residence until 1922, and the building still stands today, amid parking lots and office buildings.

On his trips to Europe and the United States, Beau carefully studied the design and techniques of French and Spanish seventeenth- and eighteenth-century ironwork, and over the years amassed a huge collection of European antique ironwork: cabinet hinges, chest locks, door-knockers, andirons and more. He sold his whole collection to the Art Association of Montreal (now the Montreal Museum of Fine Arts) in 1916 when member of the Council F. Cleveland Morgan established a decorative arts collection to encour-age young artisans to learn about design from historical examples of applied art, as Beau himself had done.[4]

What strikes me most about Beau's decorative objects is his talent for contrasting the golden lustre of brass with the warm, reddish tone of copper. He was one of the very few Canadian interpreters of Arts and Crafts metalwares in the early twentieth century. Reacting against heavily ornamented industrial Victorian designs, Arts and Crafts proponents encouraged simple forms made by hand, which displayed the personality of the artisan, not

Paul Beau, *Coffee Pot*, brass, copper and wood, 1910–1915
Private collection

the perfect precision of machine-made objects. As a result, brass and copper objects became as popular as silverwares during this period, because the metal's value was considered secondary to its value as a handmade creation. Beau made many of these small objects, from complete desk sets—blotter corners, letter holder, bookends, pen tray, inkwell and small stamp box—to vases, jardinières, trivets and trays.

Beau's work was distinctive because he borrowed freely from different styles, incorporating classical patterns, pinwheel designs, Gothic trefoil leaves, rosettes and sometimes the French fleur-de-lis. These types of motifs featured regularly in design magazines of the time such as *The Studio* (English) and *Craftsman* (American). Beau also consulted books like *Historic Ornament, Practical Design*

and Applied Design—Beau's copy was published in 1904—and probably Franz S. Meyer's *Handbook of Art Smithing* (1896) with its illustrations of wrought-iron volutes and spiral twists.

All crafted by hand, Beau's pieces are not perfect: textures can be irregular, engraved lines may be uneven and the occasional slip is evident in the chasing of embossed motifs. Often Beau would solder store-bought decorative bronze bands around the rims or sides of his pieces, or attach lion-paw feet to his bowls to give the work a more sophisticated appearance. Each object was a unique expression of this self-taught artist, and he gradually built up a name for himself.

The support of Edward and W. S. Maxwell was instrumental in building his career. Heading one of Canada's foremost architectural firms at the time, the Maxwells were ardent believers in handcraftsmanship, and when it came to metalwork, Beau embodied their beliefs. "Mr. Maxwell commissioned me to produce some wrought-iron and bronze work to decorate the old Mount Royal Club," recalled Beau. "He advised me to hire a good iron forger, which I did, and while watching [the forger] work, I learned the techniques, which permitted me to launch, for better or worse, into the art of wrought iron."[5]

The architects frequently commissioned Beau to provide wrought-iron fireplace accessories, lighting fixtures and brass door hardware for their buildings, as well as antiques from his shop for the homes of well-to-do clients. Each commission is meticulously recorded in Maxwell ledgers in pen script, detailing costs and dates of payment to Beau. In 1909, the Maxwells offered Beau one of his most lucrative commissions—close to $11,000—to create lighting and fireplace accessories for the Saskatchewan Legislative and Executive Buildings. The handsome brass coal scuttle that Beau made especially for the premier's office in Regina is still in place today.

A second stroke of good fortune was Beau's friendship with Kate Reed whose husband, Charles Hayter Reed, was the manager of the Canadian Pacific Railway hotels. These grand buildings sprang up across the country in response to the opening of the West and the expansion of tourism in Canada. Kate Reed, an accomplished interior

decorator, was well placed to take charge of interior furnishings for these hotels as they were built: the Banff Springs Hotel, Chateau Lake Louise in Alberta, the Empress Hotel in Victoria, BC, and additions to the Château Frontenac in Quebec City.[6] Paul Beau became one of her key contacts, providing antiques for her interior decorating needs (gathered on his frequent trips to Europe) and his own hand-crafted brass urns to hold the giant palm plants which Reed scattered throughout the formal rooms of these luxurious hotels.

But the most significant commission of Beau's career was un-doubtedly the Houses of Parliament. In 1916, after the Centre Block of Canada's Parliament Buildings was devastated by fire, architects John Pearson and Jean-Omer Marchand were charged with re-building the House of Commons and Senate chambers in their original Gothic Revival style. Chief architect Pearson, a proponent of Arts and Crafts design, insisted on handcraftsmanship for the ironwork. The story goes that Pearson was just about to travel to England in search of a wrought-iron specialist when Beau's name was brought to his attention. In Beau's words:

> Mr. Pearson led me to believe that the Parliament Build-ings would serve in some respects like a museum of iron-work that I would craft to decorate the buildings, so I did my best... All the pieces of wrought ironwork that decorate the Parliament have passed through my hand for alterations, modelling, *repoussé* work, if necessary, and chasing.[7]

For six years (1920–1926), Beau worked in a temporary building on Parliament Hill overlooking the debris of the destroyed Senate wing and not far from the Parliamentary Library, which was the only structure saved from the fire. A small, indistinct photograph of the "ornamental-iron workshop" shows Beau dressed in his customary tie, shirt and suit vest, putting the finishing touches to a large andiron while his six blacksmiths hammer out the iron for the seventy-three sets of fireplace fenders, baskets, screens, tools,

The reconstruction of the Centre Block of the Houses of Parliament
after the 1916 fire. Temporary workshops for the carpenters, sculptors,
and ironworkers are in the background.
Library and Archives Canada

firedogs and decorative coal-box hinges. These implements can still be found in the offices and reading rooms of the House of Commons and the Senate today.

The quantity and quality of work produced for the Parliament reconstruction was immense. Following architects' design drawings, over a six-year period Beau and his workers executed the coils, volutes and swirls of the wrought-iron railings in Centre Block, and the ornate hinges on the Senate's exterior doors, replete with fleur-de-lys, shamrocks, rosettes and thistles. Beau also personally created the four-sided calendar, decorative inkstand and House of Commons seal, still placed on the central table of the House. Beau's contributions were significant enough that they became the subject of a 1925 article, "Paul Beau Revives a Lost Art," in the *Journal of the Royal Architectural Institute of Canada*. The Parliamentary commission was the highlight of his career, and he made enough income to leave for Europe immediately afterwards, not returning to Montreal until 1931.

In 1979, I presented a small show of Beau's pieces at the Montreal Museum of Fine Arts, and the work of this forgotten metalsmith

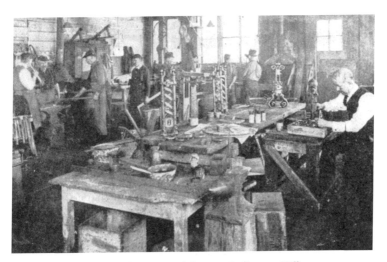

Interior of wrought-iron workshop on Parliament Hill, c. 1922
Paul Beau is seated at the right.
Photo: *Le Samedi*, Montreal, June 29, 1946

was brought back into the spotlight. But the exhibit brought more about Beau out of the shadows than I expected.

I was sitting in my museum office when I received a call from a woman named Cécile Thébaud. She told me she had visited the show and was glad to see so many of Beau's works on display. Seventy-six years old, she said she was acquainted with Paul Beau— he had been a friend of her father's—but she was mostly a friend of Beau's second wife, Bepka.

Beau had a second wife? This was a surprise to me. From my research I knew that Beau had married a Gertrude Brown in 1906, and that she had died in 1914, leaving no children. I had even visited her grave in the Mount Royal Protestant cemetery. But other than this, I knew almost nothing of Beau's personal life. I hastily suggested a meeting to Cécile. She asked that I come to her apartment.

A few days later, over tea, I asked her my question: "Beau had a second wife?"

"Oh yes," declared Cécile. "Bepka was much younger than Paul. I think she was of Romanian origin. She had family in Montreal."

"When did they get married?" I asked.

"They met in Paris, and got married there, or possibly Vienna, in 1927 or 1928. I forget when. But I know they lived on the Continent for about four years." This fit into the period that Beau had spent in Europe after his Ottawa commission.

Cécile poured me more tea as I took notes furiously.

"Bepka was an opera singer when I knew her in Montreal," continued Cécile. "Beau seemed to be well off financially, despite the Depression, and lived in a nice apartment on Drummond just below Sherbrooke Street. She and I used to shop together. She loved expensive luxuries—she was a real spendthrift with her husband's money."

"Did they have a happy marriage?" I asked.

Cécile hesitated. "Bepka was in love with a young Montreal artist, whose name was also Paul. At a certain point, in fact, the Beau household became a *ménage à trois*. I remember having meals with Beau, who was in his sixties by then, and Bepka and her young lover. I found it a bit uncomfortable and felt sorry for Beau."

Over the years, Cécile explained, she had lost touch with Bepka, who apparently suffered from depression and was in the care of doctors. Cécile was not sure whether Bepka was even still alive. But she did recall seeing a remarkable mirror with a handcrafted metal frame in their house, which Beau had fashioned for his wife.

After hearing Cécile's story and leaving her apartment, my first impulse was to find Bepka to locate Beau's mirror and any other pieces he had made especially for her.

New information about Beau continued to surface. From an ardent collector of Beau's work I learned about a metalsmith, Johan Nagels, who had worked with Beau in the later years. With great excitement, I telephoned him and we agreed to meet at the museum.

When Nagels arrived at my office, he looked perhaps sixty— elderly but still far too young to have been a contemporary of Beau. It turned out that Nagel's father, René, a well-trained Belgian ironworker, had met Beau in Europe and, after René emigrated to Montreal in the early 1930s, the two had shared a metal workshop

in Ville St. Pierre. Johan had apprenticed with his father and thus got to know Beau well.

Nagels confirmed that Beau's wife—whom he called Béatrice, not Bepka—had been a singer with La Troupe d'Opéra San Carlo at His Majesty's Theatre on Guy Street in Montreal. (She was also listed in Lovell's Montreal directory as an employee of CBC in 1946.) It was obvious that Nagels was not fond of Béatrice, who clearly took advantage of her much older husband and his money.

"What stands out most in my memory about Béatrice," he told me, "is that after Beau's death, she accused me of stealing his signature punch." This was the small iron tool used to stamp "Paul Beau & Co/ Montreal" under the base of each work. Nagels continued: "Imagine! She thought I had taken Beau's punch to stamp his mark on pieces I had made. It was all about money for her." Some months later Béatrice found the punch in her piano bench, according to Nagels, and that was the last he'd heard of her.

The 1930s were difficult times for metalsmiths, even though in 1933 Paul Beau created a large wrought-iron chapel screen you can still see today at the Church of St. Andrew and St. Paul, in downtown Montreal. Created in 1933 after designs by architect Harold B. Stout, it is a masterwork of intricate wrought-iron scroll and leaf forms, with Beau's signature rosettes hammered in brass. By late in the decade, the market for handcrafted luxury metalwares was waning, and with World War II approaching, commissions dried up and metals became difficult to obtain, especially brass and copper, which were reserved for the production of cartridge cases and artillery shells.

Retired Montreal architect Randolph Betts recounted to me how Beau used to visit his office during those years, asking for design drawings to help him drum up work. For large, important commissions, Beau tended to rely on architects' drawings. "You know, these were rough drawings," Betts went on to explain. "A lot was left to the hand and skill of the craftsman. If the designs were too detailed, the artist would feel that he was just copying." Betts remembered making drawings for objects like heraldic plaques,

different lighting fixtures, and Italian-style grilles. "I wouldn't charge Beau for my drawings," said the architect. "He seemed down on his luck."[8]

Johan Nagels remembered one client at the time who wanted Beau to create a black wrought-iron interior grille with a brass goat on it. "That goat caused Beau so many problems," sighed Nagels. "It was meant to be kicking, to symbolize the client's hard-knock life and climb up the business ladder to becoming a millionaire. When the gate was delivered, the whole thing was sent back to the workshop because the goat wasn't kicking vigorously enough. Beau had to redo it."

Soon after the war started, Nagels' father René was forced to close the workshop. "My father went to work for Dominion Engineering Works in Lachine, and he died in 1948." Johan then reopened the workshop, renaming it Nagels' Art Metal Works, and continued his association with his father's old friend. "Beau and I used to argue about the advantages of working with machines. He insisted on handcrafting everything, but I used a machine hammer for tedious, repetitive work. He was set in the old ways of working with metal."

Nagels pulled out a photograph of Beau, probably the last image of him ever taken: a slight, elderly gentleman dressed in suit coat and tie, scarf draped over his shoulders, wearing a fedora. On the worktable in front of him are the tools of his trade: lathes, picks, a couple of vices, bottles of corrosives. Beau looks toward the camera with a tired expression. In the picture he is working on a plant stand, but according to Nagels, by that point Beau was mostly making metal ashtrays.

Then Nagels told me the story of a July day in 1949 when Beau asked him for some arsenic. It was hardly an unusual request: metalsmiths use arsenic commonly to "pickle" brass to give it a rich, bronze-like patina.

"I didn't think anything of it and fetched the bottle for him," said Nagels.

That evening he received a call from a policeman, who informed him that Beau had gone to the top of Mount Royal Park and,

Paul Beau in his workshop at age 77, shortly before he died
Courtesy of Johan Nagels

swallowing the arsenic, had taken his own life. His body was found below the large cross overlooking the city.

I was stunned.

Nagels looked at me sadly. "I felt so guilty for providing Beau with the arsenic that killed him. He even left me a couple of lines in a suicide note."

Paul Beau was seventy-seven years old. His old friend René Nagels had died the year before, and his brother Henri had passed away in Paris that May. With no commissions, an estranged wife and no descendants, his death was a sad end to a brilliant career. His possessions, including his tools and signature metal punch, were eventually sold off by the *Curateur public du Québec*.

The 1979 exhibition on Paul Beau brought out not only these woeful tales but also old and new admirers of this fine artist's work. As a result, in 1982, I prepared a larger exhibition on Beau for the museum and it travelled to museums in Quebec, Ontario and Saskatchewan,[9] bringing Paul Beau's name to an even wider audience.

During the course of the travelling exhibit's preparation, I couldn't stop thinking about the mirror Beau fashioned for his second wife. It must have been remarkable. I tried to find out more about Béatrice. Was she still alive, had she kept his best pieces? Cécile had told me that Bepka's family had not been pleased with her marriage to the much older artisan, but her identity proved difficult to trace. Just as her trail was getting warmer, one morning I received an anonymous phone call in my office. A low male voice told me to stop searching for Béatrice. "It is none of your business," the man stated firmly. I was caught off guard. Was this a threat, or some sort of warning? I explained that I was not trying to dig up gossip, only to locate what would surely be some remarkable exhibition pieces. I had no interest in revealing embarrassing stories about their personal life. But the caller was adamant that I snoop no further. With few leads and mindful of the museum's reputation, I gave up my detective work. But one question still haunts me: where is the metal punch with Beau's signature now?

And I'd love to find that mirror.

An Architectural Treasure

FOR ME, IT WAS LOVE AT FIRST SIGHT—NOT WITH A PERSON BUT with a space: a small oratory in the stately mansion of James T. Davis, built on the flank of Montreal's Mount Royal. This secluded nook had originally been intended as a large closet for sheets and towels, but at some point during construction the architects Edward and William S. Maxwell transformed it into an intimate place of worship, so that Davis' wife Gertrude could pray there daily. Like her husband, Gertrude descended from Irish Roman Catholic immigrants and according to her granddaughter, Diana Davis, she was very devout.

The word *oratory* comes from the Latin verb *orare*, to pray, and applies to any space in which prayer takes place, from the massive St. Joseph's Oratory (which dominates the north-facing skyline of Mount Royal) to the two-by-four-metre space of the Davis' private chapel. When I visited the Davis house in the 1980s, I was attracted not only by the room's secret, contemplative feeling, hidden away on the second floor, but also by the splendour of its craftsmanship.

The Davis oratory is just wide enough for one person to kneel on the *prie-dieu* before the altarpiece. Each front corner of the oak altar displays a small carved pelican tending its offspring—a traditional symbol of sacrifice. These tiny sculptures, like all the wood ornament in the room, were executed by the Bromsgrove Guild (Canada) Ltd., the Montreal branch of an English firm

inspired by the Arts and Crafts ideals of William Morris. The only glimmer of daylight in the room shines through the rich reds and blues of a stained-glass window of the Virgin and Child, commissioned directly from the Guild's parent firm in Bromsgrove, Worcestershire.[1] What unites the whole room in a luminous vision of blue, silver and warm natural oak is the Gothic rib-vaulted ceiling. Stencilled with a blue-and-green floral pattern on Japanese grass-cloth, this wall covering descends like a celestial cloak to meet the high wood panelling around the room. Overhead hangs a silver lamp inset with blue velvet matching the fabric of the window curtains fringed with silver threads. Every detail responds to every other detail in a harmonious display of texture, tone and handcrafted ornament.

The Maxwells built the house in 1911 for James T. Davis, one of Canada's major building contractors. Davis learned the trade from his father William Henry Davis, who emigrated from Ireland in the 1850s with his parents and made his fortune as a contractor in Ottawa. He encouraged his two sons to join him in the business. James ultimately branched out to Montreal and started his own firm there, just as the city was going through an unprecedented construction boom. Financial success and status in Montreal society came quickly to the talented engineer, who specialized in canals and bridge piers. In 1907, Davis was called upon to rebuild the substructure of the Quebec City bridge after its notorious collapse mid-construction. In 1909, Davis hired the most renowned architectural firm of the day, Edward and William S. Maxwell, to build him a large residence on Drummond Street. Davis knew what kind of house he wanted— something along the lines of an English country house despite his meagre two-acre lot. To make up for the lack of rolling green fields, the red-brick mansion, set on the side of forested Mount Royal, had a far-reaching view of the St. Lawrence River.

In choosing the Maxwells as architects, Davis was following the tastes of his fellow prominent Montrealers. Edward Maxwell had established the office in 1892, and William became an official partner in 1902 after apprenticing at a top firm in Boston and completing his

William Notman & Son, *James T. Davis House Oratory, Montreal*, 1916
Designed by William S. Maxwell in 1915–1916
McCord Museum, Montreal

architectural training in Paris. The brothers had an ideal working relationship: Edward was manager and chief designer who maintained links with important clients. William's talents lay in planning, drawing and designing the decorative detail for exterior sculpture, interior wall decoration and furniture.

The James T. Davis residence was just one of a number of palatial houses the Maxwells built in Montreal's "Golden" Square Mile where Canada's leading financiers lived. When the brothers started planning the Davis house in 1909, they had just completed the Canadian Pacific Railway's Royal Alexandra Hotel and station in Winnipeg—symbols of the country's push to develop the West—and were drawing up a proposal for the Palliser Hotel in Calgary. The firm had recently won the international competition for the design of the Parliament Buildings in Regina, Saskatchewan, and back in Montreal they were preparing their proposal for the Art Association of Montreal's prestigious new gallery (now the Montreal Museum of Fine Arts).

The Davis house oratory was created in 1915–1916, four years after the rest of the house was completed. William Maxwell took a personal interest in its decoration, as he initialled the drawings for all aspects of the room: ceiling pattern, carpet, altar cloth, religious statues, candlesticks, lighting and even the curtain valance of the stained-glass window. In 1915, with Canada deeply committed to the war effort in Europe, construction had dropped off in Montreal, so William must have had more time than usual to devote to this commission—and designing the decorative aspects of buildings was what he loved to do.

Over twenty years after first seeing the Davis house oratory, I was brought back to it in 2010 when I was invited by curator Charles C. Hill to join the curatorial committee in the preparation of the exhibition *Artists, Architects & Artisans: Canadian Art 1890–1918* at the National Gallery of Canada. It was to be Hill's last major exhibition before his retirement from the Gallery after thirty-four years as Curator of Canadian Art. Hill wanted to review an overlooked period in Canadian art: the closing years of the nineteenth century

up to the end of the First World War—critical years in the development of progressive ideas in art and architecture in Europe and America. The exhibition would examine Canada's response to the movement toward integration in the arts, when painters, sculptors, architects, designers and craftspeople crossed traditional boundaries in each field, creating murals, sculptural ornament and architectural decoration in a true union of artistic expression.

The Maxwells were central to this discussion, and my thoughts immediately turned to the James T. Davis house and its oratory. An architectural tour de force, the room evoked the very theme of the show. This tiny chapel was rare in Canadian architecture, and it was produced down to the last detail in English Arts and Crafts tradition

Detail of the decoration on the altar of the J. T. Davis oratory, carved in oak by the Bromsgrove Guild (Canada) Ltd., Montreal, 1916

89

by William Maxwell in his role as architect, master draftsman, painter and designer of decorative objects. Not only had the oratory been preserved intact since 1916 but the architectural drawings for it still existed.

"Why not display the whole room in the exhibition?" I proposed to the curatorial team in Ottawa.

Charlie (as he is known) was not convinced.

"How can we do it? What items can be removed?" he asked.

"Well, there's the stained-glass window, and the entrance door could probably be taken out as well. The prie-dieu has disappeared but I'll try to track it down," I replied.

"Can the wood panelling be removed from the wall?" asked Hill.

"No, but the altar might very well be an independent piece," I said, recalling a vintage photograph in the archives that showed the altarpiece standing independently.

"How would you reproduce the stencilled, vaulted ceiling?" Hill asked in a skeptical tone.

I acknowledged that there would be a few hurdles.

Over the decades, many rooms in the Davis house had remained unchanged, as Gertrude Davis continued to live there for almost thirty years after her husband passed away in 1928. Music critic Eric McLean used to visit Mrs. Davis in the early 1950s for tea and informal concerts on the grand piano, and in the late 1980s he gave readers of the Montreal *Gazette* a glimpse of the elderly widow's life still couched in nineteenth-century splendour.[2] She was cared for by doting cousins, nurses, a butler who "sought solace in the bottle," a chauffeur, two gardeners and a mechanic all living in quarters within the spacious house or on the grounds. When Gertrude Davis died in 1956, her family sold the mansion to McGill University.

The building now houses the McGill School of Physical and Occupational Therapy—perhaps not the most sensitive use for rooms with marble fireplaces, luxurious wood panelling and ceilings of leafy plaster scrolls. The blue-and-white oval breakfast room has been transformed into an administrative office. The billiard room and bedrooms are filled with tables and filing cabinets, and the

William Notman & Son, *James T. Davis House,*
Drummond Street, Montreal, 1921
Built by Edward and W. S. Maxwell 1909–11
McCord Museum, Montreal

drawing room has become a classroom of desks. Glamorous guests in evening dress once conversed by candlelight around a mahogany table in the dining room where walls were hung with gilt-framed paintings. Now the room's occupants perch on metal stools as they monitor heartbeats.

Up the grand staircase, with its balustrade of hand-carved oak, one passes the library at mid-level before reaching the first floor. The oratory is immediately on your left in the corridor leading to the master bedroom. When I visited in 2010, it was intact but not undisturbed. Boxes of office supplies were stored on the altar and on shelves lining the walls. For my visit, a kindly technician had removed "all this stuff," so the room could be admired in its original state.

Curator Hill and designer David Bosschaart came down from Ottawa to visit and assess Gertrude Davis' private chapel. As we gathered, peering into it, we discussed the possibilities of recreating this unique room for the upcoming exhibition. The altar with its

reredos was crucial to the success of the presentation. Fortunately, we found that it stood independently from the wall panelling and was held flush to the wall by only two small hooks. The stained-glass window with its blue velvet curtains and the central hanging lamp could all be removed. McGill University had given permission to exhibit whatever parts of the oratory were moveable. The rest now depended upon the budget of the National Gallery, and the skill and attention of its design department—and I could see that David Bosschaart was smitten.

I had only one reservation about reproducing the oratory out of context for the exhibition. In the actual house, once through the closed door of the room, you were enfolded within the intimate, barely lit decor of this tiny room in which time had not altered a note. I feared that the air of mystery and expectation you experienced upon entering that space would be lost in a brightly lit museum gallery.

I needn't have worried. Under Hill's discerning eye, Bosschaart worked his magic and the miniature chapel was presented as an alcove in the exhibition gallery. Carpenters at the National Gallery produced natural-oak wall panelling to simulate the simple lines of the original. Davis family members tracked down two missing Saint Anne sculptures from the altar niches and helped to locate the oak prie-dieu that had been donated to St. Patrick's Cathedral in Montreal. The recreation of the rib-vaulted ceiling was a tour de force of ingenuity and patience. The oratory's floral motif was redrawn and printed on seagrass wallpaper, which gave the surface a texture similar to the original ceiling covering. Above it all, the resplendent silver lamp hung in place. The plans and elevations of the house were displayed on the gallery walls beside the alcove, along with William Maxwell's detailed drawings and watercolour elevations of the oratory. Even the architect's samples of velvet curtain approved by Gertrude Davis found their place in the exhibition cases. The small room was a highlight of the show, a reflection of the visual pleasure of ornament in a quiet room of contemplation.

The splendour of the oratory came to life alongside three hundred and twenty works from museums and private collections across Canada. *Artists, Architects & Artisans* opened in November 2013 and continued into 2014. Oil paintings, mural panels and architectural drawings were juxtaposed with furniture, ironwork, lighting fixtures, sculpture, textiles, posters, photographs and videos in a rich and exuberant display of Canadian art created for a new century.[3]

Shortly after the exhibition's opening, Charlie was interviewed on the radio:

"Mr. Hill, of all the hundreds of artworks in this show, can you pick a favourite?"

"Sure," Charlie replied without hesitation, "the Davis oratory."

The Maxwells of Montreal and Haifa

AT THE BEGINNING OF THE TWENTIETH CENTURY, THE MONTREAL partnership of brothers Edward and William S. Maxwell was the largest and arguably the most sought-after architectural firm in Canada. They had a privileged association with the Canadian Pacific Railway, receiving commissions regularly to build train stations and grand hotels across the country, from New Brunswick to British Columbia. In 1907, the Maxwells won an international competition for the Saskatchewan Parliament Buildings in Regina, their most prestigious commission. In 1912 their building for the Art Association of Montreal's new gallery (now the Montreal Museum of Fine Arts) was opened, and clients continued to request stately mansions in the city's "Golden" Square Mile. At the peak of the firm's production, ambitious young architects were lining up to apprentice with the Maxwells.

Older brother Edward established the practice in 1892 after working for three years with Shepley, Rutan and Coolidge in Boston, successors to the distinguished American architect Henry Hobson Richardson. In the summer of 1891, the Boston firm had sent the young Canadian north to oversee its commission for the new Montreal Board of Trade building. American architects regularly received commissions in Canada, which angered their Canadian *confrères*. By law the Americans had to work with a Canadian firm to supervise construction, but essentially they remained the designers and bosses. Edward had other ideas. Back home, he began making contacts

and moonlighting for local clients. He soon left Shepley, Rutan and Coolidge and put out his shingle in his native city. Prominent Montrealers were impressed by his American training (and lower fees) and construction was booming in Canada. Montreal's domination of transport, trade, finance and politics made it the most important city in the country. Edward Maxwell's timing was perfect.

Eight years Edward's junior, William Maxwell worked in his brother's drafting room before following a similar route south of the border to apprentice for three years with the Boston firm Winslow & Wetherell. In 1899 he set off for Paris to complete his training— the dream of every young architect at the time—and landed in the atelier of Jean-Louis Pascal, a preeminent French architect whose fluency in English made him a popular master among overseas students. Under Pascal, William learned the Beaux-Arts approach to architecture: clear, logical planning, artistic draftsmanship, and attention to appropriate decorative detail. In the Beaux-Arts style even small buildings could look grand and elegant.

(left) Edward Maxwell, architect, 1893
(right) William Sutherland Maxwell, architect, 1898
McCord Museum, Montreal

"Paris is delightful and I wish I could prolong my stay for years," William wrote to a friend.[1] The young architect immersed himself in the city's sights and culture, including the celebrated Exposition Universelle of 1900. However, back in Montreal, Edward had a long waiting list of commissions and needed a reliable and talented partner to help him. "Willie" was urgently summoned home just over one year into his French sojourn.

Not only had William been enraptured by Paris, he had also left his heart there with a young American, May Ellis Bolles, sister of a fellow architectural student and member of a distinguished New York family. By the time William met May, she had become an ardent follower of the Bahá'í Faith through her godmother Phoebe Hearst (mother of renowned art collector and publisher William Randolph Hearst). May Bolles made it clear to William that devotion to her faith was paramount in her life, and she hoped that William would become similarly imbued with Bahá'í ideals. The two became engaged in November 1900, but May, disappointed at William's lack of religious fervour, kept putting off the wedding day.

Back in Montreal, William resumed his duties in the firm's drafting room, having no inkling of his future partnership with his brother until he left the office one evening. "I have news for you," he recounted in a letter to his fiancée. "I noticed the painter working on the front door, but I paid no attention to him—when going out at six, I looked and behold, there was painted on the glass panel: 'E. Maxwell.' And below it was 'W. S. Maxwell' and below again—the word 'Architects.' So Dear, your Sutherland is now a practising architect and a member of a prominent firm—*que pense tu ma cherie?*"[2] William became Edward's official partner in 1902. The same year, May and William were finally married in London, England.

At first William remained at a distance from his wife's activities, even though he supported her life of travel as a missionary for the Bahá'í Faith. Even after the birth of their only child, Mary, in 1910, May's wanderings continued. Occasionally William's patience was tested when his beloved May, sometimes with their daughter in

tow, spent extended periods away from Montreal, spreading the word in America or Europe. But William Maxwell's working days were full. In the decade before World War I, the Maxwell firm was swept up in a surge of construction—first in Montreal, which was growing more quickly than almost any other North American city, and secondly in Western Canada, which had opened up for development with the completion of the Canadian Pacific Railway in 1885. The Maxwells' influential clients included Sir William Van Horne, Sir Vincent Meredith, James Ross and Richard B. Angus, all key players in the CPR and Bank of Montreal financial empires, and these men commissioned the Maxwells to build their commercial enterprises, their family mansions and their summer estates.

The brothers formed an ideal partnership. From his years in Boston, Edward had learned how to run a large architectural office. He also had good social connections and lived among his clients on Peel Street in the city's fashionable Square Mile. William, the more reserved of the two, had a talent for drawing and could impress patrons with large watercolour perspectives for building proposals. Content to stay behind the scenes, he supervised the drafting room and worked well with the artisans engaged by the firm. Above all, the Maxwells insisted on good construction and fine craftsmanship, and they knew how to keep their clients happy by offering to design a building in whatever style they wished: Gothic church, classical art museum, French-château hotel, or Arts and Crafts summerhouse.

When I began working at the Maxwell-designed Montreal Museum of Fine Arts, I grew to admire the brothers' architecture. Stark yet elegant, the museum building is a monument to art, inspired by grand French Beaux-Arts classical designs but modelled after the sparer style of American Beaux-Arts museums and libraries of the early twentieth century. In 1986, I curated a small show called *Building A Beaux-Arts Museum: Montreal, 1912*, exhibiting the architectural plans for the museum along with vintage photographs and Maxwell-designed furniture.[3] This project opened up a whole field of discovery for me, as I examined hundreds of the firm's drawings preserved at McGill University's Canadian Architecture Collection

(McLennan Library) through the foresight of John Bland, the former director of the School of Architecture.

Studying the firm's drawings, I began to recognize the painterly flourish of William's hand in Beaux-Arts cartouches, running-leaf scrolls and sketches for chairs and sideboards. I came to identify the distinctive way William would stretch out the lower line of an E or an L in handwritten titles and instructions to contractors. The firm's correspondence with clients has not survived, but its meticulous financial books have, with every payment to artisans, artists, manufacturers, carpenters, technicians and contractors noted, dated and calculated down to the last penny. Familiar names in Canadian art turn up in these records. Artist Maurice Cullen executed murals, sculptor George Hill carved ornaments, Castle & Son provided stained glass and furniture, and metalsmith Paul Beau crafted iron and brass. There were also occasional references to England's Morris & Co. for wall coverings and New York's Tiffany Studios for a glass mosaic.

According to his daughter Mary, William Maxwell lived "every instant of his life through his eyes." A shy, retiring man, he was also a respected and active figure in Montreal's cultural community. As an accomplished artist and architect, he became an active member of the Pen and Pencil Club and a founder and first president of the Arts Club of Montreal, both meeting places for the city's architects, artists, craftsmen and their patrons. A photograph from around 1927 shows Arts Club members with William seated front and centre in an armchair, everyone crowded around their most senior, well-liked member. He also served as president of the Province of Quebec Association of Architects in 1914 and president of the Royal Architectural Institute of Canada from 1935 to 1937.

To get a better sense of the private aspects of William Maxwell, I visited his former residence at 1548 Pine Avenue. Built by the Maxwell firm from 1909 to 1911, the house is semi-detached and the mirror image of its neighbour, both distinguished by the multicoloured brick pattern of their exterior walls. The bricks vary in tone from light beige to scorched brown as if each were handmade, in keeping with English Arts and Crafts principles. While the Maxwells preferred

French Beaux-Arts classical design for their public buildings, for residential architecture they looked to English models that emphasized comfort, simplicity and warmth of materials. (Though William could not resist adding a typically French stone cartouche above the front bay of both houses.) The modest home suited William's taste for an unassuming yet elegant residence with a view of the city and the St. Lawrence River beyond.

The house remains relatively unchanged since William's death in 1952.[4] His imprint is felt most in the library, a cozy room of dark-stained oak panelling with his collection of paintings on the walls and antique stained-glass panels set into the windows. Mary recalled her father relaxing here in the evenings in front of the fireplace, studying his vast collection of art and architecture books, including rare first editions. In a haze of smoke, he would spend hours, sometimes until midnight, clipping out photographs and articles from architecture and interior decoration magazines, then classifying them into folders for future reference: mirrors, railings, lamps, mantelpieces, ironwork, foyers, chimneys, garden sculpture. On the third floor of the house, the whole space is given over to a studio with a skylight. Here William painted and drew for his personal pleasure or examined his impressive collection of over three hundred nineteenth-century Japanese prints. (He also collected European prints and works by his Canadian artist friends, notably Clarence Gagnon).[5]

The more I researched the Maxwell brothers and their buildings, the more I understood how both brothers were essential to the success of the firm. When Edward died unexpectedly in 1923, at the early age of fifty-six, William was set back by the loss personally and professionally. They were in the middle of building two additional wings and the landmark tower of the Château Frontenac Hotel in Quebec City. Even though William took on a new partner, Gordon Pitts, he would never reach the heights of his association with his brother, who had guided their office through its most productive years. But William remained devoted to his craft—and a wholly unforeseen architectural commission lay in store for him.

William claimed that he was not a religious man and used to say he never set foot in a church unless he was its architect. He accepted his wife May's peripatetic life of travel but distanced himself from her faith and kept this aspect of his family separate from his work and social commitments. By all accounts May was an affectionate wife who kept up an active correspondence during her frequent absences (all the while continuing to encourage William to follow in her spiritual direction). William, in turn, was respectful of his wife's devotion and the many devotees who passed through their door in Montreal. In 1912, he even rushed to Morgan's department store to buy a white guest-bedroom suite "in Louis XV style" when the Master of the Faith, Abdu'l-Bahá, planned to spend three days as their honoured guest on Pine Avenue during his tour of North America.[6]

Established by the Persian prophet Bahá'u'lláh, who had been banished from Iran in 1868 and was buried in 1892 near Acre (now Akko) in present-day Israel, the Bahá'í Faith is based on the idea of a single universal religion encompassing all races, colours, income levels and nationalities. Its values and exotic appeal attracted adherents in England and America in the late nineteenth century. As a zealous Bahá'í, May made three trips to the community's World Centre in Haifa, Israel, close to the tomb of its founder. She regularly wrote letters requesting spiritual guidance to Abdu'l-Bahá and later to Shoghi Effendi Rabbani, his grandson, who became Guardian of the faith in 1921. During her final pilgrimage to Haifa in 1937, accompanied by her willowy daughter Mary, May sent a mysterious, urgent telegram to her husband on February 26: "Your presence here by March twenty-first essential in connection with Mary's future happiness / great destiny / complete secrecy absolutely essential / mention to no one / ...you can sail *Berengaria* on March third and catch *Triestino* March tenth Trieste arriving Haifa fifteenth... our devoted love May."[7]

William soon learned the reason for the hasty message. Forty-year-old Shoghi Effendi had watched the vivacious Mary growing up under the tutelage of her mother, from whom she had inherited a dedication to the Bahá'í Faith. During their visit, Effendi, who

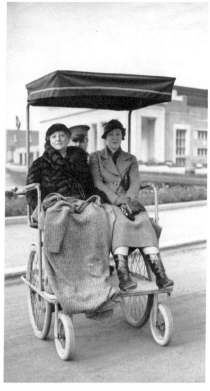

(left) William Maxwell with his daughter Mary in Munich, 1935
(right) May and Mary Maxwell at the Brussels Exhibition, Belgium, 1935
Photo by W.S. Maxwell
Courtesy of the Bahá'í International Community

had been teaching Persian to the attractive, twenty-seven-year-old Mary, had decided to marry her. May was overwhelmed by this great honour to the family. William rushed from Montreal to attend the wedding ceremony on March 24, 1937.

Despite their joy, May and William soon realized they would be sharing their beloved daughter with thousands of Bahá'í followers in her exulted status as wife of the Guardian. She would also be living in Haifa, a great distance from Canada. But Mary did not let her new position change her loving attitude towards her parents,

and she carried on a regular correspondence during their years of separation.

The 1930s were difficult years for William as commissions for Maxwell & Pitts dwindled, but he remained active in Montreal's cultural community and in 1938 was elected vice-president of the Royal Canadian Academy of Art. May continued to proselytize for her faith, despite the exhaustions of travel, and she unexpectedly passed away while on a mission in South America in 1940. William was greatly affected by the death of his wife—and his daughter was an ocean away. Mary Rabbani, sensing that her father was lonely, persuaded him to come and live with her and her husband in Haifa. In May 1940, now in his late sixties, William boarded a steamer and sailed for Israel.

A year or two later, when Shoghi Effendi Rabbani told his wife of his intention to enlarge the Shrine of the Báb, the main pilgrimage house in Haifa, Mary gently commented, "You have the world's best architect under your roof." Shoghi Effendi proposed building an impressive superstructure over the original shrine, which was a one-storey stone building at the time, perched on a spectacular site at the top of Mount Carmel overlooking Haifa and the sea.

In the ensuing years, the architect worked closely with his son-in-law on the design and construction of the monument, which was completed in 1953. What a joy it must have been for Maxwell, in his seventies, living with his daughter in Haifa, to design such a transcendent project. The white marble Shrine of the Báb, with its high circular dome covered in thousands of gilt tiles, stands out today as a landmark of Haifa. Surrounded by cypress and palm trees, it sits in splendid gardens that cascade down the slopes of Mount Carmel. William's eye for decorative details—intricate stone carving, stained glass, finely wrought metalwork—found their expression in the building's design, its proportion and symbolism evoking both Eastern and Western architectural traditions.

In 1987, the Montreal Museum of Fine Arts began preparations for a major exhibition on the Maxwell brothers' work,[8] and the organizing committee of curators had a chance to meet with Mary

Maxwell Rabbani when she passed through town to visit relatives, friends and members of the Montreal Bahá'í community. Her husband, Shoghi Effendi Rabbani, before passing away in 1957, had appointed his wife to the council of leaders of the faith. She was the last link with the founding prophet's immediate family. Like her mother, Mary was an enthusiastic traveller and drew crowds of followers wherever she went.

Madame Rabbani also inherited her mother's charisma. The curatorial committee all fell under her charm. Her family home on Pine Avenue held many memories for her, and we were only too glad to have her recall stories of her father's life and architectural work. She was clearly devoted to him and after his death brought his artworks and architectural drawings from her childhood home to Haifa. When we learned this, Irena Murray, head librarian of McGill's Blackader-Lauterman Library and a member of the curatorial team, asked if these architectural documents could be united with the extensive Maxwell firm's archive already housed at McGill. In response, Madame Rabbani invited the exhibition's curators along with her cousin Henry Yates (Edward Maxwell's grandson) to visit her in Haifa, to examine her father's archives and see what might be of interest for the exhibition and for McGill. Irena, France Gagnon Pratte and I jumped at the chance and, together with Henry, flew to Haifa for a week in April 1989.

In Haifa we grew to realize the weight Mary Rabbani bore on her shoulders as the leader of the Bahá'í Faith, whose members treated her like a monarch. At the same time, she was down to earth, with a keen sense of humour. Her warm-hearted assistants escorted us around the Bahá'í holy sites of Acre, and we marvelled at the grandiose Shrine of the Báb, set above the garden terraces. The days passed in a whirlwind of activity, as we sorted through Maxwell's drawings one by one, and took notes from his architectural plans, watercolours, travel sketchbooks and photographs. In the evenings Mary Rabbani, the most gracious of hosts, filled our ears with stories of her upbringing. In one anecdote she recalled visiting the Montreal workshop of the Bromsgrove Guild (Canada) Ltd. on Clark Street,

whose cabinetmakers created the furniture and the sculptural wood decoration in the Maxwell buildings: "I can remember my father taking a chisel out of the hand of the wood carver and very delicately doing what he called 'sweetening the curves.' He would gently, gently chisel out a greater depth or greater curve to a leaf and better the detail. Of course, the workmen adored him. He had a nose for good workers."

The Shrine of the Báb in Haifa would be William's final, most unexpected commission. In 1951 he returned to his house in Montreal because of ill health and passed away in his native city the following year. The Royal Architectural Institute of Canada's obituary was written by the institute's past president, J. Roxborough Smith, who had worked in the Maxwell firm for ten years. He referred to William's influence as "a prized heritage which has proven its worth amid the ever-changing tempo of our diversified age."[9]

After Maxwell's death, the family house on Pine Avenue was purchased by the World Centre of the Bahá'í Faith, in large part because the Master, Abdul Bahá, had stayed there in 1912. The home remains intact, a tribute to its resident creator William Sutherland Maxwell—a man devoted to his profession, to craftsmanship and to art.

Cézanne's Provence, Beyeler's Basel

In 1986 I spent a year in Aix-en-Provence in the south of France with my husband and our two young boys, living in a small rented house on a remarkable twenty-acre estate. L'Harmas, as the estate was called, belonged to Cecil Michaelis, a wealthy South African artist and ceramist who lived in Paris most of the year but spent the summer and holidays in his seventeenth-century *bastide*, a Provençal country house. The main drive off the Route du Tholonet (now called Route Cézanne) circled up to a grand entrance lined with pines, where the main farmhouse and additional buildings lay with a view south over a valley. A further short distance down a path stood our little house, decorated with hand-painted blue tiles and paintings by Michaelis and his friends. Blue irises filled the flowerbeds.

What a privilege it was to pass a year on this extraordinary property, with its ornate dovecote, landscaped garden and swimming pool. During the Second World War, the cluster of buildings had served as a shelter for Parisians fleeing the German advance—notably the artist André Masson—and half a century earlier the painter Paul Cézanne used to stroll along the Route du Tholonet to the nearby Château Noir, which figures in many of the artist's paintings.

One day Mr. Michaelis took us for a walk among the almond trees and yellow gorse of his estate. Reaching a high point overlooking the olive grove, he pointed to a large, isolated rock below.

"That was Cézanne's seat," said Michaelis.

We walked down to it, and took in the unimpeded view of Mont Sainte-Victoire in the distance, its craggy silhouette rising above patches of farmland, framed by Aleppo pines.

As an art historian, I was already familiar with the view— Cézanne portrayed this mountain hundreds of times in paintings and sketches[1]—and it recalled a Cézanne painting I knew well, *La Route Tournante en Provence*, which hangs in the Montreal Museum of Fine Arts.

Completed around 1866, *La Route Tournante en Provence* is an early work by Cézanne. An ordinary subject, the road in the centre foreground of the canvas leads the viewer into the scene as it gently curves to the right then dramatically dips out of sight, leaving viewers to imagine its winding route through the hilly Provençal landscape. A single pine tree at the side of the road reaches to the sky, its slender trunk accenting the verticality of the composition in contrast to the horizontal mass of the background mountain. Cézanne built up the structure of the forms with deliberate broad strokes of colour, eschewing a meticulous rendering of detail. Painted *en plein air*, as was his custom, Cézanne would have set up his easel on the roadside and gone to work. The precise location of this dusty, narrow road has never been identified, but it could very well have been near L'Harmas estate along the Route du Tholonet, a favourite carriage route in Cézanne's time, running eastward from Aix to the village of Le Tholonet and on towards Mont Sainte-Victoire.

Born and raised in Aix-en-Provence, Paul Cézanne knew the landscape intimately. Looking at his painting, it's easy to imagine yourself walking beside the artist in the dusty heat, amid the sun-bleached rocks near the road. A radical work for its time, the painting had passed through the hands of Cézanne's Paris dealer, Ambroise Vollard, and then on to another Parisian gallery, Bernheim-Jeune, to finally hang in the Montreal mansion of one of Canada's foremost art collectors, Sir William Van Horne, president of the Canadian Pacific Railway, whose daughter Adaline Van Horne bequeathed it to the Montreal Museum of Fine Arts in 1945.[2]

In 1999, over a dozen years after my stay in Provence, *La Route Tournante en Provence* came under my care on its way to the Fondation Beyeler in Basel, Switzerland, where it had been requested for an exhibition on Paul Cézanne and Modernism.

When a museum lends its valuable paintings, sculptures or decorative art objects to other institutions for a show, these works are usually accompanied by a member of the lending museum's staff as a condition of the loan. Financed by the borrower, this provides an additional guarantee for the safety of the work in transit (for insurance purposes) and at the same time strengthens links between museums. The "courier" accompanies the artwork by airplane, truck or boat from the moment it is first crated to its final destination, where the courier and borrowing museum's conservator together unwrap and examine the piece to make sure that it has suffered no damage. Far from being a pure pleasure trip for the courier, one is tied to the painting day and night, sometimes through different time zones, without eating or sleeping much and with long waits at customs in airports or at international borders.I was surprised that my director, Guy Cogeval, had agreed to lend our museum's only Cézanne painting, but such was Cogeval's respect for Ernst Beyeler, founder and director of the Fondation, that he let it travel to Switzerland.

The Fondation Beyeler had opened in 1997 as a museum to display the personal collection of Beyeler and his wife, Hildy. Born in Basel in 1921, Beyeler started out as an antiquarian book dealer and fell into the art market almost by chance, when he started selling prints, and he eventually became one of Europe's most reputable dealers of modern and contemporary painting and sculpture. In 1947 he launched his Galerie Beyeler at 9 Bäumleingasse in the picturesque heart of Basel and brought the art world to his door. As his career grew in the 1950s and '60s, Beyeler took a risk keeping the gallery in his native city, rather than move it to a larger art hub like Paris, but the gamble paid off. In 1970, as a founder of Art Basel, Beyeler made his hometown an obligatory destination every June for international art connoisseurs.

Beyeler's love of art propelled him into the centre of the art world, and the book by journalist Christophe Mory, *Ernst Beyeler: A Passion for Art*, includes photos of the dealer chatting at *vernissages* with prominent collectors and museum directors, and standing with friends such as Picasso, Giacometti, Francis Bacon, Jean Dubuffet, Barnett Newman and Robert Rauschenberg. As a dealer, Beyeler had been self-taught, acknowledging mentors and friends as his guides in the art world. He had an instinctive eye for quality in paintings and was quick to learn the skill of successful negotiating. Gifted with an outgoing personality, he developed a keen understanding of human psychology, once remarking to Mory, "It is up to the dealer to find out what makes a client tick."[3]

In the mid-1990s, Beyeler was considering options for his extensive private art collection founded, in his own words, on the "two pillars of modern art: abstraction and Cubism." He momentarily pondered the idea of giving his collection away to a museum, and many courted him. But he was loath to see his offspring, nurtured over the years and appreciated with such joy by him and his wife, move far away from their home. Beyeler stood by Basel and built his dream project there at the crossroads of Germany, France and Italy. Set within the extensive grounds of the eighteenth-century Villa Berower on the outskirts of town, the Fondation Beyeler rises out of farmers' fields with the hills and vineyards of Tüllingen, Germany, visible in the distance. To build the museum, Beyeler chose celebrated Italian architect Renzo Piano, who designed many museums including the Centre Pompidou in Paris.

In recalling his collaboration with the architect, Beyeler told of working hand in hand with Piano, suggesting adjustments to certain elements. The dealer knew intimately the artworks which were to hang on the walls, and he could envisage how best to set them off. Piano in turn talked of having a "creative dialogue" with Beyeler. "A building is always a portrait of the client," claimed the architect.[4]

Sensitive to the natural landscape, Beyeler wanted the new building to integrate with the villa's gardens and surrounding rural views.[5] Piano agreed. "Seeing the site in Riehen," as the architect

Ernst Beyeler riding a bicycle in Berlin's Tiergarten (park), 1993
Courtesy of Fondation Beyeler

later recalled, "I thought, it's so beautiful and the artworks are so profound, one needs to be very quiet. Only silence can allow one to become fully aware of the unfathomable depths of these works of art. The building became what it had to be: almost discreet."[6]

Acting as a courier to the Fondation Beyeler for Montreal's Cézanne, it was my first visit to Basel, in the northern corner of Switzerland. As the shipping van made its way from the airport to the Fondation—I sat up front in the passenger seat—we left behind the medieval houses of Basel, some dating back to the 1300s, and entered the suburb of Riehen, an area of stately residences. The museum was located on Baselstrasse, and a sloping path edged with dazzling orange and pink rhododendron bushes led down

from the sidewalk to the main door of the Fondation. Inside, all was whiteness and wooden floors, with natural light falling indirectly through levered openings in the ceiling. The modest size of the low-lying building gave it a sense of intimacy, befitting a private collection.[7] In one gallery, Claude Monet's *The Water-Lily Pond* shimmered with blues, greens, pinks and gold—and was mirrored by a real pond, on full view to its left, through a floor-to-ceiling glass wall. Beyond the pond, a verdant lawn with steps built into the grass rose on an incline to five trees: a magnificent horse chestnut, a luxuriant pine, a copper beech, an aged catalpa and a branching linden, all arranged in an artistic composition of colour and shape, in keeping with Beyeler's desire to include the natural setting as part of the art and architecture of his museum.

After the Fondation's conservator greeted me, we unpacked my precious cargo, inspected it together and signed off. All was well. Courier duties completed for the moment, I was brought to Ernst Beyeler who was standing in a gallery with paintings leaning against walls and waiting to be placed. A tall, handsome figure, he was obviously enjoying the installation process and he exuded energy as he walked over to greet me. He thanked me for bringing Cézanne's rare early landscape to Basel, and explained how he wanted to integrate the Cézanne paintings in the show with works by Picasso, Mondrian, Matisse and others from the Fondation's collection. With his acquired knowledge after mounting shows going back to the early days of his gallery, Beyeler attributed the success of an exhibition to the unexpected links that arise between paintings that are not usually shown together. Every curator has experienced the chance correspondences of subject, colour, composition and line that become evident during the hanging of a show. Responding to these unforeseen associations between artworks is the creative part of a curator's role in the installation of an exhibition.

While Beyeler placed paintings and gave instructions to technicians, I wandered through the rooms. All the "greats" of modern art were there: Van Gogh, Degas, Matisse, Kandinsky and Klee, along with the Cézannes. Works by Picasso filled one of the largest

galleries, and in another the quiet geometry of Mondrian was given ample space for the visitor to contemplate. The spindly forms of Giacometti's walking figures in wrought iron contrasted starkly with the white walls in another gallery.

As I stood gazing at a small work by Paul Klee, Beyeler approached me during a break in the installation.

"Are you enjoying the collection?" he asked. "Which is your favourite work?"

I was taken aback by what seemed to me an almost absurd question, as we stood among paintings by artists who had changed the course of twentieth-century art.

"How can I choose just one? There are so many outstanding works here," I feebly remarked.

He smiled and said, "Come, I'll show you my favourite."

I was intrigued as he led me away from the galleries and down some steps to the long side elevation of the building. We stopped in front of a glass wall. Immediately below us, an expansive farmer's field stretched out, framed by the museum's windows—furrow after furrow of ploughed, black earth.

"On your left, you are looking in the direction of France," he said with outstretched arm. "On your right are the hills of Germany."

It was April. The darkness of the rich soil contrasted with the springtime green of the distant hills. It could have been a painting by Gerhard Richter without the haziness, or an Anselm Kiefer with its earthy blacks and bits of hay adhering to the canvas.

And then Beyeler, who had managed thousands of works by the greatest artists of the twentieth century, turned to me almost triumphantly and pointed to the field outside the window.

"This is my favourite work of art," he said.

A Winning Teapot

ONE MORNING IN 2007 A BROWN ENVELOPE LANDED ON MY DESK at the Montreal Museum of Fine Arts. Inside was a letter from the Department of Canadian Heritage, alerting the museum that a valuable artwork was about to leave Canada. Scottish auction house Lyon & Turnbull of Edinburgh had requested a license to export a silver English teapot made in 1879. Not just any old teapot: Lyon & Turnbull had placed a six-figure estimate on this small treasure. A photo of the item was included with the letter. Would I give my opinion on the cultural significance of this teapot? Should the government let it leave the country?

When I saw the photo, I immediately recognized the teapot as a remarkable work by English designer Christopher Dresser (1834–1904). Its unadorned geometric shape was radical for its time. Only one model made from Dresser's initial drawing had ever been found, and it was the proud possession of the Victoria & Albert Museum in London, England. Could a twin have turned up in Canada?

For the design, Dresser had simply tilted a cube to create a lozenge or diamond shape, added legs and a spout, and attached a sloping handle to match the diagonal line of the teapot's body. A slice through the top created the lid, surmounted by a pyramidal finial, and in a dramatic gesture, Dresser had punched a diamond-shaped cavity in its centre. It was a masterly design, but impractical. How much tea could a 3½-inch-square metal teapot hold with a

hole in its middle? Could it be mass-produced for middle-income clients? James Dixon & Sons, the Sheffield silver manufacturer that had commissioned the design from Dresser, must have had their doubts. With only one model believed to exist, it was clear that the company had never put it into production.

As it happened, I had been on the lookout for a piece of silver by Christopher Dresser for our museum's collection and had visited dealers in England and the United States with an acquisition in mind. Dresser's designs were striking in their modern simplicity. He had been "discovered" by collectors and dealers in the 1970s when his books *The Art of Decorative Design* (1862) and *Principles of Decorative Design* (1873) were reprinted, and his pieces began to appear in exhibitions. By the mid-2000s, three books about Dresser's art had appeared already and his work was in every major design museum.

I quickly answered the Department of Canadian Heritage's request, writing a strong justification for why Canada should not lose the chance to acquire this Dresser teapot. I sent my comments off to Ottawa thinking the museum had been dealt a trump card.

Curators in major Canadian museums regularly receive such requests from the government asking them to judge the heritage value of art objects. The art in question need not be Canadian. The policy was set in place in 1977, when government officials and Canadian museums realized that many notable artworks (especially Indigenous art) were disappearing into the hands of buyers outside the country. Through the Department of Canadian Heritage's Cultural Property Export and Import Act, the government can officially delay the export of an artwork—be it painting, sculpture, decorative art object, ethnological work or archeological artefact— for six months to give museums or public archives time to raise funds to purchase the piece. If a delay is granted, a museum is given the opportunity to negotiate the sale of the work directly with the applicant for the export permit—often a commercial art gallery or auction house working on behalf of the owner.

When Lyon & Turnbull heard that their request to export the Dresser teapot would probably be delayed, thus dashing their

plan to include it in their upcoming sales auction, they passed this information on to the Canadian owner, whom I shall call Monsieur Tremblay. He lived in Trois-Rivières, Quebec, but was following events closely. As the Lyon & Turnbull offices were far away in Scotland, Tremblay decided to take the situation into his own hands. He was not going to let the word of a museum curator get in his way.

It did not take him long to telephone me at the museum and relate the story of his astonishing discovery. The unique diamond shape of the silver teapot had attracted his eye in the 1990s when he lived in the town of Sherbrooke, Quebec. He had spied it in the home of an elderly colleague from work and remembered saying, "Eh, Bob, if you ever want to part with that little teapot there on the mantelpiece, let me know." A few years later, when his colleague decided to move to a seniors' residence in Ontario, to Tremblay's surprise, Bob offered him the teapot as a parting gift. Tremblay placed the small pot on a shelf in his house and thought no more about it.

Through his work as an engineer, Tremblay had travelled the world and picked up a few mementos, one being a bronze sculpture from China. When he heard that the Canadian version of the celebrated television program *Antiques Roadshow* was organizing a broadcast in Sherbrooke, and that participants could bring in any treasured objects for evaluation, he decided to take his Chinese bronze to see how much it was worth. At the last minute, he plunked the teapot into his bag.

Before the actual filming of the episode began, there were show-and-tell meetings between local participants and dealers specialized in the authentication of every type of antique object. The dealers sifted through the possessions of hundreds of guests in search of unexpected discoveries to highlight in the television show. At this first selection process, Tremblay pulled out his Chinese bronze figure to see what attention it might receive. The dealers merely looked at it and shrugged their shoulders. Their lack of interest changed to stupefaction, however, when the silver teapot was set on a table

for examination. The specialists drew closer and formed a circle around the captivating piece. The expert in English silver, Bill Kime, studied it carefully for authentic signs of age and checked its marks, which were clearly impressed on the bottom of the teapot: there was "JD & S" for James Dixon & Sons, together with the trumpet and banner symbol the Sheffield silverware firm used in the early 1880s. Model number "2274" was also punched into the metal, as were the initials "EP" for electroplate, meaning that the teapot was not sterling silver but silver-plated metal. Kime was especially excited to see the mark of "Chr Dresser" as well, which raised the value of the piece above the level of a run-of-the-mill teapot. Kime was familiar with Christopher Dresser's reputation as a late-nineteenth-century English designer of silver, ceramics, glass, textiles and wallpaper, and could barely believe the existence of this surprising find.

But how to evaluate it? There was little time for research before the filming of the program began, as the show's participants were only in town for a one-day session. The Dresser teapot looked authentic. It would be a real draw on the international design market. As far as Kime could remember, this was an unusual model. When the cameras started rolling in front of an anxious Tremblay, Kime declared that the teapot might fetch about $20,000 to $25,000 at auction, and perhaps even more. Tremblay beamed. He couldn't believe his good fortune, and he thanked Kime for this unexpected revelation. He packed it carefully into his bag and returned home to consider the news of this too-hot-to-hold teapot.

Over the telephone, Tremblay reported to me this sequence of events, and I complimented him on his good eye for design. But after our conversation ended, I wondered how he had hooked up with Lyon & Turnbull in Edinburgh—a long-standing Scottish auction house, not as well known internationally as English and American giants Sotheby's and Christie's, but well respected nonetheless. With the designer of his teapot identified, Tremblay must have gone directly to the Internet to check out the work of Christopher Dresser. After our conversation, I did the same on a hunch, and sure enough, Lyon & Turnbull popped up right away.

They had made headlines in 2005 with their promotion of an upcoming auction which included an exceptional Dresser teapot. Lyon & Turnbull had sent some of the works that were to be auctioned in Scotland to a preview of the sale in Philadelphia, and summoned the press to attract American bidders. Sure enough, the newspaper headlines the following day read: "The World's Most Famous Teapot Arrives in USA." These words no doubt caught Tremblay's eye. The teapot in the photograph looked identical to the one he owned. Without hesitation, he must have contacted Lyon & Turnbull in Edinburgh.

According to Tremblay's account, after the director of the Scottish auction house, John Mackie, had seen the detailed photographs of the teapot and its marks, within days, he was standing in Tremblay's living room in Trois-Rivières. Mackie inspected the teapot from every angle and discussed its provenance. "As soon as I saw it, I knew it was right," Mackie later told me in a telephone conversation. "A real treasure!"

Mackie moved fast against any possible competition, and by the time he left Canada, he and Tremblay had signed an agreement allowing Lyon & Turnbull to include the teapot in their next auction sale. Mackie was just as excited as Tremblay and assured him that the teapot was so rare, it would probably fetch at auction a price beyond Tremblay's dreams. To sweeten the bargain, Mackie promised to cover the cost of a trip to Scotland for Tremblay and his wife, so they could be present at the auction, and said that their Dresser teapot would appear on the cover of the sale's catalogue.

"Ah, le jackpot!" Tremblay must have thought, as visions of a new summer chalet danced in his head. But there was one hitch: obtaining the export license from the Canadian government. When Tremblay heard that the teapot might not be allowed to leave Canada immediately for Edinburgh, he was furious and telephoned the authorities at the Cultural Property Export Review Board in Ottawa. He found out that Lyon & Turnbull had the right to appeal a delay in granting an export license, and he offered to act on their behalf. Such an appeal to the Board is usually handled in

writing or by conference call, but when the Board offered Tremblay the option of pleading in person to the members at their next meeting, he rose to the occasion. By this time Tremblay had retired from business, and he was enjoying his brief moment in the teapot drama. This turn of events, however, meant that I, as the curator-specialist who had written the letter in support of an export delay, was also summoned to appear in Ottawa before the Board.

After a number of telephone conversations with a distraught Tremblay, I met him for the first time in Ottawa as we waited to enter the Board's Council Room. We took stock of each other, and I think we were both pleasantly surprised. Energetic and fit, he had dancing brown eyes and a full head of hair. He hardly looked retirement age. He was accompanied by his wife, who was charming and put us at ease. It may have felt like a court appearance, but this was not a legal case of personal grievance. We laughed at the strange circumstances that had brought us to this meeting. When we were invited to enter the Council Room, we took our places at the end of a long oval table around which sat twelve members of the Review Board. They represented different cultural interests: anthropologists, historians, cultural administrators, professors and curators, all from different areas of Canada.

Tremblay was asked to present his case first. He was an amusing storyteller and entertained the Board as he recounted his appearance on *Antiques Roadshow* and his astonishment at the estimated value of the teapot. The Board members laughed, raising their eyebrows and opening their eyes wide in surprise, as he told his tale. I could see that they were enjoying the drama of the situation. They were more used to pronouncing on Canadian paintings, Old Master drawings or First Nations artefacts than on a pint-sized teapot. I worried that Tremblay had won them over; how was I to match his personal appeal? He did admit, however, that he was not opposed to the idea of the teapot remaining in Canada. This offered a glimmer of hope for the museum's case.

When my turn came, I began by showing the recently published

books on Christopher Dresser. All three covers bore an image of the diamond-shaped teapot from the Victoria & Albert Museum collection, the twin to Tremblay's model. The V&A had recently lent their teapot to exhibitions of Dresser's work in New York and London, and at that very moment the teapot was highlighted in a show at the Museé d'Orsay in Paris. In my argument, I purposely sounded serious and curatorial in tone, summing up what I had already offered in a written report.

Why was this uniquely shaped teapot such a star? First of all, its visual appeal: the unique lozenge shape with the unusual cavity in the middle, its size and the brilliance of the metal. Not only the form but its date of production, 1879, made it appear revolutionary. At this time in England and elsewhere in the Western world, silver objects were highly ornate. Practically every plain surface was covered with sculptural or engraved flowery decoration. Dresser had designed a teapot with no ornament and broad, flat surfaces that showed off the lustre of the metal. The teapot with its clean, geometric lines looked radically modern, intended for industrial mass production, as if it had been made in the 1920s or 1930s, not during the Victorian period.

James Dixon & Sons, the company that actually produced the teapot, was a prominent silver manufacturer, going back to 1806. Located in Sheffield, a centre of industrial-silver production, Dixon & Sons specialized in silver and silver-plated wares for middle-income clients. English art historian Judy Rudoe had researched the cost records of the firm and discovered that it had taken many hours of work to fabricate a prototype of Dresser's diamond-shaped design. Her study, published in 2005, revealed that Dixon & Sons had spent three-quarters of the total cost of production on the labour alone.[1] To save on costs, the body of the teapot had been made of nickel silver, an alloy of copper, zinc and nickel, which actually contains no silver. Only on completion was the piece silver-plated. Nickel silver was a very hard metal to work, especially with a complicated shape. The teapot's design required so much handwork that it would not have been commercially profitable for large production, and this may be

why only two models of the teapot are now known to exist. (Lyon & Turnbull's John Mackie has suggested that the two known teapots were probably special, made-to-order commissions.) Because of its rarity combined with aesthetic appeal, the teapot's subsequent value, ironically, is far above its worth in metal.

The second reason the teapot was culturally important was that Christopher Dresser played a prominent role in design reform in England from the 1860s to the 1880s. His influence in Europe and North America was second only to William Morris, who inspired the English Arts and Crafts movement. The two men progressed along parallel paths. Morris promoted handcraftsmanship harking back to the days of English medieval guilds, while Dresser, more in tune with modern industry, worked with manufacturers to improve design for serial production. Dresser was responsible for some of the most inventive forms in silver to emerge in the late nineteenth century, and recent experts have hailed him as a forerunner of the twentieth-century industrial designer. He was at the peak of his career in 1879 when he conceived his diamond-shaped teapot.

Christopher Dresser was also notable as one of the first enthusiasts of Japanese design. He travelled to Japan in 1876 to 1877 and served as a buyer of Japanese decorative art objects for Tiffany & Co. in New York, just as the craze for things Japanese was beginning in Europe and North America. Japanese woodblock prints, ivory *netsukes*, ceramics and lacquer work found their way onto the shelves of Western art collectors and artists like Claude Monet and James McNeill Whistler. Dresser admired the Japanese economy of means in design, as well as the Japanese pride in creating beautiful objects no matter how small or ordinary in function. It is not surprising, then, that two years after his trip to Japan, Dresser's teapot reflected Japanese influence in its size, geometric form, handle design and overall simplicity.

Finally, I told the Review Board, this unique teapot had star power. There was only one other like it in the world, and that one had been prominently featured in international museum exhibitions. Its modern lines and playful lozenge-shaped silhouette delighted twenty-first-century eyes.

These arguments won over the Board members, who voted to confirm the export delay of Dresser's teapot. The first hurdle was over. Now the Montreal Museum of Fine Art had only six months to find the money to acquire the piece and to convince Monsieur Tremblay to sell his teapot—and at what price? In the weeks that followed I gathered all the facts to justify the purchase and presented these to the museum's director and acquisitions committee. Next we had to plan what we would offer to Tremblay. He was a friendly guy and claimed to be naïve in matters of art, but the shrewd sparkle in his eye bespoke a sharp negotiator.

In order to obtain more information on the importance of the teapot, I turned to the Victoria & Albert Museum, keepers of "the world's most famous" teapot. The silver collection at the V&A is vast and impressive. In this prestigious museum, a visitor may walk through gallery after gallery of English and Continental silver, from ecclesiastical chalices and domestic wares to contemporary works. I was on good terms with the curator of modern English silver, Eric Turner, who in the past had accompanied V&A loans to Montreal. In 2006, Turner had been responsible for handling the acquisition of their identical Dresser teapot. When it looked like it might be sold outside Great Britain, English cultural authorities had moved quickly, and the V&A stepped in to bargain for its purchase. Eric was generous with his research and filled me in on the background of their acquisition. He, too, was amazed by the discovery of a duplicate in Canada. He had thought the V&A's model was unique, as it had only been discovered in 1986, just over one hundred years after its design. The price the V&A had paid was based on the premise that it was the only one in existence.

But where had the teapot in Canada come from? What was its provenance? Tremblay seemed like an honest fellow, but was there more to the story he wasn't letting on? I was sure that he was not an art collector or a dealer. He and his wife had seemed genuinely surprised by their find. Was the teapot authentic? I had to rely on my own experience and the judgement of specialists—a Canadian

dealer who had examined it, the Scottish dealer who had studied it, and now Eric Turner who had seen detailed photos of it. According to Tremblay, his friend Bob had inherited the teapot from an elderly aunt in England. Bob's mother had brought it to Canada on a visit to see her son in the 1960s. As provenance was critical for any museum acquisition, I wanted to know more about Bob. Tremblay told me that his friend was still alive, but he did not want me contacting him. Tremblay declared, "I'll never, never, never tell you the full name of the man who gave me the teapot." I could see that Tremblay was in an uncomfortable position. He had received the teapot as a gift and now was planning to sell it for a high price. The *Canadian Antiques Roadshow* program in which the teapot was highlighted had not yet been aired on television. If his friend Bob were to see the show, he would learn that his teapot was not an ordinary $200 piece of tableware.

The museum's director Nathalie Bondil and administrative director Paul Lavallée were both supportive of the purchase. Lavallée suggested that we obtain an actual market estimate for the teapot. Who better to give an evaluation than London dealer Martin Levy, who had discovered the first Dresser diamond-shaped teapot in 1986? When I showed Levy the detailed photos, he also marvelled at our chance discovery in Canada, and kindly gave us an estimated value for our teapot.

Armed with Levy's evaluation, we began negotiations and lunches with Tremblay to settle on a price. At one point, in the museum's restaurant, Tremblay received a telephone call from Lyon & Turnbull in Edinburgh to see how things were progressing. For a moment I wondered: had Tremblay planned the call as a pressure tactic? Was the call a hoax? But then he showed us the mock-up design for the Lyon & Turnbull upcoming auction catalogue with the teapot on the front cover, should it ever get out of Canada.

During our meetings, we proposed that Tremblay donate the teapot to the museum for a healthy tax credit, or at least make a partial gift to reduce the price for us. He didn't like this idea and started talking about the summer chalet he wanted to buy for his

wife. He would smile or crack jokes, but he was determined to get cash for his lucky find. Tremblay did, however, come down from the imagined and what I considered slightly preposterous value that Lyon & Turnbull had listed on the teapot's export application form. In our discussions with Tremblay, we pointed out the reality that auction results rarely match rosy expectations. A key point in our favour was that Tremblay was not averse to the museum having his treasure as part of a public collection, where he could proudly view it, show it to friends and tell a good story.

Finally, after much discussion, hesitation and arm-twisting on both sides, and with considerable financial assistance from a Movable Cultural Property Grant accorded by the Department of Canadian Heritage, the Dresser teapot became a highlight of the Montreal Museum of Fine Arts' design collection. A winning teapot for all concerned!

Illuminating Tiffany

LOUIS COMFORT TIFFANY'S NAME TODAY—OVER EIGHTY-FIVE years after his death—conjures up images of stained-glass angels, mauve wisteria and multicoloured lampshades. I was introduced to Tiffany glass as a young girl. In my grandmother's sunroom, under a Tiffany lamp suspended from the ceiling, we would sit and have tea and occasionally stare up at its four bulbous shades with green and yellow swirls. The lamp's natural colours reflected the organic lines of the plants and flowers in the room.

At the time, Tiffany glass was too showy for my taste—gaudy throwbacks to the Edwardian past, part of the fussy interior clutter swept away by classical revival styles and Scandinavian decor. Yes, Tiffany glass can be "showy," but forty years later at the Montreal Museum of Fine Arts, I fell under its spell as the curator in charge of a Tiffany exhibition in 2009. In the three years leading up to the exhibit, I was introduced to a vast network of Tiffany scholars, collectors, dealers and curators. Each approached Tiffany and his glassmaking firms differently. Some shared their knowledge publicly, others held their cards close to the chest. Mysteries continued to swirl around the works and the businesses—and even now, in 2020, no one knows the full story of this ambitious man and the glass made under his name.

Louis Comfort Tiffany (1848–1933) came to the medium of glass almost by accident. As a young man he wanted to be a painter.

Like many of his American contemporaries, he went off to Paris to study art and was drawn to the exoticism of the East. In 1870 he travelled to Morocco, Algeria, Tunisia and Egypt, where he revelled in the resplendent hues of the silks, glass vessels, tiles and enamels that he observed in these countries, writing of his experience: "the pre-eminence of color in the world was brought forcibly to my attention."[1]

Back in New York, he set up an apartment-cum-studio decorated with his own Orientalist paintings and exotic artefacts collected on travels. To hide an unpleasant view from one of his windows, he replaced the clear pane with a radically abstract piece of leaded glass of his own design, full of swirling colours and varied textures. Tiffany's apartment decor soon became the talk of the town and inspired requests from wealthy clients to redecorate their interiors, including President Chester A. Arthur's commission for the White House rooms (1889) and the New York residence of Henry and Louisine Havemeyer (1891–1892), who amassed a large collection of Tiffany glass. Through these commissions Tiffany continued to experiment with glass, marvelling at how the medium changed under the effect of natural and artificial light.

To see an early example of Tiffany's interior decoration, I went to the Veterans Room at the Seventh Regiment Armory on New York's Park Avenue. With its dark atmosphere of heavy ornament, intricately carved furniture and wood panelling, the late nineteenth century pervades the room. I was immediately struck by the daring beauty of the fireplace decorated with hundreds of glittering aquamarine tiles. It was a dramatic architectural statement of the kind that brought Tiffany remarkable success as an interior decorator. Increasingly obsessed with glass, Tiffany decided he could achieve greater effects of colour with this medium than with a brush on canvas. He put aside his career as a painter and set himself on a course to international fame.

Tiffany built up his reputation in the decorating business in the 1880s as he expanded into curtains, upholstery, lighting and

Louis Comfort Tiffany, (1848–1933)
Library of Congress

metalwork, and in 1885 his father, Charles, put him in charge
of decorating the new family mansion on Fifth Avenue at 72nd
Street. On the top floor he set up a studio for himself complete
with Persian tiles, stuffed birds, fur pelts, tropical plants, Oriental
carpets, and glass orbs and glowing lanterns suspended from the
ceiling. Alma Mahler, wife of composer Gustav Mahler, in later
years described her visit to the studio:

> We found ourselves in a hall so vast it seemed boundless.
> An organist was playing the prelude to *Parsifal*… A black
> chimney with four immense fireplaces, each ablaze with
> flames of a different hue, rose in the centre of the hall. We
> stood transfixed. A man with a fine head appeared—it was

Tiffany, who never spoke—and before we could get a good look at him, he vanished... High above us there was Tiffany stained glass set in the walls, transparent and illuminated from outside. We spoke in whispers... Servants passed soundlessly, carrying trays of beautiful, champagne-filled glasses. We saw palms, divans, lovely women in oddly iridescent gowns. It was a dream: Arabian nights in New York.[2]

In 1892 Tiffany opened his own glass-making furnace just in time to participate in the 1893 World's Columbian Exhibition in Chicago. He mounted a grandiose display: a full-size chapel featuring stained-glass windows, inlaid glass mosaics and an enormous chandelier of coloured glass. Soon his windows, glass vases and bowls were winning prizes at international exhibitions in Paris, Berlin and St. Petersburg.

The demand for stained-glass windows kept Tiffany afloat financially throughout his career.[3] At the turn of the century hundreds of churches and synagogues across the United States commissioned windows and interior architectural decoration from the Tiffany firm. During this boom period for the revival of stained glass, the Tiffany workers created not only religious figural compositions but also monumental landscapes in glass for private residences, public libraries, universities and hotels—most notably the Chicago Public Library in 1897 and a massive "Dream Garden" mosaic for Curtis Publishing in Philadelphia in 1916. The Tiffany name eclipsed all competitors.

Many people confuse Louis C. Tiffany's glass firm with the jewellery and silver business of his father, Charles Lewis Tiffany (1812–1902). While Louis' glass company went out of business in 1932, his father's firm Tiffany & Co. still draws crowds to its Fifth Avenue store today. With driving ambition Tiffany senior transformed a small drygoods and stationery store into a jewellery and silverware empire, ultimately selling his diamonds to the upper crust of American society and to European nobility. In 1882, the New York *Mail and Express* bragged that "The house of

Tiffany & Co…. is known the whole world over. Wherever pearls are gathered and diamond fields opened, there its agents are found eager to buy the costliest gems." Decades before Charles Tiffany's son Louis came onto the scene, the Tiffany name was associated with the high living of the Astors, Vanderbilts and other "merchant princes" of New York.

Louis never wished to work in his father's firm, but his artistic education began in its workshops, among its designers and craftsmen and in the aisles of the company's flagship store on Union Square. Young Louis had a natural instinct for marketing and learned the value of sensational publicity at the knee of his father. Charles also bankrolled his son's ventures in glass design, and at Tiffany senior's death in 1902, Louis' Tiffany Studios were at the peak of their production.

Louis C. Tiffany's star dimmed, however, after the Depression. The cool greys and beige tones of classical modernism replaced the exuberant purples, tulip reds and emerald greens associated with his glass, and Tiffany creations were shunned for the next forty years.

Tiffany died in 1933, but thankfully a number of devotees have preserved his work. One of them, Hugh F. McKean, spent two months in 1930 living at Laurelton Hall, Tiffany's country estate on Long Island, as part of the artist-in-residence program established by Tiffany through his Foundation. When McKean wasn't walking the terraces and gardens of the 600-acre property, he was wandering the mansion, admiring its collection of Asian, Moorish and Indigenous North American art, as well as some of Tiffany's finest leaded-glass windows, glass vessels and hanging lamps, all part of the mansion's interior decor.[4] As McKean relates in The "Lost" Treasures of Louis Comfort Tiffany, the master of the house would turn up every weekend with his entourage, driven in a hand-built automobile, a 1912 Crane Model 3, which the students referred to as "Mr. Tiffany's jewel box." Tiffany's interaction with the students verged on theatre performance and McKean was charmed by the handsome elderly gentleman in a white summer suit. Like Alma Mahler many years before, McKean felt transported into a dream:

We hurried up the steps through the gardens past the Daffodil Terrace, through the magnificent loggia and into the Fountain Court. There he was, seated on one of the divans, which the family called "The Throne," music rolling down from the organ loft in one of the upper stories of the court… The air was filled with the scent of flowers. The fountains, terraces, glass walls, organ music, marble floors, colored lights, bearskin rugs—snarling heads and all—potted palms and flowering plants were more than anyone could be prepared for. It was a dimly lit fantasy that could not be… [yet] there it was!"[5]

Laurelton Hall was kept up by the Foundation after Louis' death. When the house was severely damaged by fire in 1957, a distraught McKean was called in by the Tiffany family to help salvage whatever remained of artistic value. The art that McKean and his wife Jeannette saved (and purchased) is now preserved at the Charles Hosmer Morse Museum in Winter Park, Florida.

In his book on Tiffany, McKean raised questions that have puzzled researchers for years. "What part did he actually play in the firm, and what did he delegate to others?" asked McKean. "What are his personal creations and what is the work of his staff?" Tiffany left little correspondence and no personal journals and the Tiffany Studios business archives have not been preserved. Even though his creations circled the globe and news of his success filled newspapers of the day, Tiffany was secretive about the management of his firm. His signature or the firm's name appears on every window, vase, lamp and other decorative object, but who really designed and crafted the works?

Since McKean posed these questions in 1980, art historians, curators and collectors have scoured hundreds of sources in search of answers—and have turned up some surprising results. Tiffany specialist Martin Eidelberg has noted that after Tiffany's initial experiments, he never blew any glass himself; he designed only a small number of stained-glass windows; the formula for producing

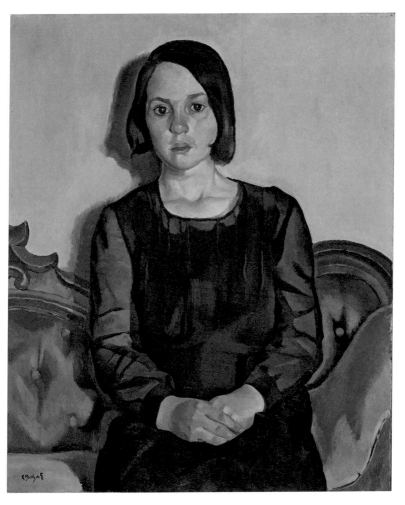

1. Edwin Holgate, *Ludivine*, 1930
National Gallery of Canada

2. Edwin Holgate, *Nude in the Open,* 1930
Art Gallery of Ontario

3.1 Edwin Holgate, *Fisherman's Kitchen, Natashquan,* 1931
Art Gallery of Hamilton

3.2 Natashquan, Quebec,
view from the Gulf of Saint Lawrence,
les Galets cabins in the foreground, 2004

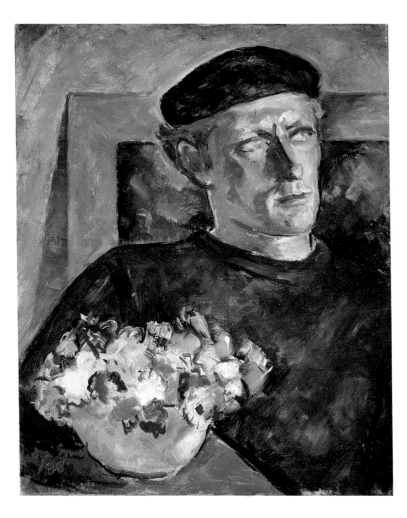

4. Jori Smith, *Portrait of Jean Palardy*, 1938
The Montreal Museum of Fine Arts

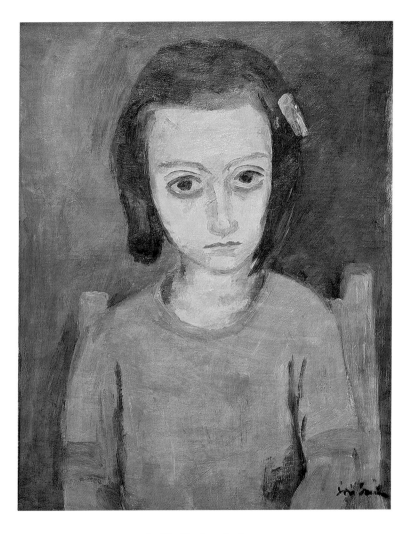

5. Jori Smith, *Rose Fortin*, 1935
The Montreal Museum of Fine Arts

6. Installation view of exhibition *The 1920s: Age of the Metropolis*
at the Montreal Museum of Fine Arts, 1991

7. Jacques-Émile Ruhlmann, *Corner Cabinet,* 1923
The Brooklyn Museum, New York

8. Kurt Schwitters *Merzbau* 1923-1936
(reconstruction 1988-89)
Lent by the Sprengel Museum, Hanover, Germany
Installed at the Montreal Museum of Fine Arts in 1991

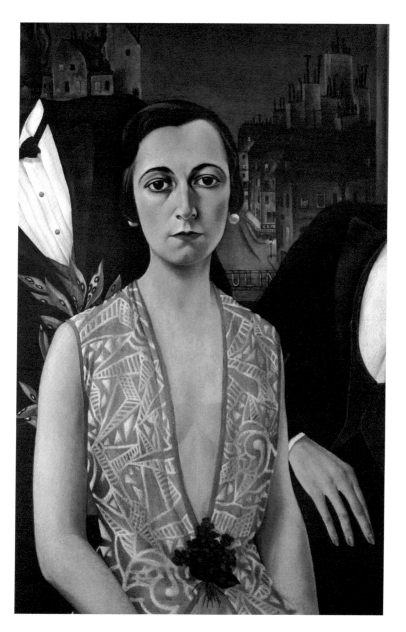

9. Christian Schad, *Baroness Vera Wassilko*, 1926
Private collection

10.1 Paul Beau
Jug, C. 1907
The Montreal Museum of Fine Arts

10.2 Paul Beau
Jardinière, C. 1910-1915
The Montreal Museum of Fine Arts

10.3 Paul Beau
Coal Scuttle, 1911-1912
The Montreal Museum of Fine Arts

11. *Oratory*, James T. Davis residence, Montreal
Detail of stencilled wall covering and altar reredos sculpted by
the Bromsgrove Guild (Canada) Ltd., 1915-1916

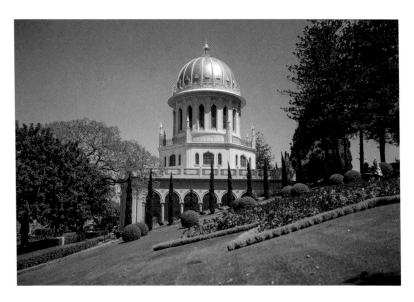

12.William S. Maxwell
Shrine of the Báb, Bahá'í World Centre
Haifa, Israel, 1948-1953

13. Paul Cézanne, *La Route Tournante en Provence*, c. 1866 or later
The Montreal Museum of Fine Arts

14.The Fondation Beyeler, Basel, Switzerland
Designed by Renzo Piano and opened in 1997

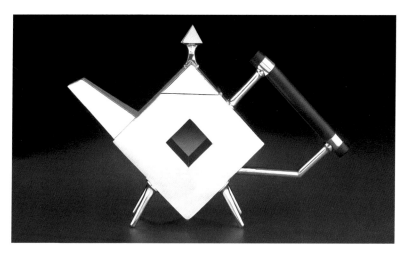

15. Christopher Dresser, *Teapot*, c. 1879
Produced by James Dixon & Sons, Sheffield, England
The Montreal Museum of Fine Arts

16. Concert hall of the Claire and Marc Bourgie Pavilion
Montreal Museum of Fine Arts,
showing some of the Tiffany windows

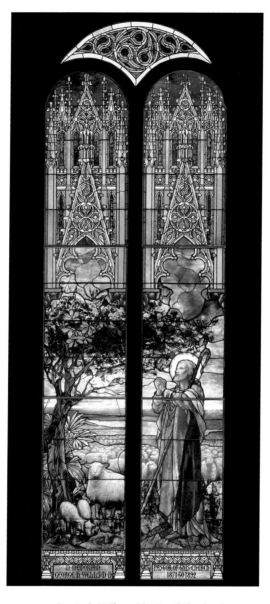

17. Louis C. Tiffany, *The Good Shepherd*
Designed by Frederick Wilson, made by
Tiffany Glass and Decorating Company, New York, 1897
The Montreal Museum of Fine Arts
(formerly the Erskine and American Church)

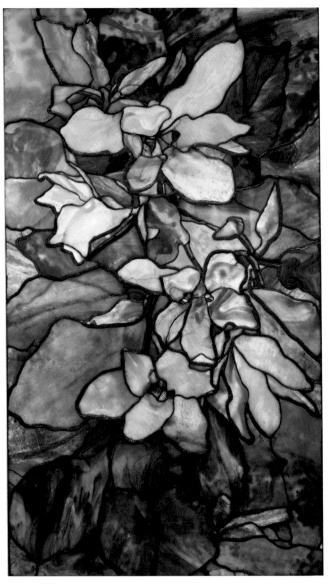

18. Louis C. Tiffany, *Magnolia*
Designed by Agnes Northrop, made by
Tiffany Glass and Decorating Company, New York, c.1900
The State Hermitage Museum, St. Petersburg

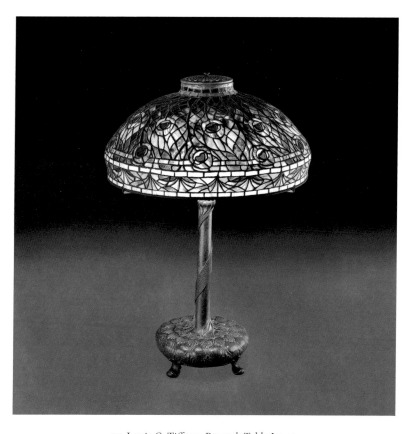

19. Louis C. Tiffany, *Peacock Table Lamp*
Designed by Clara Driscoll, made by
Tiffany Studios, New York, c. 1905
The Montreal Museum of Fine Arts

20. Japanese *kogos* (incense boxes)
17th-19th century
George Clemenceau Collection
The Montreal Museum of Fine Arts

21. Carl Poul Petersen, *Pair of Compotes*, c. 1945-1955
The Montreal Museum of Fine Arts

22.1 George Back
Wilberforce Falls on the Hood River
From sketchbook 1821-1822, Library and Archives Canada

22.2 George Back
Portage La Loche (Methye) between Lac La Loche and the Clearwater River
From sketchbook 1825-26, Library and Archives Canada

23. Installation of exhibition
Cosmos: From Romanticism to Avant-garde
Montreal Museum of Fine Arts, 1999
View of Paterson Ewen's *Gibbous Moon*, 1980,
lent by the National Gallery of Canada

24. Palazzo Grassi, Venice, built in 1770 by architect Giorgio Massari.

his famous iridescent glass was discovered by his chemist; and his sought-after lamps were rumoured to have been designed by talented young women in the firm. Tiffany was expert at public relations, placing himself at the centre of operations and crowing about his creations, but there were others working behind the scenes who were vital to the success of Tiffany Studios. Tiffany's genius was to hire outstanding designers, expert artisans, chemists, modellers and handlers of glass, all under his supervision. The names of these artists never appeared on the products and were rarely mentioned in the firm's promotional material, with the exception of the stained-glass window designers. But later scholarship has tracked down three key figures in the Tiffany network: Clara Driscoll, Joseph Briggs and Arthur J. Nash.

A native of Tallmadge, Ohio, Clara Driscoll started working at the Tiffany Glass and Decorating Company (as it was then called) in 1888 when she was twenty-seven years old. Driscoll's name never appeared publicly, but a single sentence in an article on well-paid working women in the *New York Daily News* in 1904 mentioned that Driscoll had designed the famous Tiffany *Dragonfly* lamp. This caught the scholarly eye of Martin Eidelberg and fellow art historian Nina Gray, who independently tracked down Driscoll's family correspondence. Clara wrote weekly letters to her mother and three sisters back home in Ohio and her surviving correspondence from 1896 to 1907 gives rare insight into life at the Tiffany workshops.

A chatty writer, Driscoll describes the life of a single woman in New York City: visits to the theatre, art galleries, concerts and operas, life in respectable boarding houses, and finding two husbands. A perceptive observer of the cultural and social life around her, for her sisters' amusement she wrote in one letter about meeting the world-famous dancer Loie Fuller: "When dancing she looks like a beautiful fairy spinning and floating in the air, so my amazement was simply unbounded to see that she was a little fat, dumpy, short necked, middle aged woman, with most insignificant and plain little features."[6]

Most intriguingly, Driscoll recounted her six-day workweeks at the Tiffany firm. She was clearly good at her job and when the firm expanded in 1892 Tiffany appointed her supervisor of the newly created Women's Glass Cutting Department. A few surviving photos of Driscoll reveal a modestly dressed, bespectacled young lady in high-necked blouses and long full skirts belted tightly at the waist. Driscoll's department was responsible for the selection and cutting of coloured glass for windows and mosaic decorations. The department quickly grew from six to thirty-five women and was so successful, in fact, that unionized male employees at the Tiffany plant in Corona, Long Island, threatened to strike in 1903 if the women continued to encroach on their work.[7] Louis Tiffany supported the women, and a truce was struck with a promise not to increase the number of female workers in Driscoll's department. Going forward, the women's department focused its attention on the design and production of leaded glass lampshades for the popular range of Tiffany lamps.

In her letters, Driscoll describes artistic triumphs, staff tensions and the challenges of selecting, cutting and assembling hundreds of pieces of glass for each lampshade (which would then be soldered with lead by the men's department). In 1902 she wrote about an incident in her workshop with a glass easel, used for arranging the coloured bits of glass for a lamp's design:

> The wisteria lamps were in an awful rush and the girls were going to work overtime in the afternoon. At three o'clock a most tragic thing happened. The scrubwoman was cleaning the floor under the easel when she suddenly decided to get up. Of course, she took the whole easel with her and immediately the work of four girls for six days was in about nine thousand pieces over the floor in an undistinguishable heap... About six of us fell to work without a word to repair damages. As for the scrubwoman, she looked around in a dazed way for a minute and then calmly went on scrubbing, the only untroubled and care free [sic] person in the room.

It was possible to save most of it but an awful piece of work to find the place of each little piece.[8]

Driscoll was obliged to leave the studios upon her marriage in 1909 (Tiffany employed only single women) but her letters confirm that she designed many of Tiffany's most popular floral lampshades and numerous small bronze luxury objects. She was skilled at conceiving a design for which her assistants would then prepare drawings for Mr. Tiffany's approval on his weekly visits to the department. The two worked in harmony: Driscoll had an instinct for knowing what Tiffany admired, and she was pleased to receive his approbation despite the lack of public recognition.

In one of her letters, Driscoll summed up her experience of life in her adopted city: "The people who come to New York to seek their fortunes! What volumes could be written about them!"[9] She may have had in mind her young assistant Joseph Briggs, a

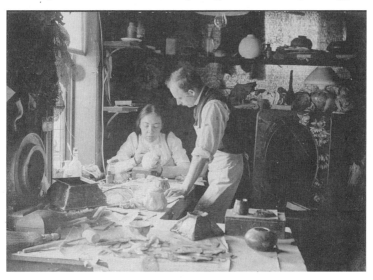

Clara Driscoll in her workroom at Tiffany Studios
with Joseph Briggs, 1901
The Metropolitan Museum of Art, Archive of the American Wing,
New York.

talented artisan like herself who found a home at Tiffany Studios amid the social and political fray of fin-de-siècle New York.

Born among the "dark, satanic mills" of Lancashire, England, Briggs received an education at the local Mechanics Institute. He had an adventurous spirit and sailed for New York at seventeen in search of a different life. By 1893, at twenty years old, he was working at Tiffany's firm.

One of the few men in Driscoll's department, Briggs carried out the heavy physical work in the production of glass mosaic panels. A rare photograph of Clara Driscoll at work with Briggs (whom she called her head workman) was taken in 1901. Although forty years of age, Driscoll looks much younger than her years, as she sits at a worktable in her apron and added sleeves (to protect her blouse) and touches up the plaster model for a small object. Briggs, sleeves rolled up, stands in attendance.

As Briggs' supervisor, Driscoll came to know something about her assistant's personal life, as revealed in her letters home. Briggs had matrimonial troubles. He had married an African-American woman from Virginia named Elizabeth whose ancestors had been slaves—a union that went against all conventions at the time and which he kept secret from the staff at Tiffany's—and the couple had two children. His wife suspected him of carrying on with the female employees and threatened to tell the firm's administrators about their clandestine marriage. A desperate Briggs confided in his boss Driscoll who quickly and confidentially spoke to all concerned and straightened out the matter. Later that year Briggs was conveniently promoted to head a newly created men's glass mosaic department.

A gifted artisan, Briggs became a good administrator and loyal employee, eventually rising in the ranks to oversee the major glass mosaic commissions. By 1922 he had gained Tiffany's respect and friendship to such an extent that the master named him a trustee of the recently established Louis Comfort Tiffany Foundation. When Tiffany Studios filed for bankruptcy in 1932, Tiffany reconstituted the business as Louis C. Tiffany Studios Corporation—with himself as president and Joseph Briggs running operations. Briggs and his

wife eventually had five children and settled into a conventional life in Wood-Ridge, New Jersey.[10] At the end of his long career and before he passed away in 1937, Briggs donated 140 Tiffany works to Accrington, the city of his birth in Lancashire. These glass artworks languished in storage for most of the century before becoming part of the city's Haworth Art Gallery collection and are now displayed as the largest Tiffany collection outside North America.

A less amicable relationship existed between the master and Arthur J. Nash. In about 1891, when Tiffany was planning to build a factory to produce his own hand-blown vessels, he went looking for a supervisor who could experiment with colour patterns and textures in glass. In particular, Tiffany sought to discover the formula for achieving surface iridescence that he saw as a boy at the Metropolitan Museum of Art on samples of ancient glass dug up from archeological sites. On a visit to England, Tiffany met Nash in Stourbridge, a traditional glass-making area. A chemist by training, Nash had already experimented with iridescence while working for two major English glass companies, and he was an able administrator. Tiffany hired him to manage the Corona glass factory when it opened in 1892.

In Tiffany's employ, Nash advanced his research into the chemical makeup of glass to produce exactly what Tiffany had dreamed of, devising the formula for lustrous, iridescent surfaces on glass vessels. Nash's radiant rainbow of colour became a hallmark of the Tiffany Studios. The golden hue was especially popular for table settings of wineglasses, finger bowls and saucers, salt sets and bud vases. Nash's son Leslie, who worked with his father, wrote that the demand for the golden glass was so great that "when it hit the market, it was like a gold rush. You couldn't stop it."[11]

Tiffany, of course, took full credit for these developments. Nash must have chafed at the lack of public recognition for his crucial contribution to the company's success. A photograph of him from 1905 shows the chemist in formal business attire staring with a fixed, defiant look, lustreware vessels all around him, their dazzling iridescence apparent even in a black-and-white image.

Arthur J. Nash, head of Tiffany's glass factory,
c. 1905

There was a dark cloud in this brilliance of gold, however. Nash distrusted Tiffany and never let his master or any other worker see the chemical formulas for his inventions. Tiffany even tried to plant men in Nash's workshop to ferret out the information, to no avail. Nash only revealed his secret to his son Leslie who worked for Tiffany Studios and succeeded his father as head of the blown glass department. But without Tiffany's money, artistry, contacts, marketing savvy and sheer drive, where would Nash, Briggs, Driscoll and their talented colleagues have been? The Tiffany firm was as critical to Nash's work as Nash was critical to its success. What was special about Louis Tiffany's approach was his willingness to let his workers experiment. He delighted in the unexpected, expressive effects produced during long hours of manipulating the hot glass. The Tiffany workmen would blow and twirl the molten gather

of glass on the end of blowpipes, reheating it again and again in the furnace, learning its secrets. Canes of colour would be added to the surface to fuse with the glass in streaky or feathery patterns, which pleased the boss. Or the workmen would let golden glass flow over the sides of a vase in production, crackling and glistening like molten lava from a volcano. Cooled into a bulging shape, the golden highlights of the so-called *Lava* vase revealed a spectrum of iridescent colour upon its textured surface. Despite Tiffany's regular supervision and advice, his craftsmen were on their own in executing the shapes and decoration of vases, bowls and goblets. They let the glass speak for itself, and the glass rewarded them all.

Tiffany in Montreal

The Montreal exhibition on Tiffany glass happened almost by accident. As part of a planned expansion in 2008 the museum purchased an adjacent building, the Erskine and American United Church, which featured a series of exceptional stained-glass windows commissioned between 1897 and 1904 directly from Tiffany Studios in New York. With key financial support from Claire and Marc Bourgie, the Arte Musica Foundation under the direction of Pierre Bourgie, and the Quebec government, the museum acquired the church, transforming the sanctuary into the sublime Bourgie Concert Hall, and added a new pavilion for Canadian art—all connected through underground passageways to the museum's other galleries. As a student, I sang with my school choir by the purple, blue and golden light of the Erskine and American's twenty windows. Little did I realize back then that I would one day become intimately acquainted with every ecclesiastical figure glowing in this Tiffany panorama.[12]

By 2008, with renovations of the deconsecrated church about to begin, it was considered too risky to leave the Tiffany stained glass in situ, so the windows (four large double-light windows and sixteen single-figure ones) were all removed for cleaning and restoration. Museum director Nathalie Bondil saw a unique

opportunity to exhibit the prized windows so they could be viewed up close before they were inserted back into their architectural frames high on the walls of the church. Nathalie came into my office one day to announce her plan. I suggested we collaborate on the project with Tiffany specialists Martin Eidelberg, Professor Emeritus of Art History, Rutgers University, New Jersey, and Alice Cooney Frelinghuysen, Curator of American Decorative Arts at the Metropolitan Museum of Art. Delighted, Nathalie agreed.

A few months later, Frelinghuysen—or Nonnie, as everyone calls her—was mounting a cherry picker in the dark, musty church to examine the windows at close hand. An elegant, lithe woman, Nonnie was not deterred by the mechanical lift or twenty-foot drop. When she reached a disciple's purple robes in the scene of *Christ at Emmaus*, she stopped the lift, pulled out a flashlight and began to examine the textures, colour and thickness of the glass, exclaiming as she touched the deep folds of "drapery glass"— fluid glass gathered and wrinkled before cooling to imitate a soft material (yet another Tiffany innovation). Nonnie was impressed.

In the next three years, I immersed myself in the subject of Tiffany glass, relying on the experienced eye of my two colleagues, and travelled around North America and Europe to select pieces for the exhibition. Two years before the show was to open in Montreal, I found myself at the world-famous State Hermitage Museum in Saint Petersburg, Russia. Under director Guy Cogeval, the Montreal Museum of Fine Arts had lent an exhibition of its contemporary gold and silver jewellery to the Hermitage, and I was sent as a courier to oversee its packing and transport back to Montreal. Tiffany was foremost in my mind, and the visit provided me with a good opportunity to confirm whether the Saint Petersburg museum owned any Tiffany glass.

Set in vast Palace Square, the eighteenth-century building that served the tsars for eighty-five years looks like something out of a fairy tale with its vivid green-painted walls, white window frames, columns with mustard-yellow highlights, and a row of sculptural figures along the parapet. The Hermitage's art collection matches

its grand architecture with masterworks of painting, sculpture and decorative arts from every period and civilization.

Upon arrival at the museum, deputy director, Dr. Tamara Rappe, met me with her assistant Olga Kostiuk who after a brief tour, led me to a small powder-blue room with classical white plaster decoration adorning the walls. There on display in a half-dozen locked cases lay the Montreal museum's treasure trove of sparkling gold and silver jewellery. Olga stated flatly that our job was to wrap up all one hundred and forty pieces. I had not expected this to be part of my courier mission, but there was no conservator to do it, so we began. Each bracelet, necklace, brooch and ring was wrapped first in light tissue, then in a swatch of soft cotton before being placed in large boxes, which would then be locked in a wooden crate for transport back to Canada. As we checked off each object, Olga warned me that in two days a customs official would arrive who, depending on his mood or whim, might ask us to unwrap all the pieces again for examination.

Sure enough, on the appointed day, a youthful officer in military dress turned up. Museum assistants removed the lid from the first box and he started pointing to different small packages, all carefully nestled in individual partitions, layer upon layer, and gesturing for them to be opened. *This is going to take all afternoon*, I thought to myself. When I grumbled to Olga, she gave me a serious look and told me to do as we were told. We unwrapped the jewellery while the officer stood unsmiling and expressionless. After half an hour he seemed to get bored and glanced down at the long paper list in his hand of artists, titles and descriptions of each object. All of a sudden, his eyes lit up when he read the title of a bracelet: *Goldfinger*.

"Pokazhi mne eto!" he exclaimed in Russian. "Show me that one!"

I pulled out the 1969 bracelet by Italian designer Bruno Martinazzi: four white-gold fingertips and a gold thumb joined into a bracelet. Under the curious eye of the custom's officer and museum assistants who had gathered closely around, I removed the bracelet and demonstrated how, around the wrist of a woman, it

Bruno Martinazzi, *Goldfinger* Bracelet, 1969
The Montreal Museum of Fine Arts, Liliane and
David M. Stewart Collection

mimicked the greedy grip of the Bond villain. The customs officer laughed and nodded, and the tension broke. Nothing that followed proved as intriguing as *Goldfinger* and soon after, the young officer's eyes glazing over, the inspection drew to a close. Olga and I rewrapped the inspected items—then I set out to find Tiffany glass in the Hermitage collections.

Louis C. Tiffany's father, Charles, had sold his jewellery to the Russian nobility, and my preliminary research suggested that his son had enjoyed their patronage as well. But I was surprised to learn that the Hermitage possessed a Tiffany window. The curator of stained glass, Yelena Shlikevich, offered to show it to me. When I saw the window—depicting a simple branch of magnolia—I drew in my breath. The luminous, opalescent white blossoms streaked with yellow displayed Tiffany's characteristic drapery glass—thick at the crease, translucent in the depressions—evoking a three-

dimensional effect. Designed by artist Agnes Northrop, one of Tiffany's protégés, the *Magnolia* window was a masterpiece of glass and light that captured the ever-changing effects of nature.

The window had been presented by Tiffany at the Paris International Exhibition of 1900 and purchased directly from the show by Russian banker and manufacturer Baron Alexander Stieglitz for the collection of the Saint Petersburg School of Technical Drawing. There the *Magnolia* window had remained all these years, far from the eyes of American Tiffany specialists.

"Yelena, could we borrow this for the Montreal exhibit?"

"No, I am sorry," she replied. "It is going to Cleveland."

"The Cleveland Museum sent a curator here? When?"

"A few weeks ago."

Darn it, I thought. It would have been a real coup to be the first to bring this exceptional piece to North America.

Disappointed, I pressed on. Shlikevich in turn introduced me to curator Yelena Anisimova, in charge of international glassware, who showed me three hand-blown, early Tiffany pieces. I finally asked her:

"Do you think there were other private collectors in Russia who purchased Tiffany glass?"

"Oh yes," she replied, "Russian nobles very much admired Tiffany's work. Tsar Nicholas II and his wife Alexandra acquired a number of pieces for their private apartments."

This was unexpected news!

"What happened to these items?" I asked.

"They were lost," was her immediate reply, "during the upheavals early in the century."

Anisimova was referring to the 1917 Revolution, when the Bolsheviks took over the royal palaces and murdered the Tsar, his wife and their children, and their possessions were dispersed.

I asked Yelena if she would write an essay on the popularity of Tiffany glass in turn-of-the-century Russia for the exhibition catalogue, as this was a little known aspect of the Tiffany story, and she agreed. [13]

The Hermitage ultimately agreed to lend the *Magnolia* window to the Montreal Museum (the Cleveland show closed before ours opened). The window became a key piece in our exhibit, and when the show travelled to the Musée de Luxembourg, Tiffany's *Magnolia* was on display in Paris for the first time since its launch in that city over one hundred years earlier.

Back in Montreal, the Tiffany church windows were in need of urgent attention. An experienced glass conservation firm in the city, Atelier La Pierre de Lune, directed by Françoise Saliou, was hired to restore the Erskine and American church's Tiffany windows. A daunting project for any conservator, Saliou and her son Thomas Belot handled the laborious task with great skill and enthusiasm under the supervision of the MMFA's head conservator Richard Gagnier. A specialist in glass who trained in Paris, Saliou was familiar with traditional European stained-glass production techniques. But in restoring these windows she was amazed to discover the radical techniques initiated by the Tiffany studios: the variety of textures, the way Tiffany glass reflected hues like an opal, and especially the craftsmen's creation of drapery glass up to four inches thick to give volume to the long robes of the figures. By using drapery glass Tiffany artists were not obliged to paint the shading of a garment in brown pigment on the glass surface (the traditional method of modelling) which affected the translucency of the glass.

As Françoise examined each window, her awe increased. Fractured bits of green glass might be scattered like confetti over clear molten glass to imitate the density and rustling of tree leaves. Elsewhere, the Tiffany technicians had dribbled black gestural lines of glass like an artist's scribble to express movement in branches and leaves. On one visit to her street-corner studio in Montreal's Plateau neighbourhood, an excited Françoise pulled Richard Gagnier and I over to her worktable. "Let me show you this," she said, pointing to some glass fragments on the table. We looked closely at five pieces from a single small section of *Christ, the Good Shepherd* window. Each piece had been cut out in the identical shape, about 56 cm

long by 18 cm high, so they could be superimposed to reproduce the tones of the rising sun on the horizon. Françoise had disassembled the five pieces to clean each individually and now carefully and slowly reassembled them, one on top of the other, explaining how the effect was created. The first piece was clear except for a blue band of horizon and streaks of blurred blue. The second had the same band in mauve. The third bore only the faintest streaks of brown. The fourth had cloudy grey rays emanating from the semicircular outline of the sun—and the fifth piece showed those rays and the orb in brilliant yellow. Five superimposed pieces, in a window of thousands of glass shapes, to capture just the right hue of the sky at sunrise. This was perfection in glass.

After months of restoration, the twenty Montreal windows were ready to dazzle museum visitors. At close quarters, the public were able to admire the ribbed herringbone pattern of an angel's wings, the rippled glass of a running stream, and the chipped lumps or "jewels" of glass inserted into a belt buckle. After the success of the show in Montreal, the lure of Tiffany took the exhibition to Paris and to the Virginia Museum of Fine Arts. Then the Tiffany windows were reinstalled in the church, now transformed into the Bourgie Concert Hall, where the public can see them at a concert almost any day of the week.

A Luminous Acquisition

Not long after the Tiffany show ended, I received an email from Brian Musselwhite, a curator of European decorative arts at the Royal Ontario Museum (ROM) in Toronto. He informed me that Sotheby's auction house in New York wanted to export two Tiffany lamps from Canada, including a large shade with a peacock design, one of Tiffany's most expensive and desirable models. The price for some Tiffany lamps could soar to over half a million dollars in the United States, and Sotheby's Canada had persuaded the Canadian owner that their lamps would fetch the best price in New York. The auction house had applied for a permit from the Canadian Cultural Property Export Review Board to take the lamps out of

the country. Would the museum be interested in acquiring one, asked my colleague? The ROM already had two Tiffany lamps and did not plan to dip into their acquisition budget for another.

A word of explanation. Before the Board grants such export permits, a Canadian museum with relevant expertise is informed of the imminent departure of a heritage artwork, and the museum may delay that export for six months while its experts assess the work's importance for Canada. If the Board grants a delay, a Canadian museum may negotiate to purchase the work. The Montreal Museum of Fine Arts, despite owning a church full of remarkable Tiffany windows, had few other works by the American designer and none of his hallmark lamps. Director Nathalie Bondil enthusiastically supported the idea of examining the lamp for a possible acquisition. On the flight to Sotheby's Canadian office in Toronto, I ticked off significant attributes of the *Peacock* lamp:

DATE: early twentieth century, a high-quality period
 of production for the firm
SHADE: peacock motif, rare, produced by Tiffany for
 only a decade. Wide variation of tones in the glass
 colours.
DESIGNER: attributed to Clara Driscoll
CONDITION: some hairline cracks in a small area of the
 glass shade
BRONZE BASE: expertly wrought in the firm's own
 foundry

As soon as I viewed the illuminated *Peacock* shade, I realized it was exceptional. Clara Driscoll and her "girls" had arranged hundreds of multicoloured pieces of glass to resemble peacock plumes in hues of green, yellow, red, blue and purple—and the vibrant, streaky colours hid the small patch of cracks where the lamp had received a knock. The bronze base decorated with vine tendrils had been designed in 1899 to accommodate electric lighting, replacing heavier bases that held fuel canisters in the days of gas lighting.

Tiffany specialist Martin Eidelberg affirmed the lamp's quality. It deserved to be in a museum collection. Working with curators at the ROM, we urged the delay of the lamp's export permit.

Sotheby's Canada was not pleased and appealed our request. A conference call was arranged between Sotheby's Canada, myself and the Canadian Cultural Property Export Review Board. Quickly, I mustered my arguments. Besides the lamp's obvious aesthetic importance, I had to convince the Board of its significance for Canada. The *Peacock* lamp had belonged to an unnamed Montreal family early in the century (Sotheby's discreetly did not release the name). So, I began researching well-to-do Toronto and Montreal families as proof of Tiffany's reach into Canada. A colleague pointed me in the direction of Sir William Van Horne, president of the Canadian Pacific Railway. Sure enough, an 1898 insurance inventory of Van Horne's Montreal mansion listed four glass tulip vases, eighteen glass finger bowls and matching dishes, an iridescent "Favrile"[14] glass plaque and a gold "Favrile" glass bowl—all commissioned directly from Tiffany.[15] Van Horne, it turned out, was a regular customer on his trips to New York. But like most Tiffany items, these had left the country, bound for auction in the United States in the 1970s and 1980s when prices for Tiffany glass escalated. Cultural losses like this were the main reason the Canadian Cultural Property Export Review Board had been created in the first place.

Tiffany's connection to Canada went deeper. The firm had produced lighting fixtures, mural decorations, mosaics, leaded-glass windows and metalwork for some of Canada's great hotels: the King Edward in Toronto (1903), the Chateau Laurier in Ottawa (1909–12) and Hotel Fort Garry in Winnipeg (1913–14). At the Charles Hosmer Morse Museum in Florida I even found personal photographs Tiffany had taken of Canada's Parliament Buildings in about 1916 while on a visit to Ottawa and a watercolour he made of the Parliamentary Library on a later trip in 1919. Tiffany also travelled to the Canadian West sketching, painting and taking photographs as he went, and he collected Northwest Coast Indigenous artworks.

The Montreal Museum of Fine Arts had repatriated eight of these objects from the Tiffany Estate sale in 1946. It was clear that Louis C. Tiffany had connections with Canada on many fronts. I hoped that the *Peacock* lamp would establish another link.

During the conference call I pleaded my case and David Silcox, representing Sotheby's Canada, pleaded his. To my surprise Silcox brought in by phone from New York James Zemaitis, a Tiffany expert and senior vice-president of 20th-Century Design at Sotheby's. Zemaitis explained to the Board why the lamp was exceptional in Tiffany's production and pointed to its clear Canadian provenance. This played into my hand, and the Board ruled in favour of delaying the export of the lamp, giving the Montreal Museum of Fine Arts time to negotiate a sale directly through Sotheby's Canada.

Sotheby's evaluation was high but not unrealistic and over the following months, devoted friends of the Montreal museum raised the necessary funds. When the lamp was paid for and safely in the possession of the museum, I finally learned the name of the original owner: Mr. and Mrs. Phillips Bathurst Motley of Westmount, Quebec. Acquired in 1906, the "Peacock" lamp was being sold by the estate of their son, Phillips Carey Motley who had died in 2003. To my surprise I recognized the name: Phillips C. Motley had been a well-known organist in Montreal, and as chance would have it, I had gone to elementary school with his daughter Eleanor Motley. Now that the sale with Sotheby's was completed, I was free to speak directly with the sellers. I contacted my old school acquaintance Eleanor who told me that the *Peacock* lamp had belonged to her grandmother Mary Ellen Scott (1879–1958), wife of Phillips B. Motley and daughter of William Scott, a leading art dealer in Montreal for eighty years. From its gallery on Notre Dame Street, William Scott & Sons sold Dutch, French and English paintings to Montreal's top collectors and through their American connections became agents for the Tiffany Studios in Canada. The Scotts had presented an exhibition of Tiffany glass at the Art Association of Montreal (now the MMFA) in 1906, and this lamp may have been among the exhibits.

With the Scott/Motley provenance, everything fell into place. The *Peacock* lamp had returned to Montreal and is now prominently displayed at the Montreal Museum of Fine Arts for the viewing public to admire. The Tiffany network had come full circle.

It Rides along the Highway like a Stream of Air, but Will It Fit into the Museum?

IN 1930S AMERICA, RADICAL CHANGES IN INDUSTRIAL DESIGN produced calculators that looked like diesel engines, Top-O-Stove potato bakers that resembled zeppelins, and Zephyr irons that looked like rocket ships ready for takeoff from the ironing board. With their sweeping lines, rounded corners and gleaming metal, these items evoked fast cars, speeding trains and soaring airplanes. Consumers mired in the Depression embraced this streamlined aesthetic wholeheartedly as a sign of an exciting and hopeful future. Blenders, toasters, weighing scales, hair dryers, electric saws—all manner of household appliances were redesigned to suit the new modernist look. Two hundred such items were presented in the travelling exhibition *American Streamlined Design: The World of Tomorrow.*[1] When the show came to the Montreal Museum of Fine Arts in 2007, I was the Canadian curator in charge of its installation.

There is nothing particularly glamorous about a Thor Silver Line electric saw, a Silvertone Rocket radio, or a Presto Streamlined stapler except their names. In the new millennium, the objects themselves seemed quaint. The exhibition needed a jolt: something big, shiny and eye-catching.

How about an airplane? I thought.

I put in a call to the Canadian Aviation Museum—housed in

a huge airfield hangar on the outskirts of Ottawa—and arranged a visit. Among the bombers and a bush plane with a canoe attached to its side, I spied a shiny aluminum Lockheed 10A Electra. Lockheed had manufactured the twin-engine plane from 1934 to 1941, and this particular one had seen many years of use by Trans-Canada Airlines, the precursor to Air Canada. The company's logo, a red-and-green maple leaf with "TCA" in gold letters in the middle, was painted on the plane's nose. Also, Amelia Earhart had flown a variation of the Electra Model 10 in 1937 on her legendary fatal flight around the world.

Perfect, I thought. A vintage 1930s airplane with a compelling story and a Canadian connection.

But would the Aviation Museum lend it to the show, and would the Electra fit inside the museum? The wing tips could be removed and the Ottawa museum was planning to relocate the plane anyway, according to its curator. Armed with the Electra's exact measurements, I returned to Montreal delighted with my discovery.

Back at the museum, the news from head of installations Paul Tellier was discouraging. Yes, we could remove two panels of a glass exterior wall, dismantle the Electra's wingtips, and fit her length into the museum. But the two huge spherical engines on either side of the airplane's body could not be removed and together were just three feet too wide for the exterior wall. "Pas possible!" said Tellier, shaking his head.

Disappointed but undaunted, I searched for some other object or vehicle that could make a bold visual impression. Flipping through the exhibit's catalogue, I came upon a black-and-white photograph of a cyclist, vigorously pedalling—pulling an Airstream trailer behind him. The motorhome glistened in the sun, all smooth sculptural curves and bright aluminum, and typified modern aerodynamic design. Light enough to be pulled by a bicycle as a publicity stunt, its hand-riveted panels were derived from airplane construction. The trailer rode along the highway "like a stream of air" according to the founder of Airstream Trailers, Wallace Byam, when he introduced his first aluminum Clipper model in 1936.[2] The luxury home on

French world champion cyclist Alfred Letourneur pulling an Airstream Liner trailer on a runway at the Los Angeles Metropolitan Airport, 1947

wheels was produced in great numbers in the post-war 1940s. Fully equipped for dining and sleeping in a compact functional space, it presented modern travel as fun, adventurous, comfortable and cheap. Designed to be resistant to changes in temperature, the post-war series of Airstream Liners were built with outer and inner aluminum shells (Aero-core fibreglass insulation sandwiched between) over a pipe-frame chassis. No screws or nails were used on the body (they loosened with road wear). The Airstream trailer epitomized supreme craftsmanship in industrial design. It was a work of art fit for a museum.

But how to lay my hands on a vintage model in pristine condition? Through the North American Vintage Airstream Club, I found myself talking to Fred Coldwell, its Denver-based historian and the proud owner of a 1948 Wee Wind, one of the smallest models that Airstream produced.[3] The sixteen-foot trailer had all the typical

Airstream features: Air-O-Lite windows, curved entrance door, cast-bronze nameplates. There were no toilet or bathing facilities in this early model but it had a single bed, two chairs, a fold-up Formica-topped table for dining, and a rear double bed/sofa with the original Gruda, California, upholstery. The aluminum and stainless-steel kitchen galley included sink, storage compartments, a three-burner stove and icebox, and even a tiny built-in receptacle for used matches. A wooden closet, a chest of drawers and a butane heater with cast-iron front grille completed the trailer. Fred had lovingly preserved his Airstream, which he called Ruby after its original owner, and he offered to drive her from Colorado to Montreal for the show.

Perfect, I thought.

But as the months passed, Fred had second thoughts about taking Ruby on the road. Less than two weeks before the show was set to begin, he emailed to say that he was not up to making the four-day trip to Montreal and back. I couldn't blame him—but he *had* left me in the lurch.

I put in a frantic call to Airstream's vintage-model shop in Jackson Center, Ohio.

"Would you have a trailer from the 1940s that you could lend to an exhibition in Montreal?" I asked.

"Hm, when is your show?" said the communications director, Rick March.

"In two weeks!" I replied.

"I think we might have one, let me check," replied Rick.

Several long minutes later, he returned.

"Okay, ah… we've got a 1948 Airstream Liner, twenty-four feet long—"

"I'll take it!" I said quickly.

"—but the interior's gutted," he continued, "and I can't in good conscience let you exhibit an unfurnished shell."

"We'll lock the door," I said.

"Well, okay, but there are windows—I don't want anyone to see the inside."

"We'll make curtains and cover the windows," I said.

"Curtains? Hmm… I don't know…"

After much coaxing, Rick agreed. Airstream Inc. saved the show. With no time to shop for vintage 1940s printed textiles, museum conservator Estelle Richard began sewing off-white linen curtains to hang inside every window.

Six days before the *vernissage*, the 1948 Airstream Liner arrived in Montreal from Ohio. With all hands on deck, the trailer was unloaded from the transport truck to street level. Part of the museum's side-entrance glass wall had been removed in advance and our carpenters had built a wooden ramp to wheel the trailer inside. But as the museum's technicians pushed it up the ramp, they stopped and groaned. It was too high for the opening! The culprit was a small chimney sticking out from the top of the roof. The height measurements we received had not included this unassuming appendage. But when I looked back at photographs of the trailer, its top air-vents closing flush with the roofline, there was the chimney, but hardly visible.

The Airstream representative and the museum's technicians stood around scratching their heads. Measurements down to the last millimetre were checked. The removal of the chimney was debated. The clock was ticking. Finally, some clever fellow suggested deflating the tires. More measurements were taken and the tires were slightly deflated. Inch by inch, the aluminum shell was guided through the open wall and rolled into the museum galleries.

"Ça y est!" exclaimed the technicians. "That's it!"

On the street, a crowd of passers-by clapped and cheered.

When the exhibition opened, the trailer looked spectacular. It filled the space like an outsized modernist sculpture and formed an arresting backdrop to the power tools, electric fans and outboard motors.

Little did visitors know how bumpy the ride had been— anything but a smooth stream of air.

[CHAPTER TWELVE]

"A Monsieur Clemenceau Is Asking for You"

At 11:00 one July morning in 2000, I received a call in my office from the museum's receptionist.

"A Monsieur Clemenceau is asking for you."

My thoughts turned immediately to Georges Clemenceau, the famous French statesman who had led France during the First World War. Could this man be a relative?

"What does he want?" I replied rather abruptly (I was in the middle of preparing a report, and preferred not to be disturbed).

"He wants to see some objects in the Asian collection," said the receptionist.

"All right, I'm coming down," I said.

A few minutes later I was shaking hands with Georges P. Clemenceau, who indeed turned out to be the great-grandson of Georges Clemenceau—*Père la Victoire* as his countrymen called him after leading them to victory during the Great War. It was July and the present-day Clemenceau, dressed in striped T-shirt and espadrilles, asked to see the Japanese *kogos* collected by his namesake.

"Well, the museum always keeps a few kogos on display in the exhibition galleries. We can look at those, and some others in the back... but maybe not all of them," I said.

"Why not?" asked Mr. Clemenceau.

"It's a large collection; the majority are in the reserves."

"How large?"

"Three thousand," I said.

Kogos, usually made of ceramic, are small covered jars for holding incense. Some are simple pots with spare lines, and some are shaped into animal and plant forms or even tiny figures. The museum had acquired its collection in 1960 as a donation from Canadian shipping magnate, Joseph A. Simard, but they had formerly belonged to Georges Clemenceau. Visitors are not normally allowed to look around collections in storage, but as Senior Curator of Decorative Arts, I was happy to show these to my unusual guest, hoping that he might know more of the story of how these kogos landed in Canada. What was the connection between the legendary French politician, these Japanese-crafted pots and a Canadian shipbuilder?

Georges Benjamin Clemenceau (1841–1929) is an alluring figure of French history who lived each day with single-minded, untiring energy well into his eighties. Raised in the Loire countryside, he trained as a doctor but spent most of his youth writing radical political journalism and founding newspapers and literary magazines. From 1865 to 1869, to escape government persecution, Clemenceau left France and spent four happy years in the United States where he served as a correspondent for *Le Temps* and taught French in a Connecticut girls' school. In his last year there he married an American, Mary Plummer, with whom he had three children. Returning to Paris with his young family after a regime change, he became mayor of the 18th arrondissement (which included Montmartre), and his life as a politician began. Serving as a member of the Chambre des Députés for seventeen years, from 1876 to 1893, Clemenceau was at the centre of political life in France, where his forceful intellect and eloquence earned him a reputation as a fierce critic—the kind who could cause a minister to resign.

Clemenceau's rises and falls in his political career were mercurial, and many biographies have been written on his life. As Wyeth Williams relates in his book *The Tiger of France: Conversations with Clemenceau* (1949), Clemenceau had few real friends, failed at creating a

Georges Clemenceau at his writing desk in his study,
Franklin street, Paris, c. 1906
Musée Clemenceau, Paris

domestic home life (he and his wife were divorced after seven years) and on his own admission was more successful out of power than when he held it. After he lost his seat as a *député* in 1893, he became embroiled in the Dreyfus Affair, eventually publishing in 1898 Émile Zola's famous open letter headlined "J'Accuse…!" in *L'Aurore*, yet another newspaper he founded. Back in politics in 1902 as a senator, he became prime minister of France in 1906, only to be thrown out after three years. Clemenceau returned to his journalist's office in the lead-up to the First World War, earning the nickname *le Tigre* (the Tiger) for the way he struck at his opponents with wit, sarcasm and ferocity.

The Tiger reached his political zenith in the middle of the Great War, at the moment France wavered on the verge of defeat. In November 1917, with one French leader after another having failed to push back the Germans, the desperate president of France, Raymond Poincaré, reluctantly turned to the seventy-six-year-old Clemenceau

and asked him to form a government as Président du Conseil and Ministère de la Guerre. Winston Churchill, a young British minister of Munitions at the time, gave a melodramatic account of Clemenceau's address to the Chambre des Députés, setting out his program for battling Germany and rejecting all talk of defeat:

> The Tiger ranged from one side of the tribune to another, without a note or book of reference or scrap of paper, roaring out sharp, staccato sentences as the thoughts broke upon his mind. He looked like a wild animal pacing to and fro behind bars, growling and glaring... The last desperate stroke had to be played. France had resolved to unbar the cage and let her Tiger loose upon all foes, beyond the trenches or in her midst.[1]

After victory had been won, Clemenceau served as chairman of the 1919 Paris Peace Conference. Historian Margaret MacMillan, in her book *Paris 1919: Six Months That Changed the World*, relishes describing the clash of personalities among the allies, opponents and their assistants.[2] Arguments flared, petty comments flew and wily tactics were employed by all as the politicians manoeuvred and made deals. At the centre of the tumult stood Clemenceau, who, despite his worsening health, worked the hours of a young man, moved by his patriotism for France and his unrelenting suspicion of Germany. William Orpen's painting *The Signing of Peace in the Hall of Mirrors, Versailles, 28th June 1919* places Clemenceau at full centre of the crowd of dignitaries, with American president Woodrow Wilson to his right and English prime minister David Lloyd George to his left.[3] As international statesmen crowd around the three, the German representative huddles in a chair with his back to the viewer, the sole member on the other side of the table.

Despite being celebrated as *Père la Victoire*, Clemenceau was stunned when his candidature for the post-war presidency was rejected by France's National Assembly in January 1920. Nearing his eightieth year, he licked his wounds and set off around the world, first

to Egypt and Sudan in 1920, then Indonesia, Singapore, Malaysia, India, Ceylon and America in 1922. Everywhere he went, plaques were dedicated to him and roads named in his honour, in thanks for his wartime leadership and peacetime negotiations. In 1929, after penning a half-dozen more books and burning all his personal letters, this giant of French history passed away.

Throughout Clemenceau's public career as a journalist and political leader, he led a parallel, equally vigorous private life as an art collector. Biographies of Clemenceau tend to mention his private collection only in passing, and despite the remarkable quantity and quality of his collection—which included hundreds of lacquerwares, *netsukes*, books, ceramics, paintings, drawings, masks, bronzes, prints and kogos—Clemenceau himself wrote little of his admiration for Asian art.

In the Montreal museum's storage vault, Georges P. Clemenceau gaped in wonder as I showed him the many kogos his forebear collected, all arranged neatly in drawers and nestled in white tissue paper: herons, turtles, flower blossoms, painted fans, fat Buddhas, kimono-clad ladies—and of course a tiger, his great-grandfather's namesake. A seated crab, the vivid blue glaze pooled around its legs like water, caught my visitor's eye, as did two mice perched on top of a large brown chestnut, and a coiled snake, ready to strike.

As we were examining the humour and invention of each kogo, many questions came to mind.

"Why do you think your great-grandfather collected so many kogos?" I asked.

"I'm not sure," Georges replied, examining a small white crane with a black bill, "and it amazes me that during his busy public life he had time to build up such a collection."

I picked up a portly deity with a high, bald head. "Perhaps he was charmed by their individuality," I said.

Georges nodded in agreement.

Two recent exhibition catalogues about Clemenceau's art collecting and social ties with French artists are, however, changing the picture

of the man: *Clemenceau et les artistes modernes: Manet, Monet, Rodin...* (2013) and *Clemenceau, le Tigre et l'Asie* (2014).[4] These books reveal his involvement in art, literature and theatre—and his contacts with famous artists who portrayed the equally famous politician in sculpture, on canvas and in photographs and drawings. Also highlighted is Clemenceau's enchantment with Asian culture and especially the art of Japan, a country he surprisingly never visited. In *Clemenceau, le Tigre et l'Asie*, almost every author singles out Clemenceau's extensive collection of kogos as unique for the time.

Kogos were used during the Japanese tea ceremony to hold the incense that was thrown on the fire to perfume the air. No larger than two by four inches, each one is unique, varying in medium, colour and form. Some kogos were created by unknown rural artisans, others by famous potters like Nonomura Ninsei (active c. 1646-94) and Ogata Kenzan (1663-1743), both of Kyoto, a major centre of kogo production. With the distinctive mark of each craftsmen impressed in the clay's underside, Clemenceau's vast collection can be traced back to over one hundred kilns across Japan, most dating from the early nineteenth century, the peak period of kogo production.

The charm of Clemenceau's kogos lies in their great variety of subject. The rough earthenwares from the early seventeenth century were simple pots of clay pinched and pulled intentionally to create an irregular shape, reflecting the Japanese admiration for imperfection in design. Later models depicting plants, animals or human figures were either crafted in simple stoneware and covered with a tinted lead glaze or were made of white porcelain painted with colourful decorative motifs.

In an article Clemenceau once wrote of a visit to a potter's studio, he revealed his sensitivity to the artisan's medium of expression:

> I spent many hours in that strange workshop, watching in wide-eyed silence ... and I learned to appreciate the malleable clay, which the Japanese potter fashioned and shaped without a wheel, until, with a delicate finger, he left on it the subtlest impression of his passing touch, his passion, his life.[5]

A close study of nature was central to Japanese design, and the kogo potters caught nature's spirals, zig-zags, blotches and blemishes in these unpretentious little pots. Clemenceau clearly admired the Japanese attention to the smallest details of animal life: the turn of the head in a tiny quail, the spotted shell of a turtle, a lowly slug slithering over a mollusc, a small spider amid the lines of its web. Double gourds, fruiting sprigs, chrysanthemums, Mount Fuji's cone-shaped summit—such typically Japanese motifs enchanted Clemenceau and probably took his mind off the stress of politics.

As an art collector, Clemenceau was inspired by the wave of *Japonisme* that swept France after Japan opened up trade to the West around 1868, during the Meiji period. In this craze for all things Japanese, Europeans began buying lacquerwares, porcelains, bronze work, ceramics, ivory netsukes and fine silks. Not only applied art, but also the inexpensive Japanese wood-block prints were sought after by collectors as well as French painters such as Manet, Degas and Monet, who were attracted by the flatness of perspective and expression of nature in these prints.

Clemenceau began collecting Asian art in the late 1870s after striking up a friendship at the Sorbonne with a cultured Japanese aristocrat from Kyoto, Saionji Kinmochi. (The two kept in touch after Kinmochi returned to Japan to enter politics, and incredibly, Kinmochi served as prime minister of Japan (1906–1908) during the same years that Clemenceau was prime minister of France (1906–1909.)[6] As his political life grew busier, Clemenceau also relied on friends such as the French consul François-Frédérik Steenackers, who lived for many years in Japan, to provide advice and make purchases for him.[7]

When Clemenceau was amassing his treasures in the late nineteenth century, kogos were not considered as desirable as Japanese ivory netsukes or lacquerwares, but Clemenceau, who prided himself on being a man of the people, seems to have been attracted by the simplicity of the handcrafted kogo. The frank directness of these functional clay objects matched his personality.

Clemenceau undertook his collecting in parallel with his political duties. As proof of this, I discovered in the Montreal Museum

of Fine Arts' archives handwritten lists of kogos, some penned in what seemed to be Clemenceau's handwriting, on pages of printed letterhead: "Chambre des Députés / Paris le _ 188_" or "189_." It was intriguing to read down the list of kogos with notes hastily scribbled beside a catalogue number: *coquillage doré décor pagoda, fleur de cerisier, cygne,* or simply *cylindrique.* I imagined Clemenceau in the privacy of his office after a day of speeches, studying each small pot, which fit neatly in the hand.

As his collections grew, Clemenceau entered the network of Paris dealers, collectors and museum directors who shared his admiration of Japanese and Chinese art. He even helped to establish two Paris museums dedicated to Asian art: the Musée Guimet, set up by friend and fellow collector Émile Guimet in 1889, and the Musée Ennery, established by Mme. Clémence Ennery who, encouraged by Clemenceau, left her home and impressive collection of Asian art to the French state upon her death.[8] In 1908 Clemenceau transferred his collection of kogos from the Musée Guimet, where they had been deposited since 1895, to the newly opened Musée Ennery.

Clemenceau also shared his passion for Japanese art and his love of nature with close friend and Impressionist master Claude Monet. Monet collected Japanese wood-block prints and no doubt encouraged Clemenceau's interest in this medium to the point where the politician's collection quickly surpassed the painter's in range and quality. Clemenceau bought a weekend retreat in Bernouville, Normandy, only twenty miles from Monet's residence, and enjoyed visiting the painter's garden at Giverny. Vintage photographs show the two men strolling across the Japanese bridge spanning the water-lily pond, the subject of so many of Monet's paintings.

After twenty years, Clemenceau's collection of Asian art, especially the Japanese prints, ranked among the most significant in France. But in September 1893 he lost his seat as the Député du Var after being tarred by his enemies in the Panama corruption scandal. At the same time, he was going through a divorce from his wife, who needed support for their three children. Financially squeezed, he wrote to a friend, "I am buried in debt, and I have

nothing left, nothing, nothing."[9] He was forced to sell at auction the bulk of his Asian collection. The largest lot consisted of 2,880 Japanese prints, many of which landed in museum collections. He kept his collection of kogos, however, possibly because they were of less value for collectors but more likely because he had a special attachment to them. At this low point in his life, he moved into a modest apartment on rue Benjamin Franklin, now the Musée Georges Clemenceau, where four or five kogos were always kept on his writing desk.

In 1976, in the Montreal Museum of Fine Arts reserve facilities, Clemenceau's kogos were discovered by Yutaka Mino, a Harvard graduate from Japan hired as associate curator of Asian art. The dusty cardboard boxes, incorrectly labelled "KOJO," had sat unopened for sixteen years until Mino opened one by chance and found "a great variety of beautiful incense boxes. I cannot find words to express the surprise I felt at that moment." He immediately set to work unpacking and studying the whole collection and organized an exhibition of the kogos in 1978.[10] When a small selection travelled to Japan, the curator of the National Musem of Tokyo, Seizō Hayashiya, stated that there was no comparable collection of kogos in all Japan.

But how had Clemenceau's kogos arrived in Montreal? Museum records revealed they had been donated by Montreal businessman Joseph-Arthur Simard in 1960. Who was Simard, and how did he come to possess them?

A native of Baie-Saint-Paul in the Charlevoix region of Quebec, Joseph Simard (1888–1963) was the son of a ship captain and spent his youth working on passenger ships before finding employment with the Sorel Light, Heat and Power Company. With a sharp eye for opportunity, Simard purchased a small shipyard in 1917 that specialized in dredging and ship repair. Over the next twenty years, he continued to acquire small businesses relating to foundry work, shipbuilding and towing in Sorel, a small town on the St. Lawrence River downstream from Montreal. In 1937 when the federal government decided to sell an underused shipyard at St-Joseph-de-Sorel,

The three brothers, Ludger, Joseph and Edouard Simard, standing on
the keel plate of a cargo vessel, Marine Industries, Sorel, Quebec,
January 16, 1942
Archives of the Société historique Pierre-de-Saurel

Simard and his two younger brothers, Édouard and Ludger, scooped
it up and unified their business operations under the name Marine
Industries Limited, with Joseph as president. The company built
small tankers, large tugboats and the first all-welded steel ship in
Canada, and quickly became one of the country's most important
shipbuilding companies.[11] At the outbreak of World War II in
September 1939, Marine Industries Limited was pushed to full capac-
ity, and grew to 7,000 shift workers going twenty-four hours a day
building minesweepers, corvettes and freighters for Canada's allies.[12]

When Great Britain encouraged Canadian industry to consider
producing armaments for the war, Simard established Sorel Indus-
tries Limited for the manufacture of munitions, specifically the
cannons known as "twenty-five pounders." To increase the com-
pany's technical capabilities, Simard sought the help of Eugène
Schneider, the head of the giant French metalworks Schneider-
Creusot and one of Europe's biggest arms dealers. Schneider agreed

to send engineers and technicians to Sorel to help the Simards start up production.[13]

Schneider, like Clemenceau, was immersed in French politics and journalism alongside his business interests, and he sat in the Chambre des Députés from 1898 to 1910, including the years when Clemenceau served as prime minister of France from 1906 to 1909. Schneider acted as head of the French mission to the international trade conference of the Allies in Atlantic City, New Jersey, in October 1919, under Clemenceau's presidency. The two men no doubt knew each other, and, as it turned out, Schneider must have been on friendly terms with the Clemenceau family.[14]

When Clemenceau died in 1929, his collection of kogos was passed on to his son, Michel, who withdrew them from the Musée Ennery where they had been on loan. Ten years later, in an unexpected turn of events, the kogos were purchased from the Clemenceau family by Joseph Simard and shipped off to Canada. A 1977 letter from Simard's son Léon to the Montreal Museum of Fine Arts sheds some light on Simard's surprising acquisition:

> On one of his trips to Europe, in 1938 or 1939, my father met Mr. Eugène Schneider with whom we were involved in gun manufacturing for Great Britain. Mr. Schneider had mentioned then, that the son of Mr. Clemenceau was in need of money, but in return, would be ready to dispose of the Kogo's [sic] collection, which his father had acquired.[15]

Joseph Simard's purchase of the Clemenceau kogos appears to have been motivated by business interests. In an interview with Léon Simard (before he died in 2015), he confirmed that while his father was negotiating the sale of corvette warships to France, Schneider had suggested that buying the kogo collection from the Clemenceau family might improve Simard's chance of a sale.[16] It is unclear how this turned out, but Marine Industries did supply at least seven corvettes for Canada and Great Britain in 1940.[17]

Simard admired Western painting rather than Asian art, but he may have fallen for the charm of the small kogos and been

impressed that they had once belonged to the president of France. Once transported to Montreal, however, the little pots remained in crates at Morgan Storage & Van Lines for twenty years, until coming to the attention of F. Cleveland Morgan, whose family owned the storage company. Morgan was a collector of Asian applied arts and prints and an active member of the Art Association of Montreal (forerunner of the Montreal Museum of Fine Arts). He established its decorative arts collection in 1916 and encouraged the acquisition of Asian objects as good examples of international design. Morgan persuaded Simard to give the kogos to the museum for its centennial anniversary in 1960.

Not until the spring of 2014 did a selection of Clemenceau's kogos return to France and to their one-time home, the Musée national des arts asiatiques-Guimet, when it mounted the exhibition *Clemenceau: Le Tigre et l'Asie*, presenting the face behind the political oratory and newspaper headlines. I made a special point of going to see the show in Paris at the Musée Guimet on Place de l'Iéna, where Georges Clemenceau had been a frequent visitor. A group of five hundred kogos from the Montreal Museum of Fine Arts were lined up like soldiers on a table: grey stonewares, blue and white porcelains and roughly textured earthenwares—the herons, the chrysanthemums, the gourds and, of course, "le tigre." It was probably a surprise for French visitors to discover the extent of the Clemenceau kogo collection, which had been hidden away for so long.

Sixty years after Joseph Simard's purchase, Georges Clemenceau's great-grandson was on the museum's doorstep, asking to see what his family had given up. He told me that France, and especially the Musée Guimet, the country's major depository of Asian art, would have liked to keep the Clemenceau kogo collection. But timing was everything in the sequence of events. In about 1939, when Simard purchased the lot, Clemenceau had been dead for ten years, war was imminent and France's attention was on Germany, not on the art collection of its illustrious former statesman. In addition, the lowly ceramic pots were not considered of high value, so the French government did not prevent their export.

"Do you think the kogos could be returned to France?" Georges P. Clemenceau asked me, as he left the museum.

It was an inevitable question. Family descendants often come to regret the decisions of their forebears.

"I doubt it," I said, shaking my head. "The museum cherishes these unique incense boxes, and our visitors love them. They are a vital part of the Asian art collection."

Thanks to le Tigre, and the Clemenceau and Simard families, the kogos travel the world, living in the public eye for other generations to admire. To me, their Canadian home seems fitting—halfway between their humble Japanese makers and their unforgettable French collector.

Commission of a Lifetime:
C.P. Petersen and the Stanley Cup

IN 1892, WHEN GOVERNOR GENERAL LORD STANLEY DONATED A silver cup bearing his name to the best amateur hockey team in Canada, he could hardly have imagined the competitiveness, suspense and magic that his gift would one day engender. Over the past century the Stanley Cup has become the Holy Grail of hockey, bestowing lifelong recognition on the best team in the National Hockey League at the end of a long winter season. Hockey fans are used to seeing triumphant players pass the cup around: each player skates around the ice rink, the massive, sparkling silver cup hoisted high above his shoulders, often crying with elation at the attainment of hockey's ultimate prize.

And the trophy doesn't rest. When the season is finished, it begins an epic journey across North America to the hometowns of every member of the victorious team, who gets to possess the cup for one day during the off-season. Now that NHL teams have increased the European talents on their rosters, the cup travels regularly to places in Russia, Scandinavia, Switzerland and the Czech Republic. A couple of years ago, I had an opportunity to meet Brad May, a veteran player who had won the cup with the Anaheim Ducks in 2007. I asked him what he did when it was his turn to possess it for a day.

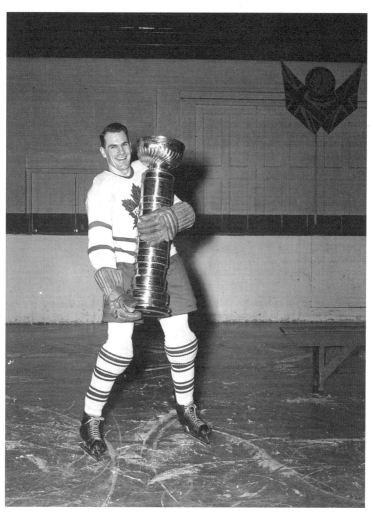

Syl Apps of the Toronto Maple Leafs, holding the
"stove-pipe" Stanley cup, 1942
Imperial Oil-Turofsky/Hockey Hall of Fame, Toronto

"You pack everything into your time with the cup," he told me. "I took it to my grandmother's house and to her church, to the summer cottage, to my old summer camp."

"I suppose you took a drink from it," I said.

"For sure," said May. "Everything has been inside the Stanley Cup bowl: champagne, breakfast Cheerios, ice-cream sundaes, rye, beer and I won't tell you what else. Babies have even been baptized in it." The cup has been thrown off bridges, strapped onto the back of motorbikes and tossed into swimming pools.

The original Stanley Cup was produced in Sheffield, England, and was basically a large punch bowl. Each year the names of winning players and teams were engraved on it, and over the years a small and unwieldy base was added to accommodate more names. But this created a problem: as more names were added, the base grew and grew, and the trophy started to change shape. By the 1940s it resembled a stovepipe, as one journalist coined it. If that weren't enough, after decades of being bashed around by elated victors, the punch bowl was starting to show its age. Something had to be done.

In 1962, NHL president Clarence Campbell commissioned a replica of the trophy, retired the original to the safety of the Hockey Hall of Fame, and turned to respected Montreal silversmith Carl Poul Petersen to create a new "presentation" Stanley Cup.

The worlds of professional sport and art museums rarely intersect, but C.P. Petersen sits at one such crossroads. In 2001, I was approached by art historian Gloria Lesser with a proposal for an exhibition on Petersen. I embraced the idea. Petersen's silverwares were unique for their time in Canada, and the price of his silver in antique stores and auction houses was rising. Also, the Montreal Museum of Fine Arts was beginning to receive donations of his silver pieces as worthy examples of modern Canadian design. Museum director Guy Cogeval was open to the idea, especially as the majority of works could be borrowed from lenders in Montreal and Toronto, conveniently reducing transportation expenses. Exhibition space and dates were reserved for a two-month show. As proud owners of Petersen silver agreed to lend us his wares, I wanted to know more about Petersen himself. What was his story?

In 1929, at the age of thirty-four, Carl Poul Petersen left his native Copenhagen and landed in Montreal. With North America in the grip of the Depression, setting up a workshop proved difficult, so Petersen found a job with Henry Birks and Sons, the leading Canadian jewellery and silver retailer. The Birks store on Phillips Square in Montreal still exists today, although it is no longer run by the Birks family. When Petersen worked there it was considered the Tiffany's of Canada, right down to the turquoise-blue boxes showcasing gifts of fine jewellery or silver. Well-heeled Montreal families patronized the decorative, columned showrooms, buying imported and locally made silverwares, porcelain dinner sets, fine leather and diamond engagement rings.

Birks welcomed Petersen because of his Danish training in traditional silver techniques. Petersen claimed to have apprenticed with the celebrated Copenhagen silversmith and designer Georg Jensen, whose works sold well in London, Paris and New York.[1] Jensen had won a Grand Prix at the Paris exhibition of 1925, and Scandinavian design (especially silver) had begun to attract attention for its simple, modern style.

Petersen's big opportunity came in the late 1930s when he was asked to create a silver tea and coffee service for Samuel Bronfman, owner of Seagram, the world's largest distilling firm, and one of the wealthiest men in Canada. The story goes that when Sam and wife Saidye built a large bar in their Westmount home, one of their employees, who happened to be Danish, suggested his friend Carl Petersen make the silver for the cocktail bar.[2] This led to the Bronfmans' request for the tea and coffee service, which included cream jug, sugar bowl, sugar tongs, hot-water kettle and a large silver tray, together with an impressive samovar for heating water.

When the Bronfmans entertained in their palatial home overlooking the St. Lawrence River, Petersen's tea and coffee set graced the table and was greatly admired by their guests. It did not take long for the silversmith's reputation to spread, and he was soon receiving commissions from the Bronfmans' friends. As a result, Petersen was able to open a workshop under his own name on McGill College

Street in 1939. During World War II silver and many other types of metal were in short supply, so Petersen contributed his skills to the Canadian war effort by making aluminum and brass mesh filters for Canadian fighter planes. After the war, the demand for Petersen's handcrafted silver returned, growing beyond Montreal into the lucrative American market. He opened a new workshop and showroom in a handsome stone townhouse at 1221 Mackay Street, registering his company as C.P. Petersen & Sons Ltd. in 1946.

Petersen had found his niche: a contemporary European alternative to Birks' conservative English and French revival designs. Petersen also sold his Jensen-inspired silverware at much lower prices than the competition. He became recognized for the distinctive Scandinavian-style designs of his dinner services, candlesticks, bowls and silver flatware with names like Dolphin, Viking and Corn, set off with decorative silver berries—a signature motif.

Customers enjoyed visiting the Mackay Street showroom, speaking with the silversmith, and placing orders directly with him or his wife, Inger. The rusticated red stone residence at 1221 Mackay is still standing, a small miracle in an area of downtown Montreal that has been ravaged by demolition and neglect. A 1947 article in the Montreal weekly paper *The Standard* shows the silversmith's workshop in a large room on the main floor.[3] In the photo, five men and one woman sit around several worktables all wedged together. They concentrate on their work amidst half-finished silver bowls, trays, small cups, bottles, brushes, tools and scraps of metal littering the tables. Petersen, wearing a vest, is part of the group along with his three sons John Paul, Arno and Ole. Petersen's wife stands close by, checking off a list. Clearly the shop was a family operation.

Another photograph shows a close-up of the one woman silversmith in the Petersen workshop, holding a small hammer as she delicately shapes the pin for a circular brooch. I wondered who she was—and after a little sleuthing I managed to track her down. Audrey Renault Riddell worked for Petersen for thirteen years, 1944-1957 (she stopped when she got married, common practice

C. P. Petersen & Sons workshop, showroom and residence
at 1221 (now 1223) Mackay Street, Montreal

at the time). She came to my office one day to chat about her years as the main jewellery maker at the Petersen firm. During our conversation Mrs. Riddell described in some detail the layout of the silver workshops in the Mackay Street house. The showroom and main workshop were on the first floor but noisy; heavy work took place in the basement on large machines for stamping, hammering and polishing. A smaller workspace for refurbishing and repairs was located on the second floor, and the top floor was the living quarters of the Petersen family. Riddell told me she had enjoyed making jewellery (the brooches were especially popular) but recalled the cramped quarters, chemical fumes, dusty air and the constant din of hammering, filing and soldering. She said Petersen was a demanding boss who ran a tight ship and kept his three sons under his thumb.

Interior of Petersen workshop, 1947
Courtesy of The Montreal Museum of Fine Arts

The commission of a lifetime landed in Petersen's lap in the 1940s when the National Hockey League tapped him as its official silversmith and when Clarence Campbell asked him to create a presentation copy of the Stanley Cup. For this prestigious assignment, Petersen not only designed a wider diameter for the base, he gave its bands their tiered shape to make the cup more aesthetically pleasing and more impressive as a trophy. He also proposed an ingenious system of removable bands, solving the "stovepipe" problem. As new champions accumulate, a new silver band replaces an old one that is removed and put on display in the Hockey Hall of Fame. The names change, but the Stanley Cup is eternal.

The NHL commission, which included the creation of new hockey awards handed out annually, was a great boon to the financial stability of C.P. Petersen & Sons, assuring its survival long after customers stopped paying top dollar for handcrafted silver tableware. Every year the Petersen firm was kept busy engraving names of new players, managers and owners on the cup's base.

Letters had to be individually hand-stamped. There are some high-profile mistakes: Hall of Fame goaltender Jacques Plante's name, for example, is spelled five different ways each year the Canadiens won the trophy between 1956 and 1961. And in 1962–1963 the cup was won by the "Toronto Maple Leaes," who lost the "f" from their name in the Petersen workshop.

As the Petersen exhibition approached, I realized the show needed a boost, something with more pizzazz than small, functional silver objects. *Why not include the Stanley Cup?* I thought. The Danish silversmith had been part of its history.

Thus began my entry into the corridors of the hockey world. When I contemplated borrowing the famous cup for the museum's show, despite being a hockey fan, I hadn't the faintest idea that this cherished artefact had a life of its own. My ignorance was understandable: the Montreal Museum routinely borrowed masterpieces by artists like Monet, Van Gogh and Gauguin worth many millions of dollars for months at a time. Why should the loan of the Stanley Cup be a challenge?

My loan inquiries focused on the NHL until I learned the league does not actually own the cup. Lord Stanley appointed trustees to be its legal guardians, an arrangement that continues to this day (although control of the cup was granted to the NHL in a negotiated agreement in 1947). My quest finally led me to Phil Pritchard, the "keeper" of the Stanley Cup at his office in the Hockey Hall of Fame, in Toronto. I reached him by telephone and blithely asked if he would lend the treasured cup for the two-month duration of the museum's Petersen show. Pritchard responded as if I had asked to borrow Michelangelo's *David*.

"A two-month loan is out of the question," he said bluntly.

"Oh, that's a shame," I said, imagining the cup sitting in storage for most of the year. "Does the Hockey Hall of Fame need it that badly?"

"The cup is on the move around the country almost every day."

"Oh. Really? Where does it go?" I asked.

"The cup travels to community events, hockey arenas, schools, hospitals, the towns of winning players…"

"I hadn't realized!"

"Yes. The cup is like a politician in election mode."

Such is its prestige, the Stanley Cup travels first class, gently coddled in its special blue blanket and a custom-made carrying case. Pritchard and others are its dutiful chaperones on the road, and never let it out of their sight. It is allowed little rest. How could I be so impertinent as to ask to borrow it for *two months*?

"All right," I countered, "How about two weeks?"

"I don't think you understand," said Pritchard.

"The Montreal Museum of Fine Arts will construct a special sealed glass display case for it," I said. "We will pay for all transport and insurance while it is in our care. It will have twenty-four-hour security."

Pritchard was silent, so I kept going:

"There will be a lot of publicity around its display," I concluded somewhat weakly, realizing that increased publicity for the cup was not one of Pritchard's key concerns.

"I'll see what I can do," he said with a sigh. "But I can't promise anything."

When we ended our call, I was not optimistic about my chances: a museum show was clearly no match for delirious hockey fans. So, after sending off a formal letter signed by the museum's director— our loan request having dwindled to a mere three days—I travelled to Toronto to meet Phil Pritchard face to face, to see if I could be more persuasive.

The Hockey Hall of Fame is housed in a converted historic bank building on the corner of Yonge and Front Streets. Before my meeting, I entered its exhibition halls, full of hockey uniforms and gleaming trophies, and found the original Stanley Cup prominently displayed. By now, there are actually three Stanley Cups: Lord Stanley's 1892 original, with the name "Dominion Hockey Challenge Cup" engraved on one side; the Petersen presentation Stanley Cup, the one I had requested; and a replica of Petersen's

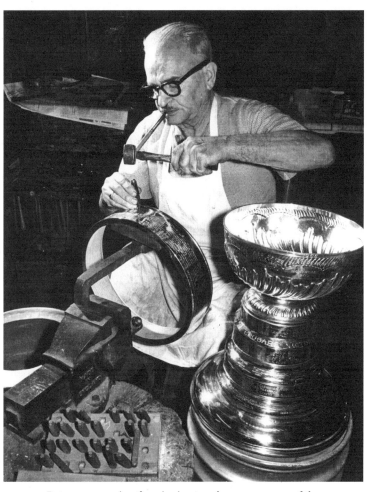

Petersen engraving the winning team's names on one of the
Stanley Cup bands, (1956–1957)
Imperial Oil-Turofsky/Hockey Hall of Fame, Toronto

cup made in 1993 by Louise St. Jacques, another Montreal silversmith. The replica is displayed in the Hockey Hall of Fame when the Petersen cup is on the road.

Pritchard was friendly when we finally shook hands, but chatting with a museum curator clearly did not hold a candle to hanging out with hockey greats. By the time I left our meeting, I had squeezed out of Pritchard a *three-hour* appearance for the cup. It would be exhibited during the show's opening-night from 5:30 to 8:30 p.m. The press would attend the opening and take pictures. Museum members and VIPs would be wowed! Good publicity all around, but too bad for the average hockey fan in the street.

On the day of the opening, the cup arrived at the museum like a rock star, silently entering through the back door. Museum staff stood gawking as chaperone Mike Bolt opened the specially designed carrying case and unwrapped the silver giant from its baby-blue blanket. Glistening rays bounced off its silver surface. Mike stood it upright on a table in the *salle d'acclimatisation,* where artworks were given time to recover from their travels and adjust to the museum atmosphere.

Just before 5:30 p.m., white gloves donned, the museum's technicians arrived to wheel the cup on a trolley up to the exhibit rooms. When they saw it, however, they couldn't contain their excitement, and asked to have a moment with the most famous sports trophy in North America. With Mike Bolt's approval, one by one the men took pictures of themselves beside the cup and one fellow, Dan Kelly, hoisted it up over his head, giving a low cheer as he pumped it up and down, imagining he was standing at centre ice amid thirty thousand screaming fans. Then Bolt said it was time to take the cup to the exhibition hall where its case stood at centre stage.

Once set in place, the silver cup sparkled like a show-off when the spotlights were turned on. The coveted hockey symbol had a personality all its own. For three hours, it drew visitors to the middle of the gallery like a magnet—a lifetime of Petersen silverware barely noticed along the way. Then, like a ravishing Cinderella, it was bundled up in its blue wrap and swept away by Mike long before the stroke of midnight.

[CHAPTER FOURTEEN]

Canadian Wilderness in Watercolour

The want of food and weakness had now so changed my appearance... my shoulders were as if they would fall from my body—my legs seemed unable to support me... had it not been for the remembrance of my friends [and] the persons of whom I had charge—I would have preferred remaining where I was to the miserable pain of attempting to move.

SO WROTE BRITISH NAVAL MIDSHIPMAN GEORGE BACK IN HIS JOURNAL on the point of death on October 15, 1821, during an expedition to the Canadian Arctic.[1] He and his company still had roughly 160 miles to go in their debilitated state, over frozen lakes and rivers, ice hummocks and swamps, travelling by foot on their return from the Arctic Ocean to Fort Providence (present-day Yellowknife) on Great Slave Lake.

Back and his men were the lead group of an Arctic expedition under the direction of the now legendary naval commander John Franklin. He had been commissioned by the British Admiralty to explore the Coppermine River in search of an overland route to the Arctic Ocean and hence a navigable northwest passage to the rich trading ports of Asia. George Back had been hired by Franklin to chart the topography of the landscape. It was an ill-fated expedition: half the crew died of starvation in the three years before the remainder straggled home in 1822. But for the efforts

of George Back and the help of Indigenous hunters, Franklin would have died too—years before his famous fatal voyage down Victoria Strait.

I was drawn into this narrative of Arctic exploration during preparations for *Cosmos: From Romanticism to the Avant-garde*, an ambitious exhibition in 1999 to celebrate the arrival of the new millennium. The show examined man's search beyond known boundaries in the nineteen and twentieth centuries, from the uncharted *terra incognita* of North America to man's reach into outer space. The Arctic regions represented one of the planet's last unmapped frontiers, and "The Voyage to the Poles" became a theme in the exhibition. I had a personal motivation to work on this part of the show as I had visited the Arctic in 1976 with a Canadian Studies student group from Seneca College. Decades later, I still held vivid memories of the wondrous far-northern landscape. With my fellow students I travelled in a Twin Otter airplane to seven northern communities on Baffin Island and the west coast of Hudson Bay, sleeping in school gymnasiums and church assembly halls, eating cafeteria-style meals. It was not luxury travel but I became captivated by the Canadian North. Inuit hunters took us out into the stark beauty of the Arctic tundra to camp or hunt for seals. When it was time for tea out on the sea ice, the hunters would simply hack a chunk of ice off a landlocked glacier nearby and boil it up in a small pot.

In Rankin Inlet four of us accompanied Inuit artist and ceramist Yvo Samgushak on a duck-hunting weekend in late May. We took snowmobiles out onto the land, miles from town, and stopped to set up camp. There was no sign of a bird or any other animal. Samgushak, who had been born without speech or hearing, scanned the sky, then beckoned to us to sit patiently, to keep still and silent. The ducks would come to us. As I kept watch, I passed the time observing the earthy browns and metallic streaks in the rocks and the hint of colour in the lichen. The remaining patches of snow contrasted with the dark tones of the land. This rocky, treeless pre-spring landscape, which at first glance appeared barren, was actually alive with varied hues of colour. Except for the wind, there was silence. Then, as if on

cue, we heard honking; the birds had arrived. Samgushak was a ready shot. Duck supper.

But that same stillness could be disturbing. In Igloolik in early May (still winter in the Arctic), I decided to walk out beyond the villlage in no specific direction. Igloolik stood at the edge of an iced-in bay of the sea, and apart from some distant low hills there were no large defining features—no snow-peaked mountains (as at Pond Inlet) or majestic fiords (as at Pangnirtung to the south). Now a vibrant centre of filmmaking, its population then numbered no more than 200 inhabitants. I walked past the prefabricated government houses, past the white mushroom-like form of the Igloolik scientific research centre and out into the white expanse. It was easy walking. The snow was not deep. All was flat, white and glistening. The land stretched on and on like this, extending to nowhere for kilometres. A film of clouds reached down to meet the horizon, and I was reminded of a conversation with a bush pilot who stressed the danger of landing a plane in the Arctic, when the pervasive whiteness makes it all but impossible to distinguish between the ground and the sky. The eery silence and the immensity of my surroundings suddenly made me, an urban creature, anxious. I retraced my steps back to the sounds and sight of people.

It was this unearthly quiet, the mystery and beauty of the Arctic, which drew men to explore the uncharted northern frontier in centuries past. Despite death-defying challenges, explorers would return again and again. Many books have been written by and about northern adventurers like Martin Frobisher, Samuel Hearne, Alexander Mackenzie and Sir John Ross (who in 1818 mistook a bank of clouds for a mountain range blocking his advance and turned back). The discovery in 2014 of Sir John Franklin's HMS *Erebus* at the bottom of Queen Maud Gulf reminds us of the ongoing dangers of polar exploration.

Like these explorers I had been seduced by the Arctic landscape—and as a curator, was eager to seek out artists who captured the lure of the North in paintings and drawings. This is how I came upon

the remarkable sketchbooks of British artist George Back, who made three expeditions into the Canadian Arctic.

Back was first and foremost a naval officer, having begun his career at the age of twelve as an apprentice with the Royal Navy. As a teenager during the Napoleonic Wars he spent five years imprisoned in France, where he received school training and showed a proficiency in art. In the rough, sometimes violent prison environment he also picked up a mental toughness that served him well in his later exploits.

Back served on the HMS *Trent* under Lieutenant John Franklin in 1818, as part of the British Admiralty's first Arctic naval expedition of the nineteenth century, sailing the waters east of Greenland. The voyage lasted only six months due to heavy sea ice, but Franklin— impressed by Back's strength, determination and artistic ability— invited the twenty-two-year-old midshipman to join his overland Arctic expedition of 1819 to 1822. The company nearly starved to death, as Back recorded in his journal, but the experience did not deter him from further exploration in the far north, and he joined Franklin's second overland Arctic expedition of 1825 to 1827.

After these two voyages, Back rose to the position of lieutenant. The young officer, however, had a reputation for being vain and overly ambitious, and he was not well liked by his travelling companions.[2] Franklin, too, became disenchanted with Back, who was not invited to join the captain's fatal third Arctic expedition—a rebuff that saved Back's life. Arrogant he may have been, but George Back's ambition paid off: he raised the funds to command his own northern expedition up the Thew-ee-choh River (now called the Back River) to the Arctic coast in 1833 to 1835. Shortly after his return, he received a knighthood (and was later named Admiral). An 1851 painting, *The Arctic Council Planning a Search for Sir John Franklin* by Stephen Pearce in London's National Portrait Gallery, shows the Admiralty's illustrious Arctic advisors gathered around a map-strewn table, making arrangements for an expedition to find the missing Franklin. Ironically, Captain Sir George Back is among them.

What impressed me most about Back was his perseverance in drawing, painting and note-taking through his rigorous travels. Back lost many possessions and very nearly his life (at one point he ate his leather shoes to survive) but managed to preserve his sketchbooks and journals regardless of weather or catastrophe.

Library and Archives Canada owns six of Back's sketchbooks, four from Franklin's two overland expeditions.[3] They are small, 11 by 18 cm, no larger than a notepad. Visitors to the archives have to don white gloves to examine them. Protected during the voyage by waterproof wrapping and stuffed inside a canvas pack, these diminutive books accompanied the artist hundreds of kilometres over hurtling rapids, choppy lakes and hilly portages. It was a thrill to handle their stained leather covers as I studied Back's artistry. Turning each page, not knowing what I would encounter next, I felt the breadth of the Canadian wilderness opening up before me as it had for Back almost two centuries earlier.

The first sketchbook begins in June 1919, as the Franklin party canoed inland from York Factory on Hudson Bay. Proceeding northwest, the men wintered in the fur-trading forts of the Hudson's Bay Company and its rival the North-West Company, and by June 1821 they were descending the frozen headwaters of the Coppermine River. Back sketches the crew carrying their birch-bark canoes across lake and river ice, accompanied by small sleds pulled by dogs or by the men themselves. By August they reached the Arctic Ocean. Back caught the drama of the moment in one watercolour of the men, eight to a canoe, paddling and poling their way through great shelves of sea ice in the shadow of massive cliffs. Near Melville Sound "the sea was so heavy that we not only took in much water, but were in the greatest danger of breaking the canoes in two," he wrote in his journal.[4]

At some point the men's supplies ran out and they turned to caribou-antler soup and rock-tripe lichen to survive. Starving and desperate on the return trip, it is remarkable that Back had the strength to continue drawing. In late August 1821 he sketched and coloured a view of the Wilberforce Falls on the Hood River.

Spray from the waterfall spills up in the right bottom corner of the page, as if the artist were immersed in the humid mist. "We could see the upper fall, rushing over the steep between immense rocks and falling with stunning noise into a narrow basin below, whilst the spray rose in clouds," wrote Back in his journal, "[and] this drove violently in one white foam to the lower fall—which was curiously divided by a pillar in the centre... Altogether it was by far the grandest scene of the kind in the country."[5] Today, photos of Wilberforce Falls—which some believe rival Niagara Falls in sheer beauty—are regularly posted on the Internet by wilderness canoe enthusiasts.

Another Back sketchbook, devoted to Franklin's second polar expedition of 1825 to 1827, includes a view of Clearwater River from the high point of Portage La Loche (also known as Methye Portage). In an earlier journal, Back described the spot and his wonder at breaking through a mass of trees and coming upon "the summit of an immense precipice—and like one bewildered in some vast labyrinth—knows not how or where to fix his eye. The view is that of a valley some thousand feet beneath you, in length upwards of 30 miles—in breadth three or four—and in the centre a meandering river holds its course near... till it becomes insensibly lost in the deep blue mist of the distant perspective."[6]

In his sketchbook painting, Back draws the viewer's eye down the winding Clearwater River into the hazy distance, toward the silhouette of a mountain range. In the foreground, the small figure of a man looks out over the dense forest before him, while others start the descent to the river. There is a mellowness in Back's natural tones of blue, green, grey and brown. He understood the translucency of watercolour, applying a thin wash to render the broad sweep of the sky and allowing the whiteness of the paper to heighten the effect of light. With the hand of a miniaturist, Back set down on paper his emotional response to the immensity of this new world. Franklin called it "the most picturesque scene in the northern parts of America,"[7] and Methye Portage was designated a National Historic Site by the federal government in 1933. George Back is now

George Back, "Panoramic View 8 Miles from Fort Franklin,
S by W to SW by W" from sketchbook 1825–26
Library and Archives Canada

acknowledged to have been one of the best naval artists of Canada's
northern frontier in the nineteenth century, before photography
took over the mission of documenting the landscape.

The Methye Portage was a regular fur-trade route for many
years and Back passed along it again on his third expedition in 1833
to 1835. This time he veered off the trail and lost his party. Back
became uneasy as he experienced the overwhelming solitude of
his position, and his earlier wonder at the sublime beauty of the
place changed to apprehension. "There is something appalling in
the vastness of a solitude like this," he wrote in his journal. "I had
parted from my companions, and was apparently the only living
being in the wilderness around me."[8] He reloaded his gun to allay
his fear.

In August 2015, I ventured north again to what is often called
the Barren Lands of the Northwest Territories in a party of nine
with Alexander Hall, a guide who had led expeditions east of Great
Slave Lake for almost forty years. Our group journeyed not far from
George Back's route up the Slave River to Fort Resolution. The land

around us was bursting with flora and fauna but devoid of people: during two weeks canoeing along lakes and rivers for over 100 kilometres, we saw no people and no signs of human habitation beyond a long-abandoned hunter's cabin and a few stone campfire circles. I imagined that this was the kind of landscape that Back had travelled, camping on carpets of lichen with mushrooms sprouting through the green-grey cover, trudging through low willow bushes and over rocks, and observing the aurora borealis illuminating the midnight sky. On calm days from higher prospects, I could look out between sparse clumps of spindly spruce towards the treeless tundra as it continued north. Like Back's watercolour sketch, "Panoramic View 8 Miles from Fort Franklin," the scene was boundless, the rocky terrain running ultimately to the Arctic Ocean. I shared Back's unease at the weight of the solitude in such an infinite unknown.

Two centuries ago, this British naval officer possessed the imagination and talent to go beyond his duty to record the topography of the land. The vistas that Back compressed into tiny sketchbooks captured his wonder at the sublime scale of the Canadian wilderness, stretching out to the horizon of his page. As he noted in 1820, "I do not pretend to describe the beauties of this view—the pencil being a more powerful vehicle than the pen."[9]

[CHAPTER FIFTEEN]

Cosmos in Venice: Rooming
in the Palazzo Grassi

Mounting an art exhibition is like putting on a play. Both have
a director, producer, script, major actors and bit players. Gather
six curators around a table with the bare outline of a theme,
let everyone throw around ideas fantastical and practical, then
write down the names of specific artists (specific paintings, even
better), and the race is on. Add three to four years of searching out
exhibits, requesting loans, redefining themes, editing out works,
making last-minute additions, preparing a 400-page catalogue
and planning the installation, and the stage is set for opening
night. Raise the curtain!

At the Montreal Museum of Fine Arts, the "performance" in the
summer of 1999 was *Cosmos: From Romanticism to Avant-garde*, an
exhibition created to celebrate the coming new millennium. Under
the direction of guest *commissaire général*, the visionary French art
historian Jean Clair, *Cosmos* examined artists of the previous two
centuries who had sought inspiration in the unexplored frontiers
of the earth and beyond, into the infinite reaches of space. Familiar
names such as Van Gogh, Brancusi, Turner and Rothko were jux-
taposed with lesser-known artists and inventive contemporary
pieces. The earliest daguerreotype of the moon, made in 1851 by
John Adams Whipple, hung alongside a 1984 NASA image of an
astronaut suspended between the earth's glowing surface and the

blackness of outer space. Nineteenth-century Arctic landscapes corresponded with the sublime paintings of America's waterfalls, mountains and dense forests. In search of new directions in art, the Russian and German avant-gardes explored cosmic themes in their depiction of gravity-free planetary orbs and floating cities. Alexander Calder's playful "Constellation" mobiles from the 1940s were juxtaposed with Spanish painter Joan Miró's cosmic signs and celestial creatures. Works were borrowed from all corners of the art world: Strasbourg, Saint Petersburg, Boston, Rome, Kaunas (Lithuania) and Toronto, just down the road. And in one of the museum's coups, Jean Clair and director Pierre Théberge convinced Berlin's Nationalgalerie to loan us Caspar David Friedrich's *Man and Woman Contemplating the Moon*, a pivotal work for the exhibition.

Cosmos was an exhibition to enthral the imagination. But I wonder how many imagined the horse-trading, pleading, fretting and intense lobbying that went on behind the scenes to pull off such a stimulating international exhibit. Over the past twenty years, complex thematic shows like *Cosmos* have become increasingly difficult to organize. Institutions have become less willing to lend their *chef-d'oeuvres* across continents or overseas. Exorbitant insurance and transportation costs (and shrinking budgets) are partly responsible.

In the case of the painting *The Icebergs* by American artist Frederic E. Church, the Montreal visitors were given a rare opportunity to see this large canvas (165 by 285 cm, or over five by nine feet), which usually hangs in the galleries of the Dallas Museum of Art. When Church launched his masterwork in New York in 1861, the public was charged admission to view it. High craggy walls of ice reflect a prism of colour, and the remnant of a ship's mast in the foreground alludes to the disappearance of the Franklin Expedition. After the painting's unveiling, it was sold to an Englishman and effectively disappeared until 1979, when it resurfaced in an auction house and was acquired for $2.5 million (a phenomenal sum at the time) by the Dallas Museum of Art.[1] The Montreal Museum convinced Dallas to part with it temporarily, but they do not plan to lend their most cherished treasure to anyone again.

For the Montreal portion of the show, Théberge had brought in New York-based artist Paul Hunter to design the decor, including the colours of the gallery walls upon which the works would hang. He had brilliantly transformed the museum's galleries for many earlier exhibitions on Keith Haring and Giacometti, for example, but the curators looked worried when he proposed crackled and blistered grey walls to simulate the parched terrain of the moon. In another gallery he suggested wide, irregular bands of blue and white to simulate astronauts' changing horizons as they hovered in space.

"How do we hang Van Gogh's radiant blue sky on a pastel-blue background?" moaned one curator.

"Trust me," Hunter replied.

"How can the weightless geometry of a Lissitsky *Proun* be hung on a wall with a diagonal blue stripe?" objected another.

"Trust me," Hunter replied again. He then proposed the final gallery be painted midnight blue with a faint glitter of the Milky Way.

Fierce lobbying and the director's fiat resulted in toning down the crackled grey, and mercifully banished the blue stripes. But in another gallery, Hunter's hand-painted astral backdrop of the heavens remained, to the consternation of California artist Vija Celmins, who arrived a day before the opening. Her series of "Galaxy" paintings and delicate drawings of shimmering stars, some bright, some dim, some almost fading out, captured the depth of blackness in the night sky. She took one look at the sparkly walls and refused to let her eight works be hung against them. We were surprised, but her objections were understandable. We had no choice but to remove her works for the opening.

So many outstanding artworks were assembled for *Cosmos*, it was impossible not to be impressed. One way that museum directors defray the enormous costs of mounting such shows is by offering the exhibition to other museums at an affordable fee, and *Cosmos* was no exception. The show's timeliness worked in its favour—everyone around the world was discussing Y2K and wondering about the future—but the window of opportunity for such a show

was limited, and closing fast. As it happened Pierre Théberge had recently accepted the directorship of the National Gallery in Ottawa and Guy Cogeval from Paris had been appointed the museum's new director. As summer turned to autumn, Cogeval made an agreement with Barcelona's Centre de Cultura Contemporània to mount a smaller travelling version of the exhibition immediately after the Montreal presentation closed in October 1999. Several months' grace was built into most of our loans, so the Barcelona show wouldn't be a problem.

Then news came of a third venue, the Palazzo Grassi in Venice, a deal arranged by Jean Clair for spring 2000. How many works from the Montreal show would be available for an extended trip to Venice? In a feverish state, a reduced curatorial committee met with Cogeval, and immediately, letters started going out in all directions, asking lenders to extend their loans. The first set of replies by fax (these were pre-email days) were discouraging. Van Gogh's *Road with Cypress and Star*, from the Kröller-Müller Museum in Otterlo, Netherlands, had been promised to another exhibition. Delaunay's *Circular Forms: Sun and Moon* had to be returned immediately to the Kunsthaus Zürich. The Musée de la Mode de la Ville de Paris recalled Elsa Schiaparelli's cape from the "Cosmic Collection" because its exposure to gallery lighting could not be extended. Also the Dallas Museum wouldn't allow Frederic Church's *The Icebergs*, the centrepiece of our Arctic theme, to cross the Atlantic. Unless we did some serious scrambling for new pieces, Venice was not in the works.

To save *Cosmos*, Jean Clair realized that he had to contact museum colleagues quickly and call in a few last-minute favours. Recognized as one of Europe's foremost curators of large thematic exhibitions, Clair was director of the Musée Picasso in Paris at the time, and he had already organized the prestigious exhibition *L'âme au corps, arts et sciences 1793–1993* for the Louvre's bicentennial, and he had served as director of the Venice Biennale Centennial exhibition in 1995.

On reputation alone, Clair confirmed two exceptional J. M. W. Turners from London's Tate Gallery for Venice, and made the strategic move to boost the number of Italian works in the show to

interest local visitors. He added a whole gallery of Italian Futurists, notably Giacomo Balla and Fillìa. Clair also brought in two of Lucio Fontana's *Spatial Concepts* (1960–65), their large, ovoid terracotta forms corresponding with Brancusi's polished-bronze egg entitled *Beginning of the World* (1924). He also negotiated the loan of Thomas Cole's magisterial *Expulsion, Moon and Firelight* (1828) from the Thyssen-Bornemisza collection in Madrid to replace key unavailable American landscapes. At the same time, Montreal's new director Guy Cogeval, a specialist in Symbolist art, was able to obtain Caspar David Friedrich's *Evening Landscape with Two Figures* (1830-35) from the Hermitage State Museum in Saint Petersburg. In Friedrich's painting, two starkly silhouetted, black-clad figures gaze from a hill at a boundless seascape, as clouds and the sun's lowering rays blur the line between heaven and earth. This evocative scene became the cover image of the revised *Cosmos* exhibition catalogue.

As the date for the opening in Venice drew closer, a problem arose with the transport of paintings from Canadian collections. Two outsize paintings by Paterson Ewen—*Gibbous Moon* and *Galaxy*—were too large to fit into a regular passenger plane for the flight from Montreal to Milan before transport to Venice. The contingent of works from Canadian museums would have to travel to New York by truck and thence in a cargo jumbo jet to Milan. I was given the task of serving as the courier for the Canadian loans, which included paintings by Lawren Harris and Tom Thomson on what may have been their first trip to Venice. A few weeks later, the Montreal Museum of Fine Arts' transportation manager, Simon Labrie, took the seven-hour trip by truck with the works to New York, and I flew to meet him at the John F. Kennedy airport.

The cargo jet left at midnight with all paintings aboard, and I was the only passenger with the two pilots and one engineer. It was a no-frills flight—no smiling flight attendants here—but I could help myself to the plentiful supply of food from a refrigerated chest not far from my seat, and there was a little bunk bed to crawl into. As we soared over Switzerland, the pilots invited me to come up to the cockpit as Mont Blanc came into view.

We arrived in Milan at 8 a.m. my time, that is, 2 p.m. Italian time. The crates of precious art were carefully unloaded from the side of the plane. At the storage area, a waiting Italian transport official ushered me through customs and introduced me to truck drivers Luigi and Pietro, who would be taking the paintings and me from Milan to the docks of Venice.

While Luigi and Pietro secured the load in place, I examined the seating arrangements in the truck. There were two bucket seats in front but no passenger seat behind. Perhaps only one of them would accompany me? At 5:30 p.m., I noticed both Luigi and Pietro were preparing for the journey. Now was the time to ask where I would sit. Knowing only basic Italian, I pointed to myself and the truck, then shrugged my shoulders and asked, "Where do I sit?" They pointed to a tiny space behind the front seats, where an old cotton sheet was slung like a hammock. Barely wide and long enough for one slim, short adult to lie in, I balked. "Ah, no!" I said firmly, wagging my finger and standing as tall as I could. This museum curator, I told myself, was not going to take yet another makeshift bed for three hours. I pointed to the front seat and said, "That's for me." Luigi and Pietro looked at each other questioningly and responded in a stream of Italian, which I took for some explanation about how they thought I would be tired after my long journey. I pointed to Pietro and gestured him towards the back. Thankfully he obliged, and we were on our way.

The drive to the outskirts of Venice was slow. I gazed out at the scenery and looked around the driver's cab: there was a photo of Luigi's girlfriend, along with a stuffed bear and a photo of Luigi in a soccer outfit. Through our limited conversation in Italian, I learned that he played in Rome with a semi-professional soccer team. And he was proud of his company's spanking new truck, which not only had Michelin tires and air suspension, but also a small machine on the dashboard, which the police could use to locate the vehicle at all times for safety and insurance purposes. I suggested that the company improve their third passenger seat.

As the truck rolled on, the rhythm of the wheels and lilting

tones of Italian made me drowsy. When we stopped for a break, I sheepishly proposed to Pietro that we change places. *Si, si*, he nodded with a smile. Back on the road, I fell asleep immediately.

When I woke up, it was 10 p.m. and we had reached the Venice docks. A wide barge sat waiting in the darkness. The crates were removed from the truck, and I watched nervously as a crane swung the precious cargo over the canal and lowered it into the boat. It was hard not to think of all the priceless canvases and sculptures from museums and galleries, worth hundreds of millions of dollars, which had negotiated the same Venetian waterway. This was the only way to get large artworks into Venice. How many masterpieces, over the years, had been lost in the watery abyss below? Watching the intense concentration on the dockworkers' faces, it felt like the wrong time to ask.

Piled high with crates, the barge moved off slowly into the darkness. I followed in a small motorboat. Faint lights along the shore illuminated the waterway. At the entrance to the Grand Canal, the barge turned sharply into its winding path through the heart of Venice. Close to midnight we arrived at the Palazzo Grassi, ablaze with light in an otherwise darkened city. There was a sense of expectation: workmen waited for the barge on the Campo San Samuele, a small square conveniently located by the palace's side entrance. The crates were unloaded and wheeled in. Clarenza Catullo, chief registrar for exhibitions, said a brief hello before returning to direct the placement of crates, and an assistant showed me to my apartment on the top floor of the palace. Before falling into bed, exhausted by twenty-four hours of non-stop travel, I opened my large window and breathed in the vapours of Venice. For the next two weeks, I would be rooming in one of the stateliest Venetian residences on the Grand Canal.

As a result of its power and wealth through international trade, Venice reached its peak as one of the great cities of Europe during the fifteenth and sixteenth centuries. This was the era when leading merchant families built their palaces along the Grand

Canal. Some of them have been demolished and replaced, others have been transformed into hotels or divided into apartments, and still others lie neglected by owners who live far away.

The Palazzo Grassi, built by the wealthy Grassi family in 1770, was the last great palace to rise in the city. Designed by architect Giorgio Massari, its classical symmetry and tripartite facade harks back to earlier Venetian palazzos. The rusticated stone walls at water level rise up to the *piano nobile*, the principal floor of the palace, where elegant Ionic pilasters flank high, round-arched windows with balustrades. Above these a series of pedimented windows, more balustrades and more pilasters are surmounted by a red-tiled hipped roof. The canal facade with its imposing Palladian entrance is the formal face of the Palazzo Grassi; tourists and museum employees enter through the side door on the Campo San Samuele, where the *vaporetto* stops in front of the San Samuele church and its twelfth-century bell tower.

Looking out my attic-floor window the next morning, I had an excellent view of the Grand Canal at its bend. It was March, ahead of peak tourist season, but boats of every dimension plied the waterway: ferries, private motor boats, *barcas* filled with vegetables and fruits, water taxis from the airport and the occasional gondola. Up and down the canal I could see a parade of columns, pilasters and pediments of other grand palazzos. At the junction of the Rio di Ca' Foscari stood the 1590 Palazzo Balbi where Napoleon had stayed. It now housed the Veneto Regional Council. Next in line, the medieval palace Ca' Foscari, built for Doge Francesco Foscari in the 1450s, now served as the seat of Venice University. Its Gothic features and brick walls matched the neighbouring Palazzo Giustinian, where for seven months in 1858–1859 Richard Wagner composed the second act of *Tristan and Isolde*. So many famous writers, musicians, architects, painters and opera singers had passed along the Grand Canal and even into the Palazzo Grassi. The whole experience reminded me of French poet Théophile Gautier's words in his *Voyage d'Italie*:

The Grand Canal in Venice is the most enchanting place in the world. No other city can present a spectacle of such delight, such strangeness, such fantasy... Every palace has a mirror in which to admire its own beauty, like a flirtatious woman. The splendid reality is doubled by a charming reflection.[2]

As the Grassi family's fortunes waned, ownership of their palace passed from counts to opera singers to artists to hotel managers and financiers. In 1984 it was purchased by the FIAT group, headed by the Agnelli family. Gianni Agnelli turned the building into a centre for art exhibitions, and the whole structure was restored by his close friend, architect Gae Aulenti. One of the few women architects of her generation in Italy, Aulenti is best known for her transformation of the Gare d'Orsay in Paris from a Beaux-Arts railway station to a national museum of modern French art. For the Palazzo Grassi, Aulenti turned the large formal floors into exhibition galleries, the upper floors into guest apartments, and covered the open inner courtyard with a pyramidal glass roof. She continued to serve as the Palazzo Grassi's in-house designer of exhibitions.[3]

A knock at the door: Had I slept well? Good. Had my coffee? Good. Let's get to work.

Downstairs, Clarenza was directing more arriving crates, each accompanied by couriers from museums across Europe. Once unpacked, works were examined by a conservator to assure no damage had occurred during transport, and the art was positioned in the galleries according to the layout of the show. Jean Clair would arrive from his office in Paris for a couple of days to direct the installation, followed by a troop of technicians. Clair frequently altered the installation plans drawn up on paper. When confronted by the actual work, he could judge whether its size, subject and tone clashed with its neighbour or might need a more prominent space on the wall. To hang an exhibition is one of the most creative and

enjoyable challenges of a curator's job, and curators usually like to work alone. Even Gae Aulenti, who was a formidable presence in her own right, deferred to Jean Clair when he turned up on the scene. Aulenti would withdraw from the galleries and disappear for the afternoon. But the minute Clair left to return to Paris, she was back sending orders to all concerned, while her trusted assistant smoothed out any jarred feelings.

In the final stretch before the opening, paintings were still being adjusted. From my vantage in another room, framed by a doorway, I spied Jean Clair marching off with a small painting under his arm. Aquiline nose thrust forward, he was moving Russian artist Ilya Chashnik's *Cosmos-Red Circle on Black* to a new location in another gallery. A few hours later, I watched the tall, lanky frame of my director, Guy Cogeval, steadfastly walk the painting back to its original position. On opening day, I casually checked the Chashnik's final location and noticed that the Italian technicians had been faithful to their *commissaire générale,* Jean Clair.

The Italian assistants also showed their spirit when Claudio Parmiggiani's *Boat Carrying Nine Planets* (1994) arrived—an eight-metre-long gondola holding nine large marble spheres. It would be a highlight of the exhibition, but manoeuvring the gondola's pointed bow and delicate curved stern up the interior staircase of the palace was going to be too risky. It had been too expensive and too fragile to put on a plane to Montreal, but no one in Venice was about to let a winding staircase get in the way. Gae Aulenti proposed using a mechanical leverage system to hoist the *barca* in its crate up the outside of the building and in through a second-storey window. No one batted an eyelid. Two hours later, I watched as the elongated wooden frame enclosing the vessel was winched up, inch by inch, and eased through the window. Once inside, the gondola was uncrated to reveal its tapered form, stained black as the night sky. Then nine marble spheres of varying sizes were aligned inside— Mercury, Venus, Earth, Mars, Jupiter, Saturn, Uranus, Neptune and Pluto—and the gondola was ready for its galactic journey through the heavens.

Room after room in the Palazzo's vast two-floored exhibition space gradually filled with art. NASA's 1965 Gemini Space Suit lay slumped in an armchair like an exhausted astronaut, awaiting its support. One painting arrived with a dreary frame in bad condition. "Could we have a new frame made?" asked Jean Clair. Clarenza nodded efficiently and took the piece away. A day later, it was back in the gallery with a brand-new gilt-leaf frame. Only in Venice, I thought—where artisans, framers and expert gilders were all on hand—could this be done.

Two days before opening, a great banner was raised over the palace's facade:

COSMOS
Da Goya a de Chirico da Friedrich a Kiefer
L'arte alla scoperta dell'infinito
Venezia, Palazzo Grassi 26.03–23.07.2000

That morning, an unusual bustle filled the palace. Jean Clair was away and Gae Aulenti was in charge. I headed to the ground floor to see what all the fuss was about and caught sight of Aulenti perched like a schoolgirl on a small chair beside the giant entrance doors leading to the Grand Canal. She was clearly waiting for someone. I wondered who Aulenti was expecting. The massive doors were usually kept firmly shut; visitors came through the side entrance on the square. Looking around, I noticed something else unusual: the elaborate branched chandeliers on either side of the grand staircase had been turned on.

Suddenly there was the rumble of a motorboat engine outside, and then the colossal double doors creaked open. A shaft of sunlight cast its rays into the gloomy hall, illuminating the stooped figure of a frail-looking gentleman walking in slowly, aided by a cane. Aulenti jumped up and greeted her guest. Clarenza was watching with me. "That's Gianni Agnelli," she whispered in my ear, "the owner of the Palazzo Grassi. He is coming for a preview of the show." As head of the FIAT Group and scion of an old family, Agnelli was one of the most powerful men in Italy.

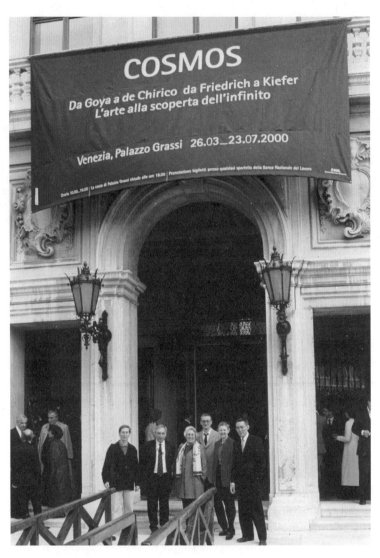

Opening of Cosmos exhibition at the Palazzo Grassi, Venice
Left to right: Christopher Phillips, Jean Clair, Constance Naubert-Riser,
Guy Cogeval, Rosalind Pepall and Didier Ottinger

Together Aulenti and Agnelli walked slowly through the central roofed-in courtyard, followed by an entourage, and took the elevator up to the exhibition galleries. Parmiggiani's gondola lay in wait, as did Thomas Moran's *Golden Gate, Yellowstone National Park* (1893). One floor up, the pockmarked craters of Yves Klein's 1960s planetary reliefs vied with Russian artist Ilya Kabakov's *The Man Who Flew Into Space From His Apartment*, a 1980s installation of a bedroom filled with Soviet posters and broken bits of plaster on the floor around a suspended seat-holster from which an imaginary person had blasted into space through the ceiling. Wenzel Hablik's spiralling *Firmament* (1913), Barnett Newman's *Yellow Edge* (1968) and Anselm Kiefer's *Starfall* (1998), its shooting constellations literally falling off the canvas, had all travelled from Montreal via Barcelona and found their places in the show. I was proud to see the Lawren Harris painting *Icebergs, Davis Strait* and Tom Thomson's *Aurora Borealis*, which I had escorted to Venice, integrated with art from the cultural capitals of Europe. Vija Celmins' glittering night skies made their return to the show, and there in a corner, the Gemini spacesuit finally stood upright.

On opening night two days later, patrons of the Palazzo and other special guests arrived in elegant evening wear, stepped off their motorized launches and climbed the stone stairs to pass through the imposing Palladian entrance. The water glistened with the reflections of small candles placed along the edge of the quay.

During the formal dinner, a guest turned to me and said, "You must have a marvellous job."

I hesitated to answer, recalling stressful moments during the hectic months of planning for the show. But as I sat in the Palazzo's courtyard and thought of the thrilling masterpieces that filled the building, I smiled.

"This line of work certainly has its advantages," I replied.

ENDNOTES

Chapter One

1. Nicole Cloutier, former Curator of Canadian Art at the Montreal Museum of Fine Arts, began a preliminary study of Holgate's work in about 1991, in view of an exhibition.

2. Jacques Des Rochers and Brian Foss, eds. *1920s Modernism in Montreal: The Beaver Hall Group*, exhibiton catalogue (Montreal Museum of Fine Arts, 2015), which has an excellent bibliography on the subject.

3. After signing the lease for the Beaver Hall Hill studio in October 1920, Holgate set off on a two-year honeymoon in France with his wife, Frances Rittenhouse. Despite his absence, he exhibited paintings in the two Beaver Hall Group exhibitions of 1921 and 1922. Lilias Torrance Newton, a prominent member of the Beaver Hall circle, later recalled that the group almost folded when Holgate left for Europe (Charles Hill interview with L.T. Newton, September 11, 1973. National Gallery of Canada archives, Ottawa).

4. Jean Chauvin, *Ateliers* (Montreal and New York: Louis Carrier, 1928), 20.

5. Edwin Holgate, Montreal, to Eric Brown (director of the National Gallery of Canada), January 9, 1936. (National Gallery of Canada archives), cited in Brian Foss, "Living Landscape," in Rosalind Pepall and Brian Foss, exhibition catalogue, *Edwin Holgate* (Montreal: Montreal Museum of Fine Arts, 2005), 48.

6. Thomas Archer, "The Art of Holgate," *Saturday Night*, April 15, 1933.

7. Montreal publisher Louis Carrier described Holgate's precision in his painting in 1928: "Holgate has a vigour that brooks of no luxury, a discipline that harbours no sensuousness, a restraint that wards off abandon, a robustness that shatters mere delicacy. There is no art for art's sake in his work: there must be a subject to interpret, a message to deliver, an impression to convey; …He studies his subject, mulls over his message, makes sure of his impression; then wields brush or pencil or knife with a sureness of hand, under a critical coldness of eye, but with a warmth of purpose and a relentless inflexibility almost puritanical in mood." (*Les Casoars: En souvenir des dîners du Casoar-club*. (Montreal: Louis Carrier, 1928), 23.

8. Holgate's model and art student, Madeleine Rocheleau Boyer, recalled the artist telling her to "Try and make a quiet statement."

Cinquante Artistes de Chez-Nous, "Madeleine Boyer" (Montreal: Galerie d'Art les deux B, 1983), 62.

9. Patrick Copeland, "Henry Holgate," *Biographical Dictionary of Canadian Engineers*, edited by Rod Millard (collected by the University of Western Ontario). tomkane.ca/cdneng/holgate.html (accessed January 1, 2020).

10. I am grateful to Gabriel Landry of Longueuil, Quebec, who gave me this information relating to the Alphonse Landry family.

11. « Le transport n'était pas facile dans ce temps-là ; il est arrivé près de huit jours plus tard. Ma mère était déjà en terre. » Bernard Landry correspondence with Ludivine Landry, Sept-Îles, February 1999 (*Journal de bord de Natashquan*, vol. 2).

12. Charles Hill interview with Ludivine Landry Cormier, October 20, 1986, National Gallery of Canada archives, curatorial files.

13. Bernard Landry, Feb. 1999.

14. Hill, interview , October 20, 1986.

15. Charles Hill interview with Edwin Holgate, September 20, 1973, National Gallery of Canada archives.

16. Edwin Holgate to Eric Brown, Montreal, February 17, 1937. National Gallery of Canada archives.

17. A.Y. Jackson to Alice Massey, Toronto, November 16, 1930. National Gallery of Canada archives file for Edwin Holgate, taken from the Massey Papers, University of Toronto CB87-0082.

18. Ibid. Holgate file.

19. Alice Massey to Edwin Holgate, February 11, 1931, Agnes Etherington Art Centre, Queen's University, Kingston, Holgate Papers, Scrapbook EH4.

20. Ibid. Holgate Papers, Scrapbook EH4.

21. Pierre Frenette, Bernard Landry, *Natashquan...Le goût du large* (Montreal: Nouvelles éditions de l'arc, 2005), 10.

22. Paul Charest and Bernard Landry, *Le Site Patrimonial des "Galets" de Natashquan: Son histoire, ses fonctions, ses caractéristiques* (Municipality of Natashquan, 2016), 41.

23. Rosalind Pepall, telephone interview with Gilles Vigneault, July 11, 2018.

24. Holgate also created one of his finest wood engravings, *The Stairway*, which led from the kitchen to the second floor.

25. Rosalind Pepall interview November 28, 2017, with Gabriel Landry who had interviewed Anicet Landry, son of Alphonse Landry.

26. After Natashquan, Gallix moved on to a church near Sept-Îles, and a small village, Gallix-sur-Mer, was named in his memory for the French priest's devoted service to the Côte-Nord.

27. After her children grew up, Ludivine and her husband, Paul Cormier, moved to St. Nicolas, near Lévis, Quebec, to be close to their daughter. When Paul died in 1992, Ludivine returned to the Côte-Nord and settled in Sept-Îles, where she died in 2000.

28. « Aussi bonne cuisinière /De votre gâteau de noces vous serez fières / Ses travaux au crochet sont aussi beaux / Que ses mitaines, bas et chandails faits au tricot / Dernière couchée/Première levée / Ne prononce jamais, le mot fatigué. » Rolande Cormier, text written for the Journée des ancêtres, Festival Innucadie, Natashquan 2012. (National Gallery of Canada archives)

29. « Il m'aurait été difficile de voir que cette peinture ferait un si grand chemin! » Bernard Landry, February 1999.

30. « On n'arrive point à Natashquan. On y revient se retrouver soi-même comme dans un pays de quelque vie passée…Les maisons et les gens, les sapins, les chaloupes, le sable des chemins semblent vous reconnaître. Et vous accueillent. » Gilles Vigneault, *Au cœur de la Côte-Nord.*

31. Holgate to Anicet Landry, November 10, 1946. Gabriel Landry collection.

Chapter Two

1. Jori Smith to P.K. Page, March 20, 1974, P.K. Page papers MG30 D311, vol. 11, Correspondence Jori Smith 1963–1983 (folio 4), Library and Archives Canada, Ottawa.

2. Smith Papers, MG30 D249, vol. 10 (folio 3), Library and Archives Canada.

3. Jean Palardy to Mme. Palardy, June 18, 1928, Smith papers, vol. 9, (folio 33).

4. Palardy to Smith, Ste. Anne de Chicoutimi, April 8, 1929. Jori Smith papers, vol. 9 (folio 5).

5. The Library and Archives of Canada collection has a number of Smith's drawings that are signed Chicoutimi and dated July 1929.

6. « Comment une femme comme vous, si bonne et gentille peut être une Protestante? » Jori Smith manuscript of her days in Charlevoix, p. 2. Smith papers, vol. 10 (folio 2).

7. Jori Smith, *Charlevoix County, 1930* (Penumbra Press, 1998), 1–32. Published when Jori was ninety-one.

8. Ibid. 24.

9. Édith-Anne Pageot, "Jori Smith, une figure de la modernité picturale Québécoise. Étude d'un cas: le portrait d'enfant," *Globe* 3, no. 2 (2000): 182.

10. Smith to Madeleine Lemieux September 26, 1964, Smith papers, vol. 9 (folio 34).

11. Kirk Niergarth, *The Dignity of Every Human Being: New Brunswick Artists and Canadian Culture Between the Great Depression and the Cold War* (Toronto: University of Toronto Press, 2015), 129.

12. Charles Hill interview with Jori Smith, June 16, 1974 National Gallery of Canada archives.

13. G. Campbell McInnes, "Contemporary Canadian Artists," *The Canadian Forum*, July 1937, 130.

14. « un véritable laboratoire de culture matérielle. » Roger Blais, *Jean Palardy: Peintre témoin de son époque* (Montreal: Éditions Stanké, 1993), 13.

15. The Commission changed its name to the National Film Board of Canada in 1950 and then moved its head office from Ottawa to Montreal in 1956.

16. Smith to Palardy, October 11, 1944, Smith papers, vol. 8 (folio 5).

17. Smith to Madeleine Lemieux, August 14, 1974 (unposted), Smith papers, vol. 9 (folio 1).

18. Jori may well have resented Pellan's success. Alfred Pellan had been the talk of Montreal when he returned from Paris in 1940 and exhibited his modern compositions of daring colour, rarely seen before in Quebec art, which Jori acknowledged had influenced her and many local artists. Pellan was the first Canadian painter to be given an exhibition in the prestigious Musée national d'art moderne in Paris in 1955.

19. Cited in Sandra Djwa, *Journey with No Maps: A Life of P.K. Page* (Montreal and Kingston: McGill-Queen's University Press, 2012), 85.

20. Smith in conversation with Rosalind Pepall, October 31, 1996.

21. Paul Duval, "Montreal Artists Establishing New Landmarks in Canadian Art," *Saturday Night*, November 10, 1945.

22. Smith to Madeleine Lemieux, October 20, 1964 (unposted), Smith papers, vol. 9, (folio 34).

23. Smith to P.K. Page, January 31, 1975, Smith Papers, vol. 9 (folio 1).

24. Anne Stratford, the daughter of Jori's friend Philip Stratford, had originally proposed an exhibition to celebrate the artist's ninetieth birthday. Karen Antaki, curator of the Leonard and Bina Ellen Art Gallery

at Concordia University, enthusiastically supported the project. See Karen Antaki and Rosalind Pepall, *A Celebration/une Célèbration: Jori Smith* (Montreal: Leonard and Bina Ellen Art Gallery, Concordia University, 1997).

25. P.K. Page papers, MG30 D311, vol. 11, Correspondence Jori Smith 1963–1983, (folio 4).

Chapter Three

1. The Senate war paintings were restored in the summer of 1998, and the conservator had to work on them in the chamber proper, while the Senate was in recess.

In place of the Kerr-Lawson paintings, the museum was able to borrow for the 1920s show two large English paintings from the Canadian War Museum collection: John Armstrong Turnbull's *Air Fight*, about 1917–18 and Frederick Etchells, *Armistice Day, Munitions Centre*, about 1918–19.

2. Since my 1990 visit, an Internet site has been set up for the Mobilier National, and major works are now on display in the renovated galleries of the nearby Gobelins Manufactory. See mobiliernational.culture.gouv.fr.

3. Emmanuel Bréon and Rosalind Pepall, *Ruhlmann, Genius of Art Deco* (Montreal Museum of Fine Arts in association with Musée des Années Trente, Sómogy éditions d'art, Paris, 2004), and in collaboration with J. Stewart Johnson and Jared Goss, curators at the Metropolitan Museum of Art, New York, Department of Modern Art.

4. Since the Montreal viewing, the *Merzbau* copy has indeed travelled the world, and you can even see it being installed at the Berkeley Art Museum, University of California, in 2011 on YouTube.

Chapter Four

1. Jean Clair, ed. *The 1920s: Age of the Metropolis*, exhibition catalogue (Montreal: Montreal Museum of Fine Arts, 1991), 17.

2. Jill Lloyd and Michael Peppiatt, eds. *Christian Schad and the Neue Sachlichkeit* (New York: Neue Galerie and W.W. Norton & Company, 2003).

3. https://austria-forum.org/af/AustriaWiki/Nikolaus_von_ Wassilko (accessed November 16, 2018).

4. Sabine Rewald, *Glitter and Doom, German Portraits from the 1920s* (New York: Metropolitan Museum of Art, and New Haven and London, Yale University Press, 2006), 152, cited from Christian Schad's *Bildlegende* (picture captions), written in 1977–78 for a book by G.H. Herzog that was never published.

5. Rewald, 152. (The other Frau Wassilko whom Rewald mentions was the second wife of Vera's father.)

6. Schad did eventually return to painting in a more sentimental, hyperrealist approach, and he died in Stuttgart in 1982 .

7. Gérard Régnier, Pontus Hulten, *Les réalismes (1919-1939)*, exhibition catalogue (Paris: Centre Georges Pompidou, 1980). Jean Clair is the *nom de plume* of Gérard Régnier.

8. I am grateful to Nancy Gershman for sharing details of her grandmother's life with me.

Chapter Five

1. Pierre L'Allier, *Henri Beau 1863-1949*, exhibition catalogue (Quebec: Musée du Québec, 1987), 22.

2. The records of the Collège Notre-Dame on Queen Mary Street in Montreal indicate that Paul Beau attended the school for two years, from 1882 to 1884.

3. Letter from Paul Beau to Marius Barbeau, July 3, 1941, Fonds Marius Barbeau, B307, Archives of the Canadian Museum of History, Gatineau, QC.

4. Rosalind Pepall, "Founding a Collection: F. Cleveland Morgan and the Decorative Arts," in Rosalind Pepall and Diane Charbonneau, eds. *Decorative Arts and Design: the Montreal Museum of Fine Arts' Collection* (Montreal: Montreal Museum of Fine Arts, 2012), p. 18.

5. Beau to Barbeau, July 3, 1941. The Maxwells hired Beau for the additions and alterations they were doing on the Mount Royal Club building on Sherbrooke Street in 1902–03. The building was destroyed by fire in 1904 and replaced by a building designed by New York architects, McKim, Mead and White in 1905.

6. See Kate Armour Reed, *A Woman's Touch: Kate Reed and Canada's Grand Hotels* (John Aylen Books, 2016).

7. Beau to Barbeau, July 3, 1941.

8. Interview with Randolph C. Betts by Rosalind Pepall, January 12, 1979.

9. Rosalind Pepall, *Paul Beau (1871-1949)*, exhibition catalogue (Montreal Museum of Fine Arts, 1982).

Chapter Six

1. The window was designed in 1910 by Archibald J. Davies, director of stained glass at the Bromsgrove Guild of Applied Arts, Worcestershire, England, and then sent to Montreal.

2. Eric McLean, "Magnificent Davis House Recalls Bygone Era," *Gazette*, Montreal, November 27, 1988.

3. Charles C. Hill, *Artists, Architects & Artisans: Canadian Art 1890-1918*, exhibition catalogue (Ottawa: National Gallery of Canada, 2013). The Davis house and oratory are discussed in R. Pepall, "Arts and Crafts Traditions in the Canadian Domestic Interior," 61–7.

Chapter Seven

1. W.S. Maxwell to G.A. Monette, Paris, February 9, 1900. Province of Quebec Association of Architects correspondence, 06-P-124-1 chemise 2, Archives nationales du Québec à Montrèal.

2. W.S. Maxwell to May Bolles, January 29, 1901, cited by Violette Nakhjavani (assisted by her husband Bahiyyih Nakhjavani), *The Maxwells of Montreal* , 2 volumes (Oxford: George Ronald, 2011), vol. 1, 128.

3. Rosalind Pepall, *Construction d'un musée Beaux-Arts: Montréal 1912: Building a Beaux-Arts Museum* (Montreal: Montreal Museum of Fine Arts, 1986).

4. It has been preserved by the World Center of the Bahá'í Faith since 1952.

5. Nancy Yates, "The Artistic Achievements of William Sutherland Maxwell," Appendix II in Nakhjavani, p. 394–5.

6. William's association with the Bahá'í community has been described in the book by Nakhjavani, 2011.

7. Ibid., vol. 2, 260.

8. Susan Wagg, Harold Kalman, eds., in collaboration with France Gagnon Pratte, Ellen James, Irena Murray and Rosalind Pepall, *The Architecture of Edward and William S. Maxwell,* exhibition catalogue (Montreal: Montreal Museum of Fine Arts, 1991).

9. J. Roxborough Smith (name spelled incorrectly in the published reference), "Obituary: William Sutherland Maxwell," *Journal of the Royal Architectural Institute of Canada* 29, no. 10 (October 1952), 311.

Chapter Eight

1. Philippe Conisbee, and Denis Coutagne, et al, *Cézanne in Provence* (Washington D.C. : National Gallery of Art in association with Yale University Press, New Haven and London, 2006).

2. Janet Brooke, *Discerning Tastes: Montreal Collectors 1880-1920* (Montreal: Montreal Museum of Fine Arts, 1989), 61–2.

3. Christophe Mory, *Ernst Beyeler: A Passion for Art* (Paris: Éditions

Gallimard, 2003); English edition (Zurich: Scheidegger & Spiess, 2011), 114.

4. Fondation Beyeler, ed., *Renzo Piano – Fondation Beyeler: A Home for Art* (Basel, Boston, Berlin: Birkhäuser, 1998), 33.

5. The actual villa building now houses administrative offices and a restaurant.

6. Fondation Beyeler, ed., 33.

7. The building was expanded towards the north in 2001 to accommodate more exhibition space. Plans for a future "House for Art" on the property are in the works.

Chapter Nine

1. Judy Rudoe, "Design and Manufacture Evidence from the Dixon & Sons Calculation Books," *Decorative Arts Society Journal*, (2005): 66–83.

Chapter Ten

1. Louis Comfort Tiffany, "Color and its Kinship to Sound," *Art World* 2, no. 2 (May 1917), 142.

2. Alma Mahler Werfel, *And the Bridge Is Love* (New York: Harcourt Brace, 1958).

3. It should be stated here that Tiffany coloured glass was not "stained" glass in the medieval sense of staining the glass surface with silver nitrate to produce a yellow tone. Tiffany used little "staining" on the glass surface. But I use the word "stained glass," as it has become the generic term for all types of coloured, leaded glass. For a definition of true stained glass, see Alice Cooney Frelinghuysen, "Tiffany Domestic and Ecclesiastical Windows," in Rosalind Pepall, ed. *Tiffany Glass: A Passion for Colour* (Montreal Museum of Fine Arts and Skira Flammarion, Paris, 2009), 74.

4. Alice Cooney Frelinghuysen, *Louis Comfort Tiffany and Laurelton Hall: An Artist's Country Estate*, exhibition catalogue (New York: Metropolitan Museum of Art; New Haven, Connecticut, London: Yale University Press, 2006).

5. Hugh F. McKean, *The "Lost" Treasures of Louis Comfort Tiffany* (Garden City, New York: Doubleday, 1980), 13.

6. Martin Eidelberg, Nina Gray and Margaret K. Hofer, *A New Light on Tiffany: Clara Driscoll and the Tiffany Girls*, exhibition catalogue (New York: New York Historical Society in association with D. Giles Limited, London, 2007), 148.

7. Ibid., 119–20. The union did not admit women.

8. Ibid., 64.

9. Ibid., 132.

10. *Lancashire Life*, July 30, 2015, "Joseph Briggs, the Accrington Link to the World Famous Tiffany Glass," www.lancashirelife.co.uk/out-about-joseph-briggs-the-accrington-link-to-the-world-famous-tiffany-glass-1-4171953 (accessed January 30, 2020).

11. Martin Eidelberg and Nancy A. McClelland, *Behind the Scenes of Tiffany Glassmaking: The Nash Notebooks* (New York: St. Martin's Press, 2001), 142.

12. The Montreal Tiffany windows were originally installed in the American Presbyterian Church on Dorchester Boulevard (renamed boulevard René-Lévesque) and were commissioned by some of its prominent members. In 1934, when the congregation outgrew its building, they amalgamated with the Erskine United Church and moved into its larger Romanesque Revival building of 1894 on Sherbrooke Street. The twenty Tiffany windows were then transferred to the renamed Erskine and American United Church.

13. Yelena Anisimova, "Tiffany and Russia," in Pepall, ed., *Tiffany Glass*, 214–19.

14. A Tiffany brand name stemming from the Latin word for handmade, *fabrilis*.

15. Sir William Van Horne papers, (CA OTAG SCO65), E.P. Taylor Research Library and Archives, Art Gallery of Ontario, Toronto.

Chapter Eleven

1. David A. Hanks and Anne Hoy, *American Streamlined Design: The World of Tomorrow* (Paris: Flammarion, 2005), exhibition organized by the Liliane and David M. Stewart Program for Modern Design, Montreal.

2. Bryan Burkhart and David Hunt, *Airstream: The History of the Land Yacht* (San Francisco: Chronicle Books, 2000).

3. Fred Coldwell, "Ruby, a 1948 Wee Wind," *Vintage Advantage Newsletter* 9, no. 4 (2003).

Chapter Twelve

1. Wyeth Williams, *The Tiger of France* (New York: Duell, Sloan and Pearce, 1949), 151, cited from Winston Churchill, *Great Contemporaries* (London: Odhams Press, 1937).

2. Margaret MacMillan, *Paris 1919* (New York: Random House, 2002).

3. The painting, dated 1919, hangs in the Imperial War Museum, London, England.

4. Christophe Vital, and Florence Rionnet, *Clemenceau et les artistes modernes: Manet, Monet, Rodin…* (La Roche-sur-Yon: Conseil général de la Vendée et Paris: Somogy éditions d'art, 2013), and Aurélie Samuel, Matthieu Séguéla and Amina Taha-Hussein Okada, *Clemenceau, le Tigre et l'Asie* (Paris: Musée national des arts asiatiques, Guimet and Éditions Snoeck, 2014).

5. « J'ai passé dans l'étrange atelier beaucoup d'heures, les yeux écarquillés, sans rien dire… et j'ai pris l'amour de la bonne terre plastique que l'homme façonne et modèle, ou le Japonais dédaigneux du tour, se plaît à marquer, d'un doigt féminin, la discrète empreinte de sa sensation fugitive, de sa passion, de sa vie. » Georges Clemenceau, "Sans nom," *La Dépêche de Toulouse*, April 24, 1895, cited in Samuel, Séguéla and Okada, *Clemenceau*, 62.

6. Biography of "Saionji Kinmochi," *Encyclopedia Britannica*, online: updated December 3, 2019.

7. Matthieu Séguéla, "Le Japonisme de Georges Clemenceau," EBISU, 27, autumn–winter 2001 (Tokyo: Maison Franco-Japonaise), 14-15.

8. Matthieu Séguéla, "Le faiseur de musées," and "Le musée d'Ennery ou l'art de l'amitié," in Samuel, Séguéla and Okada, *Clemenceau*, 136–49.

9. « *Je suis criblé de dettes, et je n'ai plus rien, plus rein, plus rien.* » Séguéla, EBISU, 27, 19.

10. Yutaka Mino and Seizo Hayashiya, *Exhibition of Kogo: Japanese Ceramic Incense Boxes from the Georges Clemenceau Collection* (Tokyo: Asahi Shimbun, 1978). Also, from 2000 to 2004, an exhibition of 582 kogos from the Montreal Museum of Fine Arts collection travelled to seven museums in Japan. Montreal Museum of Fine Arts, *Kogos from the Georges Clemenceau Collection* (Tokyo: T. G. Concepts Inc., Taniguchi Jimusho, 2000), with introduction by Rosalind Pepall, 12–13).

11. James S. Pritchard, *A Bridge of Ships: Canadian Shipbuilding during the Second World War* (Montreal and Kingston: McGill-Queen's University Press, 2011), 54.

12. Robert G. Jones, Catherine Objois, and Joey Olivier, *L'Histoire économique de la région de Sorel-Tracey du dernier siècle, 1905 à 2005* (Sorel: Page Cournoyer Publications, 2005), 27.

13. Pritchard, *A Bridge of Ships*, 54. Chloé Ouellet-Riendeau, « Les Princes de Sorel » : Analyse du rôle de la famille Simard dans le développement de la ville de Sorel (1909–1965), MA thesis, Université de Sherbrooke, 2017, p. 63–6.

14. The link between Eugène Schneider and the Clemenceau family after the statesman's death in 1929 is unclear, but it seems to have been through Georges Clemenceau's son Michel, an engineer, who was hired by his father's friend, Nicholas Pietri, an agent in France for the English firm of Vickers, a major supplier of naval ships and armaments. Louis Altieri, *Nicolas Pietri, l'ami de Clemencèau* (Paris: Éditions Michel, 1965).

15. Léon Simard to Yutaka Mino, April 7, 1977. Montreal Museum of Fine Arts archives.

16. Interview with Léon Simard by Laura Vigo, Curator of Asian Art, Montreal Musem of Fine Arts, April 2013. See Vigo, "Encens, thé et esthétique, Georges Clemenceau et sa collection de boîtes à encens japonaises," in Samuel, Séguéla and Okada, *Clemenceau*, 158.

17. Pritchard, p. 310.

Chapter Thirteen

1. There is no documentation available in the archives of the Georg Jensen firm to confirm Petersen's apprenticeship there. (Information kindly given by Michael von Essen, curator of the Georg Jensen Museum, Copenhagen, to the author in 2003.)

2. Gloria Lesser, *Carl Poul Petersen: Silversmith* (Montreal: Montreal Museum of Fine Arts, 2002), 10. This service is in the McCord Museum collection.

3. Ken Johnston, "Petersen Silverware, Canadian-Made, Has International Reputation," *The Standard* (Montreal), January 18, 1947. Photos by Gray Sperling.

Chapter Fourteen

1. C. Stuart Houston, *Arctic Artist: The Journal and Paintings of George Back, Midshipman with Franklin, 1819-1822* (Montreal and Kingston: McGill-Queen's, 1994), 186.

2. Clive A. Holland, "George Back" *Dictionary of Canadian Biography*, vol. 10, 1972.

3. George Back fonds, MG24-H62, sketchbooks 1955-102 and 1994-254, Library and Archives Canada, Ottawa.

4. Houston, *Arctic Artist*, 164, cited from Back's "A Journal of the

Proceedings of the Northern Land Expedition under the command of Captain Franklin R.N.," 1819–1822, holograph manuscript in the McCord Museum, Montreal.

5. Houston, 165.

6. Houston, 54–5.

7. John Franklin, *Narrative of a Second Expedition to the Shores of the Polar Sea in the Years 1825, 1826, and 1828* (London: John Murray, 1828; reprinted Edmonton, M.G. Hurtig, 1971), 4.

8. George Back, *Narrative of the Arctic Land Expedition to the Mouth of the Great Fish River, and along the Shores of the Arctic Ocean in the Years 1833, 1834 and 1835* (London: John Murray, 1836; reprinted Edmonton: M.G. Hurtig, 1970), 72.

9. Houston, *Arctic Artist*, 55.

Chapter Fifteen

1. English collector Sir Edward William Watkin bought *The Icebergs* and took it across the Atlantic where it was forgotten for almost a hundred years, ending up in the hallway of a boys' school. See Eleanor Jones Harvey, *The Voyage of the Icebergs: Frederic Edwin Church's Arctic Masterpiece*, (New Haven and London: Yale University Press, 2002).

2. « Le grand canal de Venise est la plus merveilleuse chose du monde. Nulle autre ville ne peut présenter un spectacle si beau, si bizarre et si féerique… Là, chaque palais a un miroir pour admirer sa beauté, comme une femme coquette. La réalité superbe se double d'un reflet charmant. » Théophile Gautier, *Voyage d'Italie* (Paris: G. Charpentier éditeur, 1879 ; first published 1852), 134.

3. After the death of Gianni Agnelli, the Palazzo Grassi was purchased in 2005 by French art collector François Pineault, and the building is still used for art exhibitions. Gae Aulenti died in 2012 at age eighty-four.

IMAGE CREDITS
BLACK & WHITE ILLUSTRATIONS

COLOUR PLATES

1

Edwin H. Holgate (1892–1977)
Ludivine, 1930
Oil on canvas, 76.3 x 63.9 cm
National Gallery of Canada, Ottawa
Vincent Massey Bequest, 1968
©Estate of Edwin Holgate. Photo: NGC

2

Edwin H. Holgate (1892–1977)
Nude in the Open, 1930
Oil on canvas, 64.8 x 73.6 cm
Art Gallery of Ontario, gift from Friends of Canadian Art Fund, 1930
Inv. 1326
©Estate of Edwin Holgate. Photo: AGO

3.1

Edwin H. Holgate (1892-1977)
Fisherman's Kitchen, Natashquan, 1931
Oil on panel, 31 x 40 cm
Art Gallery of Hamilton, gift of the Art Institute of Ontario in
memory of Dr. Marty Baldwin, 1968
Inv. 68.72.30
©Estate of Edwin Holgate. Photo: AGH

3.2

Natashquan, Quebec, taken from the Gulf of St. Lawrence
Photo: Vincent Mercier, 2004. Collection: Bernard Landry

4

Jori Smith (1907–2005)
Portrait of Jean Palardy, 1938
Oil on canvas, 56.2 x 45.5 cm
The Montreal Museum of Fine Arts, purchased with the support of
the Canada Council's Acquisition Assistance Program and the
Marguerite Lalonde Trudel Bequest
Inv. 1996.17a
©Estate of Jori Smith. Photo: MMFA, Brian Merrett

5
Jori Smith (1907-2005)
Rose Fortin, 1935
Oil on canvas, 51 x 41 cm
The Montreal Museum of Fine Arts, gift in memory of Talbot
and Alice Johnson
Inv. 2017.373
©Estate of Jori Smith. Photo: MMFA, Christine Guest

6
Installation view of exhibition *The 1920s: Age of the Metropolis* at the
Montreal Museum of Fine Arts, 1991. Photo: MMFA, Bernard Brien

7
Jacques-Émile Ruhlmann (1879-1933)
Corner Cabinet, 1923
Kingwood veneer with ivory inlay on mahogany
126.7 x 85.1 x 59.7 cm
The Brooklyn Museum, New York, purchased with funds given by
Alastair B. Martin, Joseph F. McCrindle, Mrs. Richard M. Palmer,
Charles C. Paterson, Raymond Worgelt and an anonymous donor
Inv. 71.150.1

8
Kurt Schwitters (1887–1948)
Merzbau 1923–36 (reconstruction 1988–89)
Wood, plaster, mixed media,
393 x 580 x 460 cm
Sprengel Museum, Hanover, Germany
Photo: MMFA, Bernard Brien

9
Christian Schad (1894–1982)
Baroness Vera Wassilko, 1926
Oil on panel, 72.7 x 47.6 cm
Private collection
Photo courtesy Nancy Gershman
©Estate of Christian Schad (SOCAN), 2020

10
Paul Beau (1871–1949):
Jug, about 1907
Brass and copper, 16.9 x 12.5 cm
The Montreal Museum of Fine Arts, purchase, Horsley and Annie
Townsend Bequest
Inv. 1966.Dm.2

Jardinière, c. 1910–15
Copper and brass, 21.5 x 26.6 (diam) cm
The Montreal Museum of Fine Arts, gift of Margot and Serge G. Morin
2014.14

Coal scuttle, 1911–12
Brass, 45.8 x 41.1 x 28 cm
The Montreal Museum of Fine Arts, gift in memory of Mr. and Mrs. Ray
E. Powell, given by their family
2000.82

Photos: MMFA, Christine Guest

11
Oratory, James T. Davis residence, Montreal, detail of stencilled wall
covering and altar reredos sculpted by the Bromsgrove Guild (Canada)
Ltd., 1915–16
Photo: Brian Merrett, Montreal, courtesy of the National Gallery of Canada

12
William S. Maxwell, Shrine of the Báb, Bahá'í World Centre, Haifa, Israel,
1948–1953
Photo: Copyright© Bahá'í International Community

13
Paul Cézanne (1839-1906)
La Route Tournante en Provence, about 1866 or later
Oil on canvas, 92.4 x 72.5 cm
The Montreal Museum of Fine Arts, Adaline Van Horne Bequest
Inv. 1945.872
Photo: MMFA, Brian Merrett

14
The Fondation Beyeler, Basel, Switzerland, designed by Renzo Piano
and opened in 1997
Photo: Mark Niedermann, courtesy of the Fondation Beyeler

15
Christopher Dresser (1834–2904)
Teapot, about 1879
Silver-plate and ebony, 16.9 x 25.1, 5.4 cm
Produced by James Dixon & Sons, Sheffield, England.
The Montreal Museum of Fine Arts, purchase, Movable Cultural
Property grant from the Department of Canadian Heritage under the
terms of the Cultural Property Export and Import Act, the Museum
Campaign 1988–93, and the Deirdre Stevenson Funds
Inv. 2011.35
Photo: MMFA, Christine Guest

16
Concert hall of the Claire and Marc Bourgie Pavilion, The Montreal
Museum of Fine Arts
Photo: MMFA, Paul Boisvert

17
Louis C. Tiffany (1848–1933)
The Good Shepherd, 1897
Leaded glass, 395 x 152 cm
Designed by Frederick Wilson, made by Tiffany Glass and Decorating
Company, New York
The Montreal Museum of Fine Arts (formerly the Erskine and
American Church), purchase
Inv. 2008.429.1-9
Photo: MMFA, Christine Guest

18
Louis C. Tiffany (1848-1933)
Magnolia, about 1900
Leaded glass, 134 x 77 cm
Designed by Agnes Northrop, made by Tiffany Glass and Decorating
Company, New York
The State Hermitage Museum, St. Petersburg
Photo: MMFA, Christine Guest

19
Louis C. Tiffany (1848-1933)
Peacock Table Lamp, about 1905
Leaded glass, bronze, 67 x 47 (diam) cm
Designed by Clara Driscoll, made by Tiffany Studios, New York
The Montreal Museum of Fine Arts, purchase Claire Gohier Fund, gift
of Gérald-Henri Vuillien and Christophe Pilaire in honour of being
granted Canadian permanent resident status, Ruth Jackson Bequest,
gift of the International Friends of the Montreal Museum of Fine Arts,
and gift of Joan and Martin Goldfarb
Inv. 2011.373.1-2
Photos: MMFA, Christine Guest

20
Japanese *kogos* (incense boxes) from the George Clemenceau collection,
The Montreal Museum of Fine Arts, gift of Joseph-Arthur Simard, 1960
Photos: MMFA, Christine Guest

Gifu prefecture, Japan
Mino-yaki
Oribe style kogo, early 17th century
Stoneware, white slip, painted designs in brown iron oxide and green glaze
4 x 5.9 cm
Inv. 1960.Ee.1039

Kyoto
Mice on a Chestnut, 1800
Porcelain, coloured glazes
4.4 x 4.7 cm
Inv. 1960.Ee.190

Unrinin Bunzo
Rabbit, 1800
White glazed stoneware
4.3 x 5.6 cm
Inv.1960.Ee.670

Tiger, 19th century
Porcelain, painted enamel decoration

5.5 x 3.8 x 6.9 cm
Inv. 1960.Ee.1531

Seifu Yohei
Lantern with pierced cover, about 1850
Porcelain, blue decoration
5.8 x 4.7 (diam.) cm
Inv. 1960.Ee.1259

Minpei-yaki or Awaji-yaki
Figure of a Woman, about 1830
Porcelain with painted enamel decoration
6.5 cm (h)
Inv. 1960.Ee.500

21
Carl Poul Petersen (1895–1977)
Pair of Compotes, about 1945–55
Silver, 20.8 x 22.4 x 19.5 cm
The Montreal Museum of Fine Arts,
gift of the Honourable Serge Joyal, P.C., O.C.
Inv. 2004.281.1 & .2
Photo: MMFA, Christine Guest

22.1
George Back (1796–1878)
Wilberforce Falls on the Hood River, sketchbook 1821–22
Watercolour on paper, 11.1 x 18.3 cm
Library and Archives Canada, acquired with the assistance of Hoechst
and Celanese Canada and with a grant from the Department of
Canadian Heritage under the Cultural Property Export and Import Act
Inv. Fonds George Back: 1994-254-2
Photo LAC

22.2
George Back (1796–1878)
*Portage La Loche (Methye) between Lac La Loche and the Clearwater
River,* sketchbook 1825–26
Watercolour and pencil on paper, 13.8 x 21.6 cm

Library and Archives Canada
Inv. Fonds George Back: 1955-102-25
Photo: LAC

23
Installation view of exhibition *Cosmos: From Romanticism to
Avant-garde* at the Montreal Museum of Fine Arts, 1999
Photo: MMFA
©Estate of Paterson Ewen

24
Palazzo Grassi, Venice, built in 1770 by architect Giorgio Massari
Photo: Matteo De Fina, courtesy of the Palazzo Grassi

ACKNOWLEDGEMENTS

In writing stories of diverse experiences going back in time, I have relied not only on memory and scattered notes but also on the help of many people, some who appear in the book and others who were behind-the-scenes. I am especially indebted to the former director of the Montreal Museum of Fine Arts, Pierre Théberge, who sadly passed away in 2018. He led me into the most stimulating ten years of museum life on the teams organizing three international exhibitions in the 1990s, along with his friend and prominent art historian Jean Clair. I pay tribute not only to Pierre Théberge but to other directors I served, more recently Guy Cogeval who led the museum in a whirlwind of projects, and Nathalie Bondil who has undertaken with great success a major expansion of the museum's galleries as well as its outreach into the local community and abroad. I am grateful for her support and especially for urging me and colleague Diane Charbonneau to complete an all-encompassing book on the museum's design collection.

Among others from the Montreal Museum, very special thanks go to Marie-Claude Saia, head of rights and reproduction services, who searched out photographs from her vast bank of museum images and offered advice on copyright issues. I also express my gratitude to Danielle Blanchette, archivist *extraordinaire*, who sought out the smallest details that were missing from my notes and memory, and to Danièle Archambault, recently retired, who as registrar and head of archives managed her team with great patience and consideration. Thanks also go to Joanne Déry and Thérèse Bourgault, who facilitated my visits to the museum's library.

Beyond the museum, in particular, I warmly thank Elaine Kalman Naves, the first person outside my family to read the stories. It was reassuring to be able to count on her comments and encouragement in the early days of the manuscript. Every story brought its share of those who offered assistance with the research or preparation of the book. Among them are Bernard Landry, a devoted historian of

Natashquan and its people; Gabriel Landry who grew up there, and Marie-Claude Vigneault who toured me around the community. At McGill University's McLennan Library, Rare Books and Specials Collections, I owe a debt of gratitude to librarians Jennifer Garland and Ann Marie Holland, who helped me access the John Bland Canadian Architecture Collection. Others to whom I am thankful for their help through interviews or through their support are Charles Hill and Cyndie Campbell at the National Gallery of Canada, Diana Davis, Nancy Gershman, Victor Isganaitis, the late Mary Maxwell Rabbani and Karen McKye, Secretary General, National Spiritual Assembly of the Bahá'ís of Canada, Constance Naubert-Riser, Cameron Pulsifer, the late Liliane M. Stewart, Laura Vigo, and Inta Zvagulis. For assistance with photographic images, I would like to thank Mary Handford, Heather Hume, and Jonathan Rittenhouse, who graciously granted permission to reproduce images from the Paterson Ewen, Jori Smith and Edwin Holgate estates, respectively. Additional thanks go to Brian Merrett, Hélène Samson of the McCord Museum, Saskia Menges of the Fondation Beyeler, Basel, Samantha Martin of Airstream Inc., Jackson, Ohio, the David Tunkl Gallery, Beverley Hills, California, and the staff of Library & Archives Canada.

I am greatly indebted to Simon Dardick and Nancy Marrelli, publishers of Véhicule Press, who enthusiastically accepted the manuscript and guided the publication to fruition. Also it was a great pleasure to work with Derek Webster, who with patience and humour, pushed and pulled the stories into shape. In addition, I am grateful to copy editors Diane Carlson and Correy Baldwin, David Drummond for his cover design and Jennifer Varkonyi, marketing manager.

Lastly, I would like to acknowledge my sisters, Sarah, Jennifer and Anne, who followed the progress of the writing, offering their thoughts as they urged me forward, and especially Diana who in addition lent her librarian skills when deadlines loomed. My late mother, Esmé Seton Pepall, who had heard many of these stories before they were written, was ever in my thoughts. My sons Philippe

and Charles and their families, Julia Betts, Jason Whetter, and grandson Arthur, were there to ease any pressure, and I am especially indebted to my husband Armand de Mestral, who was always the first to read each story and offer advice, whether loving, literary or legal.

BIOGRAPHICAL NOTE

Former Senior Curator of Decorative Arts (retired 2012), and form-
erly Curator of Canadian Art at the Montreal Museum of Fine Arts,
Rosalind Pepall has participated in a wide range of exhibitions, pub-
lications and conferences for over thirty years. She served as lead
curator for the North American presentation of *Ruhlmann: Genius
of Art Deco* (2003–04), in collaboration with the Metropolitan
Museum of Art, New York, and the Musée des Anneés Trente,
Paris; the travelling exhibition, *Edwin Holgate, Canadian Painter*
(2005–07), and *Tiffany Glass: Colour and Light* (2009–10), presented
in Paris, Montreal, and Richmond, Virginia. More recently, she co-
edited *Decorative Arts and Design: The Collection of the Montreal
Museum of Fine Arts* (400 pages), published in 2012, and served as
a member of the curatorial committee for the exhibition *Artists,
Architects, and Artisans: Canadian Art 1890-1918*, presented at the
National Gallery of Canada in 2013 to 2014, under the direction
of Charles Hill. She continues to serve as a consultant, conference
speaker and writer in the field of art.

INDEX